THE YEAR 1200 II

THE YEAR 1200

A Background Survey

Published in conjunction with the Centennial

Exhibition at The Metropolitan Museum of Art

FEBRUARY 12 THROUGH MAY 10, 1970

II Compiled and edited by
FLORENS DEUCHLER

THE CLOISTERS STUDIES IN MEDIEVAL ART II

The Metropolitan Museum of Art

DISTRIBUTED BY NEW YORK GRAPHIC SOCIETY LTD.

ON THE COVER:
Fresco (detail) from monastery of San Pedro de Arlanza, Spain, about 1220
The Cloisters Collection, 31.38.1a

A NOTE ON CROSS REFERENCES:
References to catalogue entries in *The Year 1200: I The Exhibition*
will be found in this book in this fashion: I, no. 100

Design: Peter Oldenburg
Color separations: Electronics Corp.
Color illustrations: Vinmar Lithographing Co.
Typesetting: Finn Typographic Service, Inc.
Printing and binding: Jenkins-Universal Corp.

CONTENTS

CONCERNING THE YEAR 1200

THE METROPOLITAN Museum's Centennial exhibition *The Year 1200* consists of masterpieces of Western European art created between 1180 and 1220. It is an attempt to bring into focus the stylistic trends that stretched from the twelfth century into the beginnings of High Gothic, which culminated in the court style of Louis IX (reigned 1226–1270) as exemplified in the Ste-Chapelle in Paris. It is the ambition of this undertaking to clarify the backgrounds and explore the roots that brought medieval art in France to a climax.

The achievements under St. Louis in architecture, sculpture, stained glass, and illuminated manuscripts, all of them highly homogeneous works and monuments of purest stylistic balance, had their origin in the art of the years 1180–1220. This earlier art—the substance of our exhibition—is the result of an amalgam of French, Flemish, Mosan, and Byzantine ingredients with a whiff of antique. The period of 1200 may be called "transitional" in a chronological sense and interpreted as a link between Romanesque and Gothic. Although the works produced between 1180 and 1220 lack stylistic unity, a small group of French origin reached the peak of classical balance. This classicism is the most striking peculiarity of the style "between" the ages. The group is in a style of its very own, which has not yet been fully labeled by art historians. Tentatively described by Louis Grodecki as the "style antiquisant," it will never again be equaled.

This intriguing development took place during the reign of Louis IX's predecessor, Philip Augustus (1180–1223). Philip's role as a commissioner and promoter of the arts is still to be investigated, but it seems beyond doubt that we have to assign important patronage to the royal house. The French court style originates obviously as early as 1200 in Ile-de-France, the region consisting of Gâtinais, Hurepoix, Brie, Mantois, French Vexin, Beauvaisis, Valois, Noyonnais, Soissonnais, Laonnais, and Parisis. Paris is only one of many places where we can find evidence of the king's presence, and the capital grew only gradually into its role as the paramount center of artistic life, which it was to be in the later thirteenth century.

Among the different sources of the flowering of intellectual and artistic life in Paris, one circumstance dominated the years around 1200: namely, the emergence of the university as the main center for learned studies. Salerno, Bologna, and Paris were the three earliest universities in Europe. Each of them became a model for later institutions. Paris was the great center for logic, metaphysics, and theology,

and the archetype of the "masters' university." Founded in 1200 by Philip Augustus, Paris was recognized by Pope Innocent III, whose legate, Robert Courçon, gave it its statutes in 1215. From the very beginning, the University of Paris was closely connected with the Church. It had strong ties to the schools that had grown up on the Left Bank of the Seine from the time of Peter Abelard and to the cathedral school where Peter Lombard had taught. These were the sources from which the university had sprung. The virtual monopoly on teaching by the mendicant orders—especially the Dominicans, who reached Paris in 1217, and the Franciscans, who arrived in 1219—had an important impact on scholastic learning.

One of the major topics dealt with in Paris was Aristotle's work, which first started to reach the West in the second third of the twelfth century. Its effect on Western thought was extraordinary. A major part of Aristotle was translated not from the Greek but from the Arabic. Those translations included Neoplatonic as well as Arabic elements. Details on this will be found in Marie-Thérèse d'Alverny's essay, "The Arabic Impact on the Western World."

The purpose of this and the other essays that follow is to point up the multitude of elements that affected political, intellectual, and artistic life during the period we are investigating. We hope that this information will enable the reader as well as the visitor to the exhibition to gain insight into the major areas of artistic production represented. The photographs further extend the scope of this volume by illustrating key monuments that we cannot exhibit in New York. These monuments are an invaluable complement to the material of the exhibition, for they are, after all, the context out of which the objects in *The Year 1200* come, the "style Philippe-Auguste."

The Museum's and my personal gratitude go to the authors who consented to write the essays for this volume. It is one of the many goals of our new publication series The Cloisters Studies in Medieval Art to make available background material for more specialized publications of the Medieval Department and The Cloisters. I also acknowledge thankfully the collaboration of Margaret Frazer, who wrote the captions for the Byzantine section, and the help of Michael Botwinick, Assistant Curator, who kindly supervised my own texts. Konrad Hoffmann, the author of the catalogue of the exhibition, gave me valuable help in selecting the objects illustrated in this complementary volume.

FLORENS DEUCHLER
Chairman, Department of Medieval Art and The Cloisters

THE YEAR 1200 II

Nave looking east, Amiens Cathedral.
1220–1236

(ill. 16)

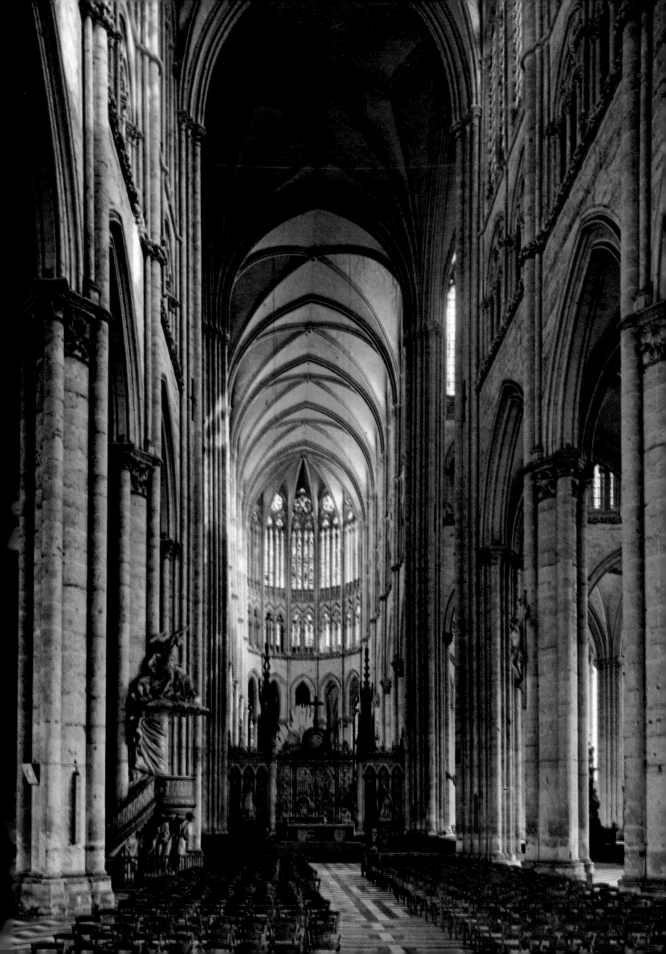

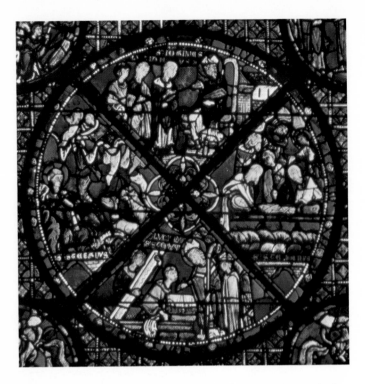

Detail of the History of the Relics of St. Stephen window,
Bourges Cathedral. About 1210

Rose and windows in the south transept,
Chartres Cathedral. About 1220

(ill. 83)

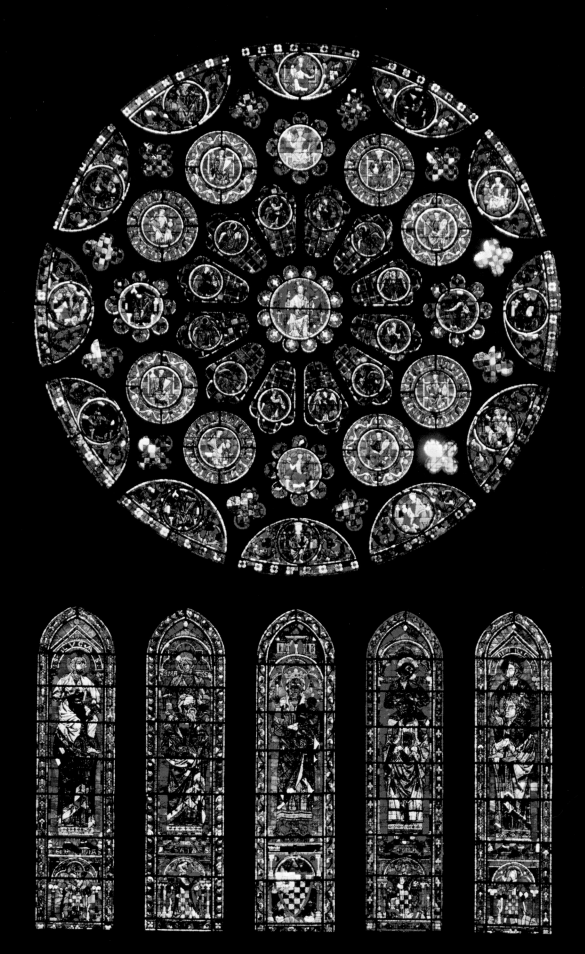

Croce dipinta, signed by Berlinghieri Berlinghiero,
Lucca, Pinacoteca. Tuscany, 1210–1220

(ill. 91)

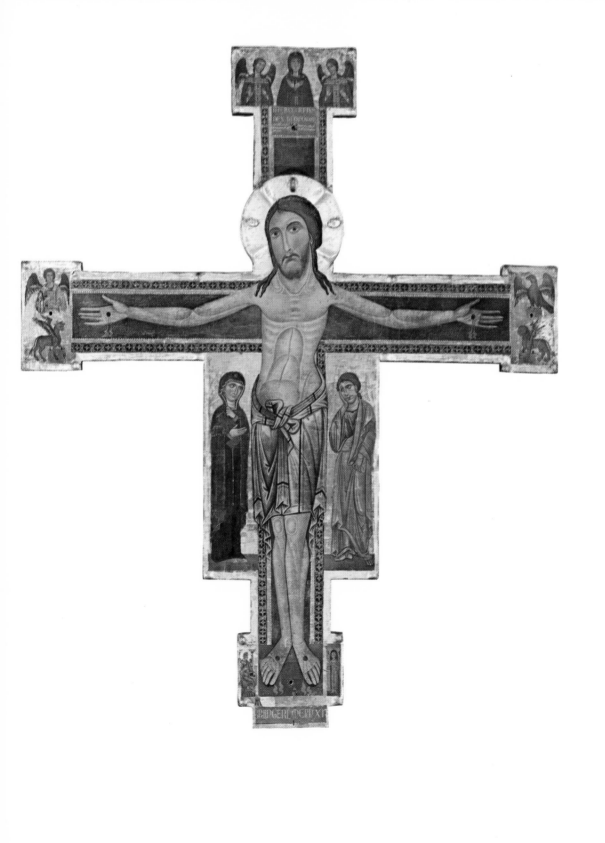

Detail of the painted wooden ceiling,
church of St. Michael, Hildesheim. About 1220

(ill. 92)

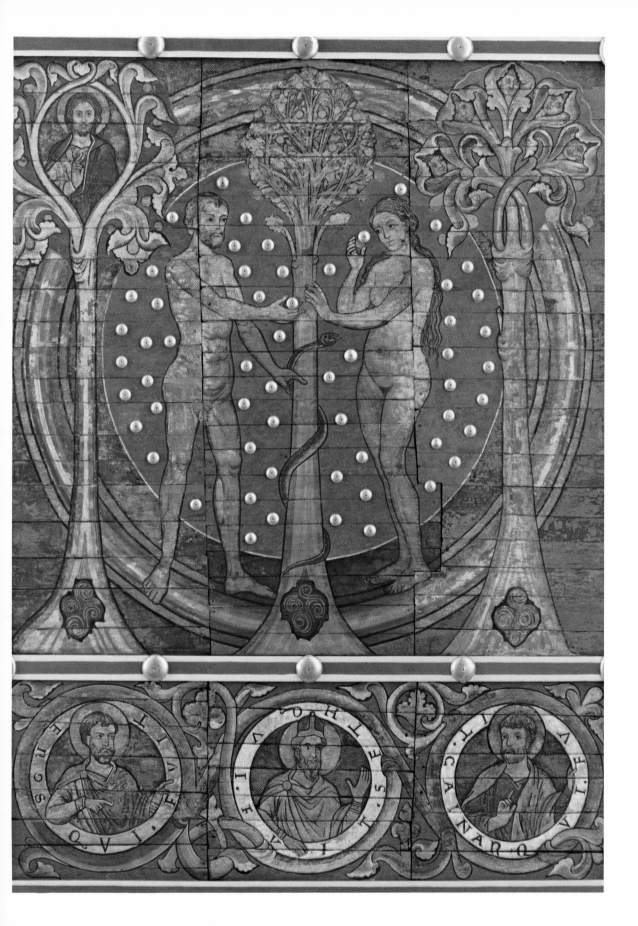

Page from the Gospel book

from the Benedictine Abbey of Gross-St.-Martin in Cologne,

Brussels, Bibliothèque Royale. Cologne, about 1210–1220

(ill. 212)

Gold and enameled reliquary cross,
Washington, D.C., Dumbarton Oaks Collection.
Salonika, about 1200

(ill. 228)

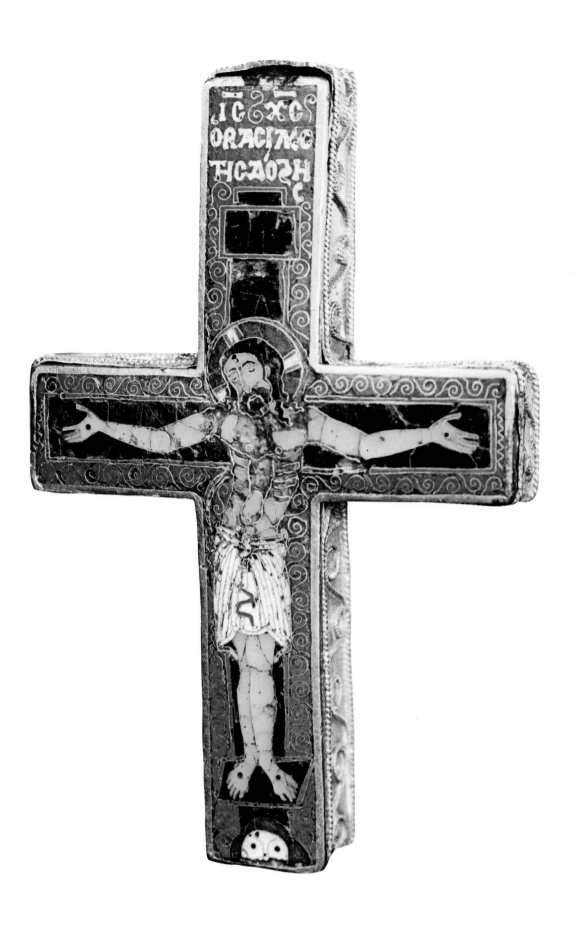

Mosaics on the west wall of the nave,
Monreale Cathedral (Sicily). 1180–1190
(ill. 229)

Charles J. Liebman

ART AND LETTERS IN THE REIGN OF PHILIP II AUGUSTUS OF FRANCE: THE POLITICAL BACKGROUND

IT IS NOT without reason that Philip Augustus has been called the greatest artisan of French unity in the Middle Ages. He was known as *Philippe le Conquérant* until the sixteenth century, when the surname Augustus, first used by his biographer and contemporary, Rigord, came into general use. One of Philip's advisers was Stephen of Tournai, who played a role of considerable importance in ecclesiastical affairs during the reign of this monarch. Stephen was also the patron of the leading artists and scholars of the day: a notable illustration of Stephen's manifold influence is afforded by his extensive relations with the kingdom of Denmark and the circumstances attendant on the production of the famous psalter that belonged to Philip's second wife, Ingeborg of Denmark.

The long reign of Philip Augustus (1180–1223), during which Philip battled King Henry II of England and his successors Richard the Lionhearted, with whom he set forth on the Third Crusade (1190), and John Lackland, was marked by the virtual expulsion of the Plantagenets from the Continent. By 1204 Philip had conquered the great duchy of Normandy. Two years later the counties of Anjou, Maine, and Touraine were acquired for the crown, and Philip Augustus had succeeded in securing for the Capetian dynasty power unknown since the days of the Carolingians. The brilliant victory of Bouvines (1214), where he defeated a coalition headed by the German emperor Otto IV, insured that for a long time to come France was to be immune from foreign aggression. Philip's most important vassals were the duke of Burgundy and the counts of Brittany, Champagne, Flanders, and Toulouse.

Philip's first marriage (1180) was to Isabella of Hainault, who died ten years later. Wishing to secure an alliance with King Canute VI of Denmark, Philip in 1193 married Ingeborg, the king's sister, whom he repudiated immediately after

I

their marriage and imprisoned. This unhappy state of affairs, which lasted nearly twenty years, brought Philip into direct conflict with Pope Innocent III, who pronounced an interdict on the kingdom of France, which was raised after nine months (1200). Meanwhile, the king had married Agnes of Meran, who died in 1201. It was only in 1213 that Ingeborg was permitted to resume her rightful place as Philip's queen.

Philip Augustus introduced important financial, judicial, and legislative measures. The royal administration was strengthened by the creation of bailiffs (*baillis*), whose duties were outlined in detail for the first time in 1190. In Paris, the same year, construction was begun on the first castle of the Louvre, heavily fortified, and on a great wall encircling the city, completed in 1209. A notable vestige of the wall of Philip Augustus remains to this day on the left bank on Mont Ste.-Geneviève, named for the great abbey that traced its origins to the Merovingian king Clovis (466–511), who was buried there with his wife Clotilda and St. Geneviève, the patron saint of Paris. At the time of Philip's coronation, Stephen of Tournai had been abbot of Ste.-Geneviève for more than three years.

Stephen of Tournai, canonist, theologian, preacher, hagiographer, and poet, was born in 1128 at Orléans; it was there that he completed his first studies, which included dictamen, the art of epistolary composition. After five years at Bologna, renowned as a center for legal studies, Stephen attended the famous schools of Chartres. He was abbot of St.-Euverte at Orléans from 1168 until 1176, when he was called to Paris to direct Ste.-Geneviève. Paris in the twelfth century had become a great center of learning; we know that Peter Abelard taught on Mont Ste.-Geneviève and also at the cathedral school of Notre-Dame. Shephen's letters show that during his abbacy (1176–1192), the most illustrious in Ste.-Geneviève's history, he was the patron of Peter the Chanter and Simon of Tournai, two famous masters who taught in Paris at this time. It is not unlikely that his circle also included Alan of Lille, the scholastic philosopher, and Herbert of Bosham, who was Thomas Becket's secretary. The last phase of Stephen's life began in 1192 with his designation as bishop of Tournai; his letters disclose that during his episcopate he remained in close contact with Paris, where the first royal charter of the university, which originated in the cathedral school of Notre-Dame, was issued in 1200 by Philip Augustus. Stephen died at Tournai in 1203.

The letters, of which there are more than three hundred, are a primary source for the history of the times and cover a wide variety of subjects. They have been termed Stephen's most important work. There are letters to seven popes and to many lesser dignitaries of the Church. During his administration of Ste.-Gene-

Authentication by Stephen of Tournai, as abbot of Ste.-Geneviève, of a copy of an agreement (1184–1188) between the chapter of Troyes and the curé of Ramerupt (Arch. du dép. de l'Aube, G. 3186). This document was also certified by the abbots of St.-Victor and St.-Germain-des-Prés. Stephen's note reads: "Ego Stephanus Sancte Genovefe dictus abbas notum facio omnibus ad quos presens scriptum pervenerit, ita contineri expresse verbo ad verbum in autentico, sicut continetur in hoc rescripto."

viève, Stephen had occasion to write to the Plantagenet king Henry II, to the king of Hungary Béla III, and to Princess Ingeborg's brother, Canute VI of Denmark. Of especial interest is a series of letters concerning a noble Danish clerk, Peter Sunesøn, a nephew of the celebrated Absalon, archbishop of Lund, called the founder of Copenhagen. After studying at Ste.-Geneviève under the direction of Stephen of Tournai, Peter in 1191 became bishop of Roskilde, and two years later he escorted Ingeborg on her bridal trip to Amiens. His brother Andrew was chancellor to Canute VI, had also studied with Stephen, and was the most learned theologian of his country. In 1194 he went to France and then to Rome to plead the cause of the Danish princess.

There are many indications of Stephen's close ties with the royal house of France. We learn from a letter in which he arranges for a lodging in Reims that he was present when Philip was crowned in that city at the age of fourteen, during the lifetime of his father, Louis VII the Young (1179). Louis died the following

KL

Iuliuſ · habet dieſ · xxxi · luna · xxx ·

T muſ maciat iuli deinuſ labefactat.
I uliuſ habet dieſ · xxxi · luna · xxx ·
xix Iulii.
viii A vi S̃ cõrum proceſſi et Marciniam · niĩ.
xvi G iiii Tranſlacio S̃ã Marcini.
v D iii
E ii Octab̃. Apoſtolorum.
xiii
ii G viii 15̃ E̅ uodii epĩ ⁊ conf̃.
A vii 15̃
x B vi 15̃ S̃cõrum Septẽm fratrum.
C v 15̃ Tranſlacio Sancti Benedicti.
xviii D iiii 15̃
vii E iii 15̃
F ii 15̃
xv G IDVS
iiii A xvii Auguſti.
B xvi kl̃
xii C xv kl̃ S̃ã Arnulfi niĩ. Sol in leone.
i D xiiii kl̃
E xiii kl̃ S̃ã Margarete uirginiſ.
ix F xii kl̃ S̃ã Victoriſ niĩ. ⁊ S̃ce praxediſ uirg̃.
G xi kl̃ S̃ce Marie magdalene.
xvii A x kl̃ S̃ã Apollinariſ niĩ.
vi B ix kl̃ S̃ce Xp̃ine uirginiſ.
C viii kl̃ S̃ã Iacobi apoſtoli.
xiiii D vii kl̃ S̃ã Marcelli epĩ.
iii E vi kl̃ A n̅n̅o d̅n̅i q̅ꝫ · êe · quartodecimo · uenit philippe li roiſ de
F v kl̃ Nazarii celſi pantaleoniſ m̃ĩ.
xi G iiii kl̃ S̃cõrum feliciſ. ſimplicii. fauſtini. ⁊ beatriſ.
xix A iii kl̃ S̃cõrum Abdon et Senneſ. niĩ.
B ii kl̃ S̃ã Germani epĩ.

frãce en batailloe · le roi reban ⁊ le conte de flandreſ · ⁊ le ſire de bolongne ⁊ pluſieſ autreſ baronſ.

year, and Stephen of Tournai, according to an English chronicler, was by his death-bed. Stephen wrote his epitaph and compared this monarch to David and to Solo-mon. Some years later he also composed an epitaph for Maurice de Sully, the bishop of Paris who in 1163 had embarked on the construction of the present cathedral of Notre-Dame. At his death in 1196 he had completed a major portion. Maurice de Sully's labors are recalled in Stephen's verses.

Stephen was godfather to the eldest son of Philip and his first wife, Isabella of Hainault, the future Louis VIII. The boy was twelve years old when Stephen wrote him, promising to send him a horse that he had requested. Stephen, exhorting the youth to love God and to love his father, also urged him to apply himself to the study of letters, which would be both useful and necessary in the kingly coun-cils and negotiations that lay ahead, in peace and in war.

Of greater political significance is a series of letters, relating to the bishopric of Dol, in Brittany, in which Stephen of Tournai acted as spokesman for Philip Augustus himself (1184) and for his mother, Adela of Champagne, during Philip's absence on the Third Crusade. The bishops of Dol, a suffragan diocese of the archbishopric of Tours, over which the French kings in theory exercised tem-poral power, had long sought their independence of Tours. This power appears in reality to have been in the hands of the counts of Brittany, who were at this time vassals of Henry II of England. The proposed creation of an archbishopric of Dol, vigorously supported by the king's Plantagenet rivals, was held to threaten gravely the royal interests. Stephen's attachment to the crown is clearly demonstrated in the letters, addressed to Pope Lucius III and to Pope Celestine III, in which he spoke for the young king and his mother.

His attachment to the French royal house and, in particular, to Philip Augustus, did not deter Stephen of Tournai from becoming the principal protector of Inge-borg of Denmark at the time of her repudiation by the French monarch. A letter to William of the White Hands, archbishop of Reims, his ecclesiastical superior and Philip's uncle, is a firm but compassionate and very moving plea for the aban-doned queen. In a second letter, he thanked the archbishop in Ingeborg's name,

July calendar page from the Ingeborg Psalter, fol. 6 verso, with the memorial entry referring to the battle of Bouvines and Philip Augustus's victory in 1214. The text reads: "anno dni. m. cc. quartodecimo. ueing (ui) phelippe li rois de france en bataille. le roi othon et le conte de flandres. et le c(on)te de boloigne et plusors autres barons." ("In the year of the Lord one thousand two hundred and fourteen the king Philip of France defeated in battle the king Otto and the count of Flanders, and the count of Boulogne and many other barons.")

although the unhappy affair was not to be resolved during Stephen's lifetime. The matter of Dol in Brittany and his protection of Queen Ingeborg are clear indications of Stephen's political role during Philip's reign and more particularly of his moral authority. It is in this light that the origins of a famous manuscript, the Ingeborg Psalter, may be viewed (ills. 190–201).

This great illuminated psalter, considered the masterpiece of medieval book illustration, was produced for Queen Ingeborg at about the time (1195) that Stephen, bishop of Tournai, had become the queen's protector. Recent research on the Ingeborg Psalter has emphasized, in several of the illuminations, the symbolic utilization of royal pretensions and rights. An example is the baptism of Christ, showing a dove with an ampulla of holy oil in his beak; this is thought to be a reminiscence of St. Remi and the baptism of Clovis. This and other examples that might be mentioned appear to reflect the preoccupations of Stephen of Tournai and of the noble Danes, by then elevated to the highest offices in their land and committed to protecting the rights of their princess, who had studied with Stephen in Paris.

The calendar of the Psalter records the deaths of Ingeborg's parents, King Waldemar I and Queen Sophie. It also mentions Eleanor, countess of Vermandois, at whose death in 1213, the year of Ingeborg's reconciliation with the king, important lands were added to the crown, as well as the great victory of Philip Augustus the following year at Bouvines. Eleanor of Vermandois had, in the same way as Stephen of Tournai, befriended Ingeborg during her hour of trial. It is significant that Stephen also encouraged in the countess a love of literature. A richly illuminated manuscript, now in the Pierpont Morgan Library in New York (Ms. 338), was inherited by Eleanor from her mother, a noblewoman to whom the text, part of a vast biblical commentary in French prose, was dedicated. The miniatures of this manuscript were produced in the same atelier as the Ingeborg Psalter, and the commentary has been attributed to a protégé of Stephen's who taught in Paris. A versified life of St. Geneviève, likewise in French, was inscribed to the countess herself. Here again is seen the influence of Stephen of Tournai and of the great abbey, which he directed at a decisive moment in the history of France.

Ingeborg survived Philip Augustus by a number of years and was recognized as queen by Philip's successors, Louis VIII and Louis IX—St. Louis.

Robert Branner

HIGH GOTHIC ARCHITECTURE

ONLY ONCE IN AN AGE does man create an eternal architecture, one that inspires awe by the grandeur and immutability of its conception yet invites everyone to invest it with his own dreams and aspirations. Such is St. Peter's in Rome, the Parthenon, the pyramids of Egypt. Such also is the small group of churches built in North France around 1200 and known as High Gothic, headed by the cathedral of Chartres.

The High Gothic cathedral is a monument to clarity and reason (ill. 13). Within its own frame of reference Chartres has the same invincible logic as the Parthenon. Every part has its proper place, nothing has been omitted, nothing is superfluous. Instead of the starkly opposed verticals and horizontals of the Greeks, the medieval architect used graceful arches. But similar principles underlie his design. Vertical shafts support each arch or rib and the substance of the structure can be read on the surface. Never for a moment are we allowed to doubt its inherent stability.

Yet the High Gothic cathedral is not a sterile exercise in logic. It is a visionary design, a vivid, living testimony to the dream of its maker. Composed of solid blocks, it is open and vast. Rooted to the earth by massive, ponderous walls, it soars upward into aerial towers and spires. It forms a finite space with every vista clearly limited, yet it appears to be constantly expanding in size. And it has huge windows to let in floods of light, but thanks to the stained glass the interior is as dim as twilight.

These paradoxes are more apparent than real, however, for the High Gothic style is not tense, but calm and balanced. Whether it be Chartres or Reims, or Soissons or Amiens, the interior always has three stories in the classic proportions A:B:A, a dark area in the center flanked above and below by two tall, light stories, one of windows and the other an arcade opening onto an aisle. The stories are stretched down the nave in bands, but more important is their repetition as a vertical group, for this forms the bay, the basic unit of High Gothic design. The bay is bordered from top to toe by projecting shafts that cut into the main space

7

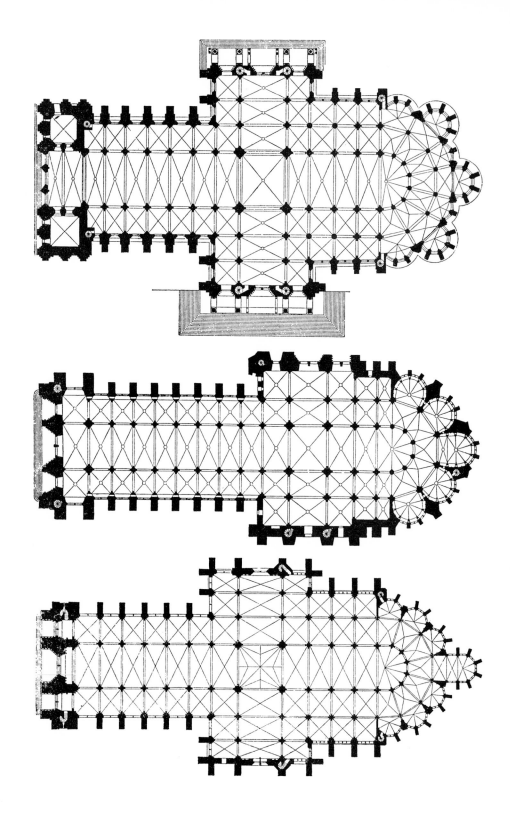

of the church and give the latter rhythm and articulation. They also provide the warp against which the woof of horizontals is woven, so that the wall is like a giant web. But this, too, is an illusion, for the anatomy of the church, like the human frame, is in reality a three-dimensional skeleton. The wall is a mere skin stretched between uprights and arches, on which rest the ribs of the vault, its hips in turn supported on the outside by flying buttresses. The space of the nave is framed and protected by these struts, which give it order and coherence.

The calm of High Gothic is in part due to its enormous size and weight. The key term to understanding the style is probably gravity, both in the sense of earth-drawn and in the sense of seriousness and imperturbability. Chartres and Reims, in particular, are massive and ponderous, with no finicky details to distract us (ill. 14). But they are not oppressive, thanks to their sheer size and scale. The void is so grandiose that we seem to grow smaller when we enter it, a feeling that is rapidly converted into the opposite effect, that the building itself is growing larger. The balance of High Gothic is not only of one stone upon another and of void and solid, but also of weight and height, of light and dark. Rarely has there been an architecture of such serenity.

We must not think that all High Gothic churches are identical, however, for although they were built in a short period around 1200, they express the different personalities of their makers. Chartres (begun in 1194) and Reims (begun in 1210) seem obsessed with eternity when contrasted with Soissons and Amiens. Soissons (begun about 1197) is much lighter and thinner than the others—and also smaller—and its architect was preoccupied with making us feel these qualities. The piers are lighter, the shafts on their sides have been omitted, the upper windows are taller and less squat. The architect also went beyond the "absolute" logic of Chartres by combining elements in an elliptical manner, so that individual parts once placed next to each other now are merged.

Amiens (begun in 1220), the work of Robert de Luzarches, is also thin, but it is not elliptical (ill. 16). It has still another kind of logic, not that of Soissons or of Chartres and Reims, but rather of Paris. It is refinement personified, it has a virtuoso structure, a carefully articulated elevation, it gives the impression of having been worked over, elaborated, chased like a piece of jewelry. Yet when we enter Amiens we are astonished by its austerity, to which the richly decorated moulding above the arcades gives scant relief. The master of Chartres had a clear,

Plans of the cathedrals of Chartres, Reims, and Amiens

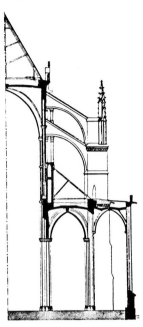

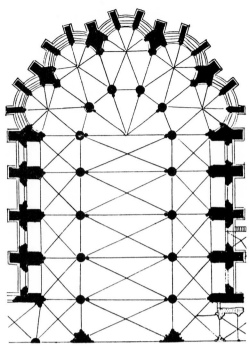

Cross section
of Amiens Cathedral

Plan of the choir of Soissons Cathedral

inventive mind, while in comparison Robert de Luzarches was an intellectual, sharp, intent, daring. With him, High Gothic comes to a close.

Small as it is in size and duration, the High Gothic group stands out sharply from the earlier Gothic style of the twelfth century. That period was one of experiment, when architects were still trying out different ways to support the great ribbed vaults they wanted to place over the naves and different kinds of surface texture and lighting arrangements. The choir of Vézelay is a fine example of such an essay (ill. 12). It has the same stories as Chartres, but not the same proportions or the same structure. The verticals do not descend directly to the pavement but stop at the arcading, and the articulation is uneven and irregular. The building has a strong wall-surface that we feel everywhere, but it is lightened and modified by elaborate mouldings, colonnettes, and capitals. This is enhanced by the use of contrasting lemon-yellow and dark brown stone and by polished, shining columns and bases. And Vézelay is small—much smaller than Soissons—so that it does not impose itself on us in the same way. It is a precious object, but one lacking in the precise combinations of High Gothic design.

Braine, church of St.-Yved. Built between 1200 and 1216, this church is, thanks to the short campaign, one of the most homogeneous monuments of the period and perfectly reflects the early 13th-century architectural style. Drawing by R. N. Shaw published in London in 1851. For details see ills. 31, 33, 34

Another twelfth-century essay, of an entirely different sort, is provided by the transept of Noyon cathedral (ill. 9). Here each end, rounded like an apse, is a hollow wall, pierced lengthwise by passageways and crosswise by windows. The shafts are no longer applied to the surface as they are at Vézelay, but now actually form the wall themselves, and they are given relief by the space that flows between and around them. The vault seems merely to be a natural extension of the wall into an overhead cover.

Each of these essays has its own character. Noyon marks the achievement of a fully skeletal structure, of the sort that was to lead ultimately to Chartres; Vézelay is sophisticated and discreet. But both are tentative and lack the authority of final statements. That was to be made only by the masters of 1200.

The impact of High Gothic on European architecture was enormous. Not only did Chartres fix the future of the Gothic style in France, but it also established a format that was to be widely imitated in cathedral design across Europe. For generations Chartres was viewed as a model of what the Gothic cathedral should be. The force of this movement was almost physical, for one can see the other designers of around 1200 literally pushed aside, shunted away from North France where Gothic had originated. Two outstanding examples of this "rejection" are the cathedrals of Lausanne and Bourges (ills. 7, 15). Both have the short windows that were typical of the twelfth century, and both have relatively tall central stories, which means different proportions from those of Chartres. Lausanne (1192) also has a screened passage running in front of the upper window, so that it resembles Noyon more than Chartres: the elevation is in relief, drawn on the slot-like spaces of the passages rather than on a flat wall. The design of Lausanne originated in North France in the 1170s, when it was the wave of the future; Chartres and Reims literally put it out of business. Bourges (1195) on the other hand, is more complex, for it was designed by a visionary with the same training and the same stature as the master of Chartres. But his aesthetic reactions were different. Instead of elongating the windows, he lengthened the piers, jacking the wall up so high that there was space for a whole other church of three stories in the aisle. This meant that the spaces could cascade down in three stages (nave and two aisles), to form a sort of hollow pyramid. And Bourges is not "partitioned" into sharply defined bays, as is Chartres; instead, it gives the illusion of total unity. But for that very reason it could not serve as a model for later generations, since the whole had to be copied or nothing at all. Chartres, with its tremendous simplicity and imitability, had triumphed.

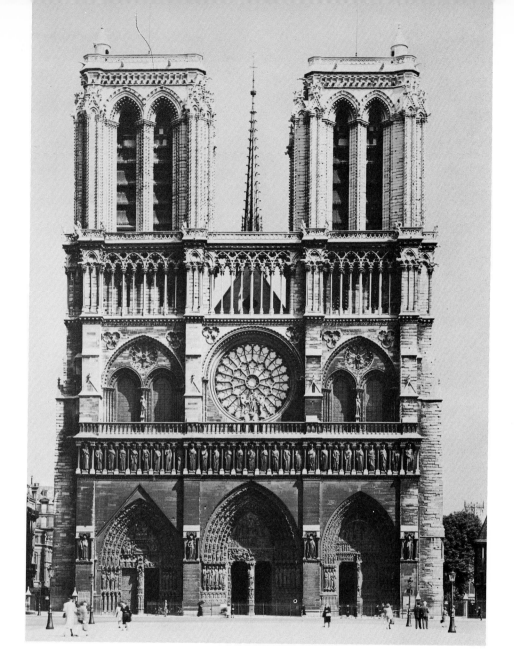

1. *Paris, Cathedral Notre-Dame. West façade. About 1200–1220*

This façade, which has been changed little since its original construction, is dominated (like its model, St.-Denis, consecrated in 1140) by two towers. The buttresses run down to the level of the portals, articulating the surface into three vertical sections, which correspond to the nave and its two side aisles in the interior. Horizontal galleries intersect the vertical layout of the façade. The nine compartments and the two towers are carefully balanced to give an impression of monumental peace, typical of French Gothic architecture conceived between 1200 and 1220. Dates of construction: choir, about 1163–1182; nave, about 1190; right portal, about 1165; left portal, about 1210; portal of the Virgin, about 1225–1230; transept, after 1250.

2. *Laon, Cathedral Notre-Dame. West façade. Conceived about 1170; built 1190–1210*

This is the only monument in France that can give a true idea of what a Gothic cathedral was intended to look like. It has five tall towers and was designed to have seven. Two construction campaigns: about 1170–1190 and 1190–1210.

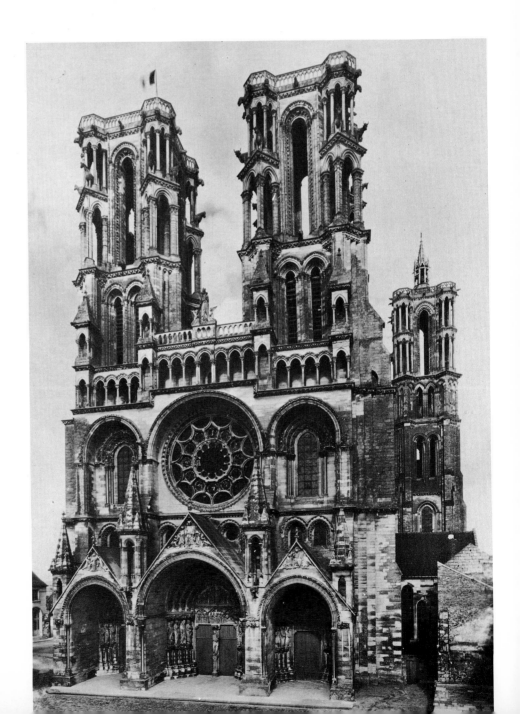

3. *Chartres, Cathedral Notre-Dame. West façade. 12th–14th centuries*

Chartres Cathedral was built primarily between 1194 and 1221. Only minor parts of the exterior, such as belfries and the north spire, were not finished during that period. The spire over the south tower was the first in France.

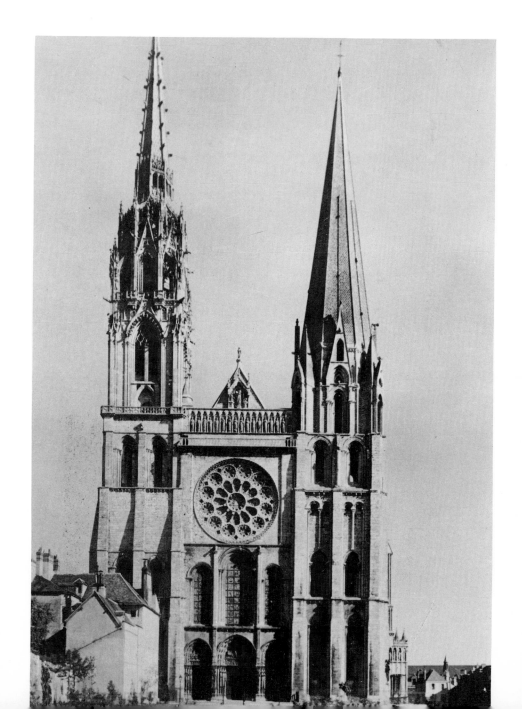

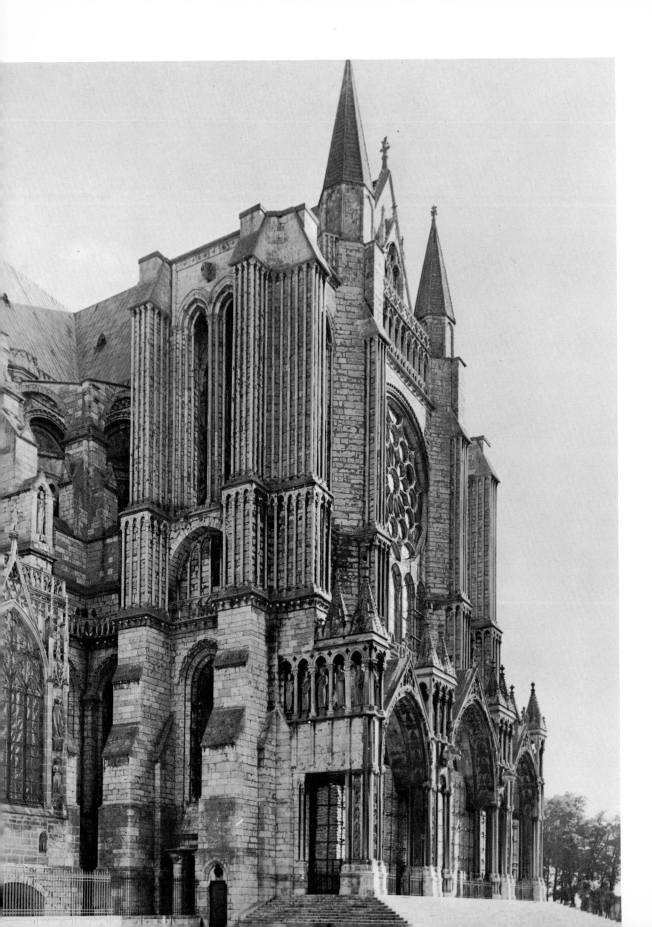

4, 5, 6. *Chartres, Cathedral Notre-Dame. South porch (left), about 1230. North portal (top), about 1205–1210; porch after 1215. South portal (bottom), from about 1210*

The south porch shows how architecture as a structure can change into sculptural forms. The north portal has in the central tympanum a relief depicting the Coronation of the Virgin, a theme that appeared for the first time at Senlis (about 1180–1190). The sculpture of the south façade, carved after 1212, has as its subject the Last Judgment. Chartres displays the most elaborate sculptural program of the early 13th century.

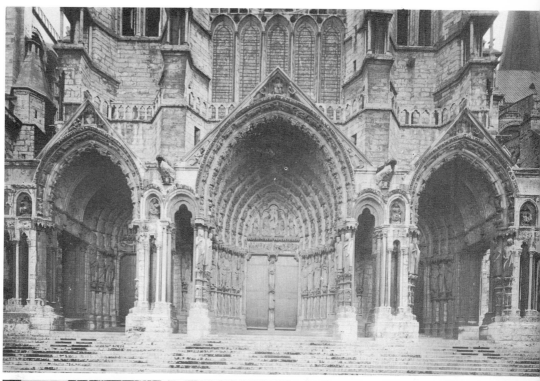

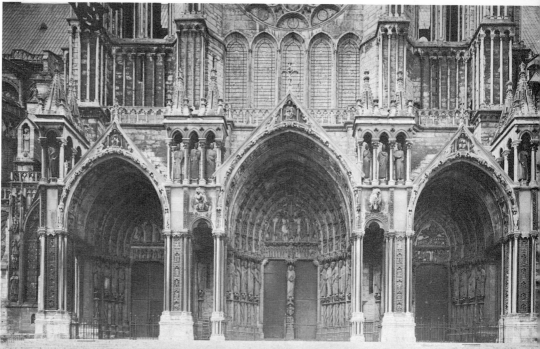

7. *Lausanne, Cathedral Notre-Dame. Nave looking east. Begun in 1192*

This cathedral belongs to the Burgundian school of the late 12th century. The interior is a perfect example of the transitional style, which combines the still heavy Romanesque forms with early Gothic innovations.

8. *Braine, church of St.-Yved. Chevet. About 1195–1220*

This church was consecrated in 1216 (see also p. 11). The construction campaign, including an important sculptural program (ills. 52, 61, 75), took place over a relatively short period of time. St.-Yved goes a step further than Lausanne in the direction of Gothic.

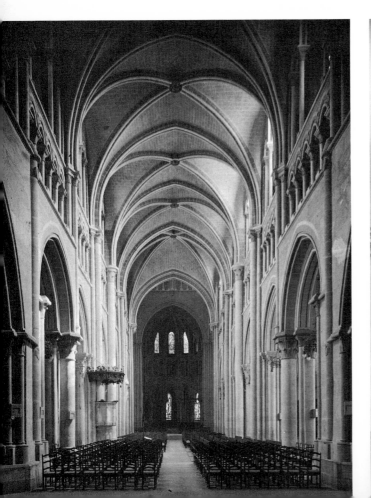

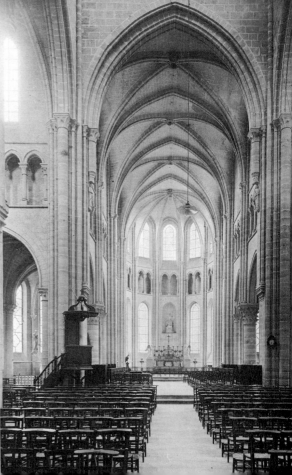

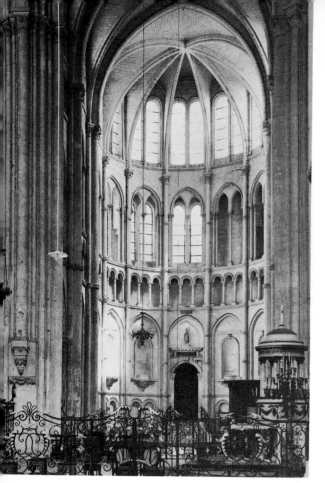
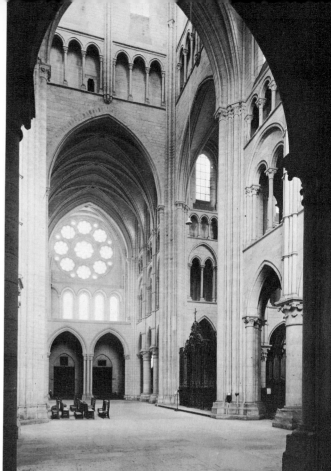

9. *Noyon, Cathedral Notre-Dame. South transept. End of the 12th century*

The transept of Noyon, as well as the south transept terminal of Soissons, is rounded and has a four-story elevation. In this configuration, which may be seen as an early attempt to gain greater height, an arcaded passage was inserted between the gallery and clerestory.

10. *Laon, Cathedral Notre-Dame. North transept. Begun about 1170*

The four-story scheme (see ill. 9) was also used for this transept, built during the first construction campaign. The windows show an early stage in the development of plate tracery, in which the roundels of the rose were cut out of the wall (for a later example see ill. 13).

11. *Angers, church of St.-Serge. Choir vault. 1200*

Shortly after the first cathedrals in Ile-de-France were started, a totally different concept of Gothic developed in the Loire Valley, a domain of the Plantagenet kings of England. The vaults are domical, and the ribs are multiplied in number and reduced in bulk to form a network of thin tubes. In essence a cathedral, but reduced in size, this church is in effect a pavilion of gracious proportions.

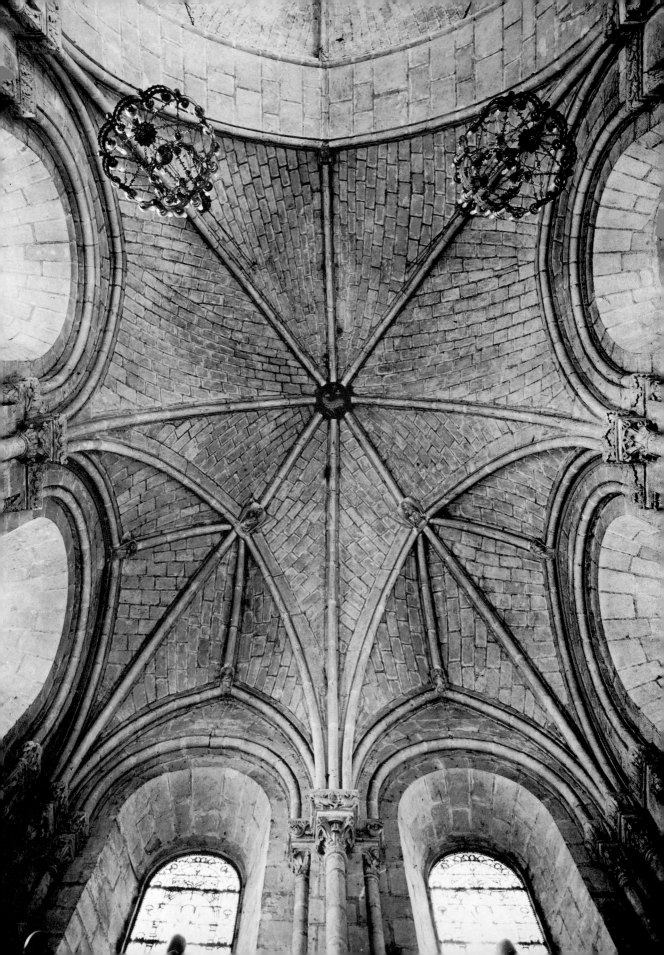

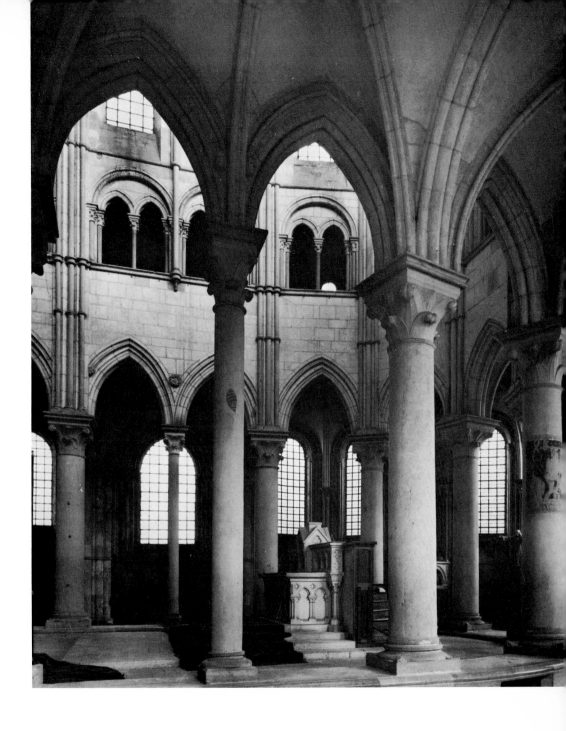

12. *Vézelay, church of Ste.-Madeleine. Hemicycle and ambulatory. Around 1200*

The choir at Vézelay, erected between 1198 and 1206, is enclosed by a polygonal ambulatory. The elevation indicates a rejection of the four-story scheme. This, however, is not yet the elevation of Chartres (ill. 13), though it contains the same basic elements—a main arcade, a small gallery (instead of a triforium), and a clerestory. The structure is not dissimilar to that of High Gothic.

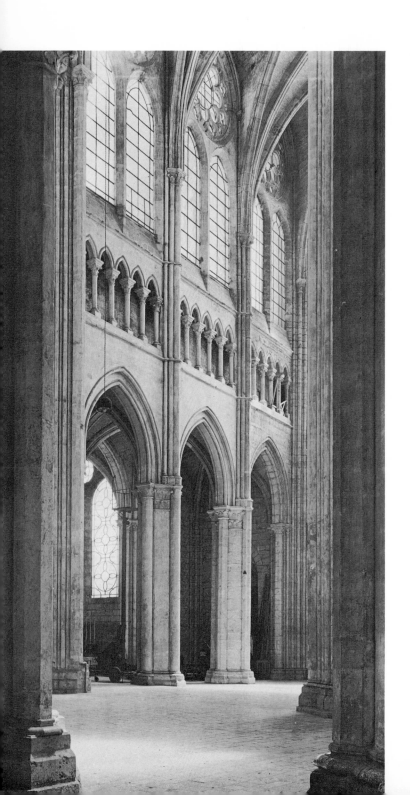

13. *Chartres, Cathedral Notre-Dame. Nave. 1194–1221*

With Chartres Cathedral, as rebuilt from 1194, the style of about 1200 turned decisively into High Gothic. Its tall arcades, tall clerestory windows, and replacement of the gallery with a low triforium band, the whole arranged in a dramatic A:B:A proportion, were taken over by Reims (ill. 14), Amiens (ill. 16), and many other cathedrals and churches. The Chartres window heads are filled with plate tracery, decoratively shaped openings cut through the solid stone (see ill. 10 for an earlier example).

14. *Reims, Cathedral Notre-Dame. Nave looking east. Begun in 1210*

This interior shows that the development was toward a higher elevation, thinner members, larger openings, and less inert wall areas. The elevation of the nave was designed around 1211 by the architect Gaucher de Reims. He was followed by Jean Leloup (1219–1235), who began the famous west façade; by Jean d'Orbais (1235–1255), responsible for the east end and the transept; and by Bernard de Soissons (1255–1290), who shaped the rose of the west façade. This traditional sequence of architects is, however, debatable.

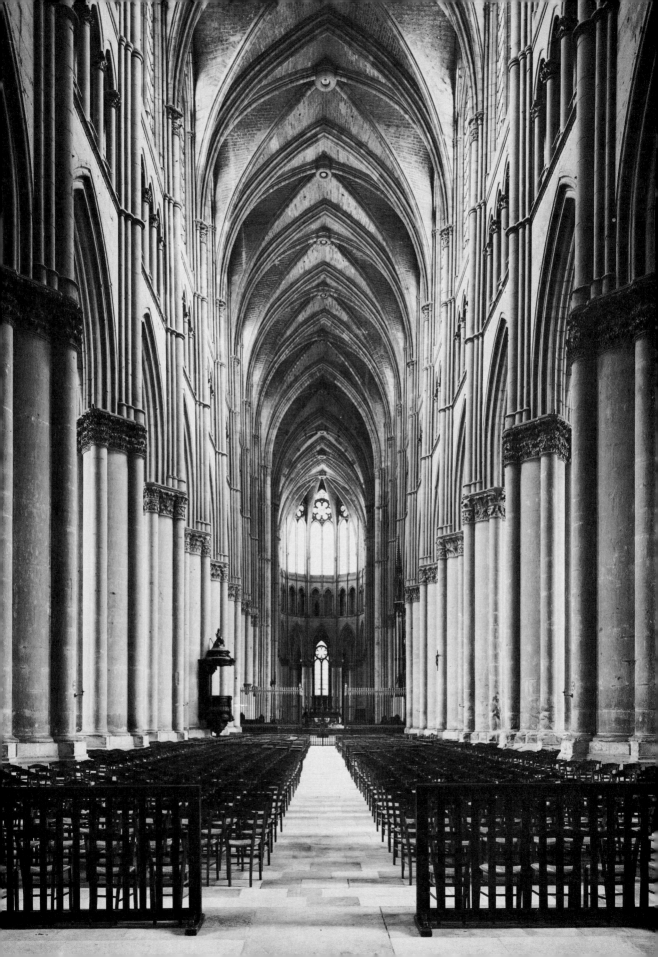

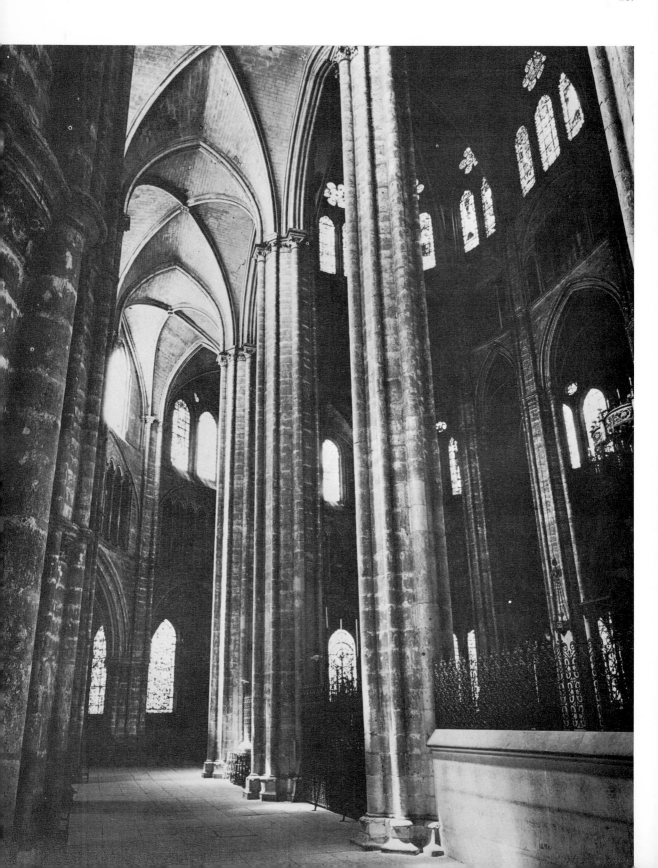

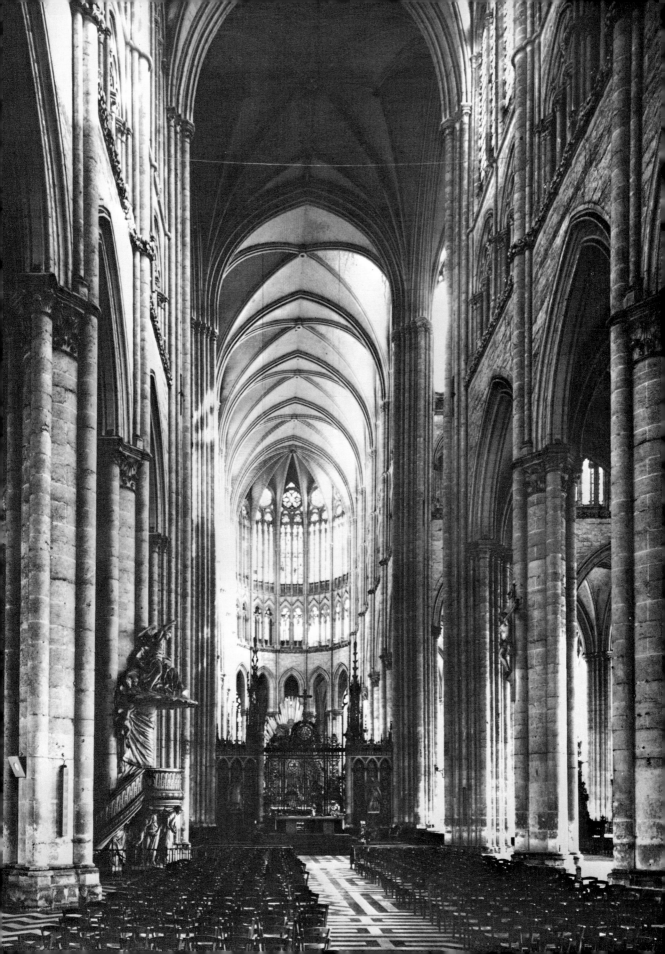

15. *Bourges, Cathedral St.-Etienne. Choir and ambulatory. Begun in 1195*

The cathedral was built in two massive campaigns. The first started in 1195—only one year after Chartres was begun—and ended in 1214. The second lasted from about 1225 to 1255. The final consecration took place in 1324. In this building the vertical emphasis is increased by the extension of the vaulting shafts right up from the floor to the ceiling. The three-story elevation (with flying butresses outside) is very peculiar. Instead of enlarging the clerestory downward, the architect drew the piers up to a height of 54 feet, exposing another complete elevation of three stories through the arcades. He then added two very low aisles at the sides, bringing the number, including the nave, to five. The whole of the east end of the cathedral retains its original 13th-century glass.

16. *Amiens, Cathedral Notre-Dame. Nave looking east. 1220–1236*

The nave of Amiens Cathedral brought the classic phase of Gothic architecture to a conclusion. Each window of the clerestory was subdivided into four lancets with three rosettes above, as if each lancet in the windows of Chartres (ill. 13) had been invested with a smaller version of the whole design. Mullions and bar tracery replace the regular, pierced masonry of Chartres. "Bar tracery, in which long, curved pieces of stone are assembled to form intricate patterns, was henceforth to be a standard Gothic technique, providing an area for the display of virtuoso design" (Robert Branner). The triforium of Amiens was linked to the clerestory by slim colonettes, so that both stories were tied together on the flat surface of the elevation.

17. *Canterbury, Cathedral. Choir. After 1174*

The campaign to rebuild the eastern end of Canterbury Cathedral (1175–1184) after the disastrous fire of 1174 is one of the best documented in early Gothic architecture, thanks to the diary of the monk Gervasius. The choir and parts of the crossing and presbytery are the work of the French architect William of Sens. The general elevation relates closely to that of Sens Cathedral. But the extensive influence of northern France is suggested by some details, for example, the use of dark marble for detached shafts, probably derived from Notre-Dame-la-Grande, Valenciennes. The remainder of the presbytery, Trinity Chapel, and "Becket's Crown" are the work of William the Englishman, who took over after William of Sens fell from a high scaffold. William the Englishman introduced a true triforium passage absorbed into the thickness of the wall (perhaps from St.-Vincent, Laon), a "Laonnais passage," and bundled shafts, all of which suggest a close connection with northeastern France. Curiously, it was the Englishman whose sense of form was closer to what was developing in Gothic. Canterbury had little immediate effect in England, but rather joined with those churches, such as Lausanne Cathedral (ill. 7), that developed counter to the Chartrain type in the 13th century.

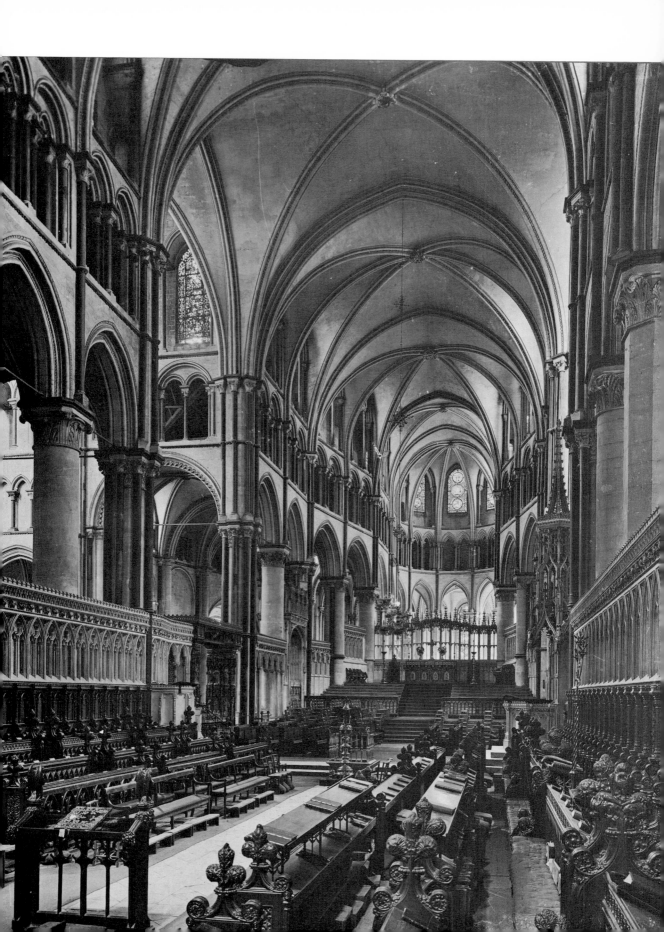

18. *Bamberg, Cathedral. 1215–1237*

Germany developed its own interpretation of the Gothic style. Some French innovations were hesitantly adopted by the builders of the Romanesque-looking cathedral at Bamberg. The towers, for instance, were inspired by those of Laon (ill. 2). The cathedral was rebuilt after a fire from 1215, and the consecration took place in 1237.

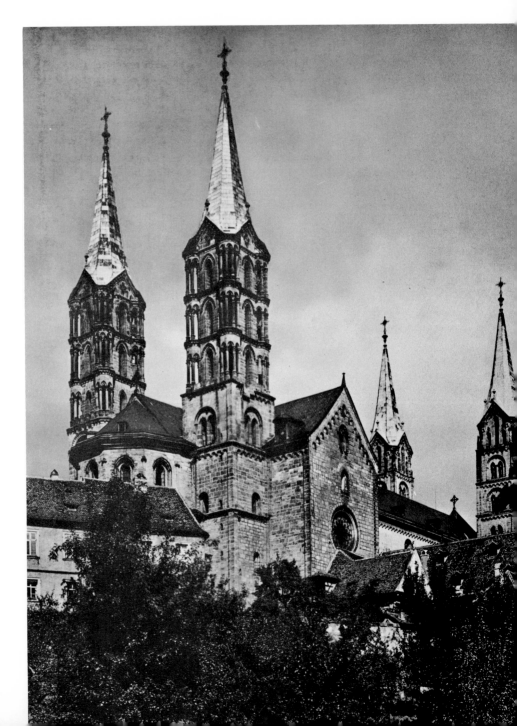

19. *Cologne, church of the Holy Apostles. 1172–1200*

The terminals of the transept are rounded, so that this building seems to have three choirs flung centrifugally from the crossing, resulting in a trefoil shape. The church is an excellent example of Rhenish architecture around 1200. The stylistic vocabulary is still Romanesque, but the division of the walls into small compartments, the addition of an exterior triforium (dwarf-gallery), and the complicated shapes of the towers are characteristic of artistic intentions we find formulated in French Gothic.

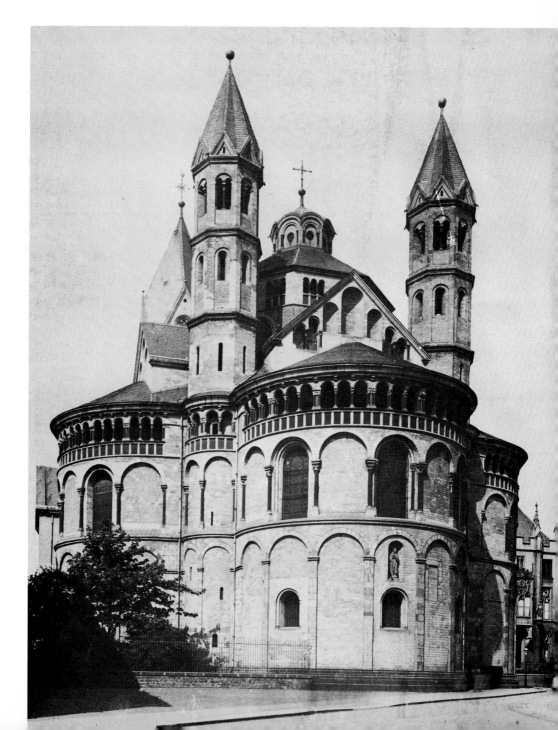

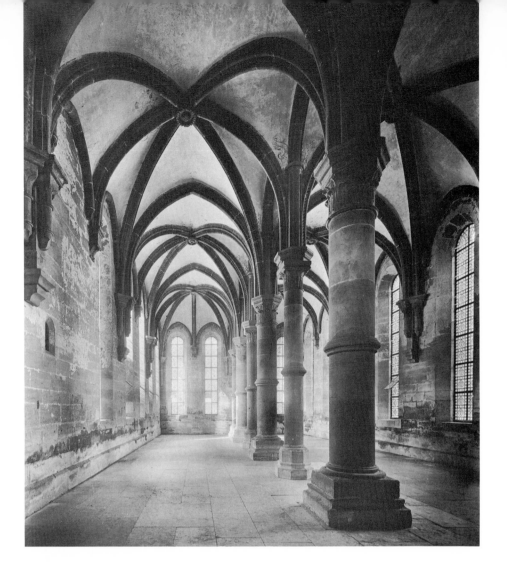

20. *Maulbronn, Abbey. Refectory. About 1220–1225*

The Gothic style first appeared in Germany in some Cistercian churches, such as those in Ebrach, Walkenried, and Maulbronn. The new style was considered "French" *(opus francigenum)* as late as the 14th century. The Maulbronn refectory is stylistically *retardataire;* the vocabulary of forms (column rings, capitals, heavy ribs, windows without tracery) corresponds to that used in France around 1180–1190. This time lag *(Stilverspätung)* is characteristic of German art of this period.

21. *Limburg an der Lahn, Cathedral. Transept. Before 1235*

The four-storied scheme from Laon (ill. 10) was adopted at Limburg about 1225, with the same time lag as at Maulbronn (ill. 20). The skeletal structure of the French model, however, does not combine well with the heavy walls. The result is a mixture of French Gothic and German Romanesque, the one not yet assimilated and the other not yet outmoded.

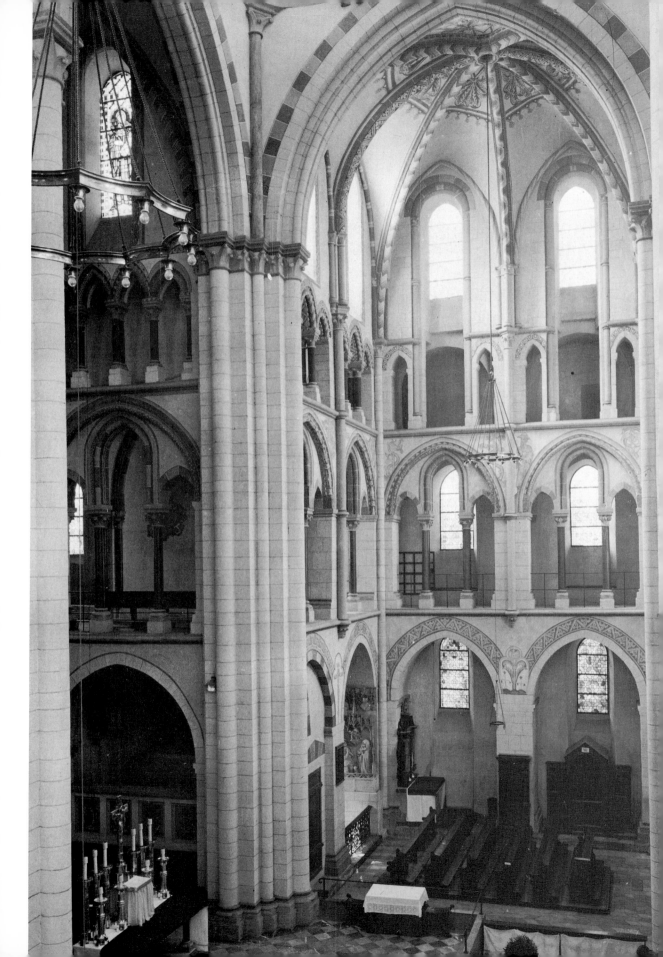

22. *Fossanova, Cistercian abbey. Nave looking east. About 1200*

The Cistercians built their churches in remote spots, for instance, in Fossanova (Latium), south of Rome. The building, begun in 1187, is a French Gothic church transplanted to Italy. This country took up the Gothic style slowly and with many reservations, with the result that the structures were always more Italian than Gothic. "Il Gotico" was considered, in the peninsula, a barbarian style, by definition.

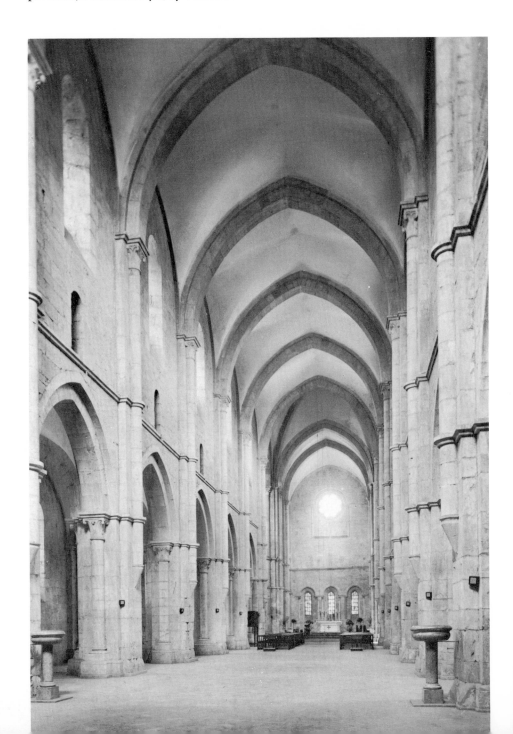

Eleanor S. Greenhill

FRENCH
MONUMENTAL SCULPTURE

IT IS ONE of the great paradoxes of art history that monumental sculpture in the round, whose production had terminated at the close of antiquity, reappeared in Western art not within the confines of the ancient classical world, but in a remote region of northern Europe roughly coterminous with the royal domain of the Capetian monarchy—Ile-de-France, the immediately adjacent territories, especially the valley of the Aisne on the eastern border, and Champagne. This rebirth is all the more surprising since the Germanic settlers of that region had not known the art of depicting the human figure in its natural organic unity at all prior to the Carolingian renaissance. Nor had the region participated in the great flowering of monumental sculpture in relief that had taken place in the first quarter of the twelfth century in France—in Languedoc, Provence, and Burgundy. Indeed, prior to about 1140 it had no tradition of monumental sculpture beyond the carving of simple capitals.

When Abbot Suger of St.-Denis imported sculptors from Languedoc about 1140 to adorn the jambs of his western portals with monumental figures from biblical and Christian history, it was an epoch-making event. Between that date and about 1200, sculpture in northern France went through a development roughly analogous to that which took place between 500 and 450 B.C. in Greece, rapidly advancing from an archaic to a classical depiction of the human figure.

To judge this, one has only to compare the sculptures of the western portals at Chartres (since those at St.-Denis do not survive) with those of the transepts (ills. 4–6, 53), carved some half a century later. On the west, the figures are still highly stylized; their draperies fall in long parallel folds, while their elongated bodies conform to the cylindrical shape of the columns to which they are, as we say, adorsed. Column and statue are carved from the same block, and the statues vary in length according to the size of the block and the position on the jambs. Their feet dangle as they levitate in front of their columns like weightless beings

33

from another world. Efforts to identify these figures with specific historical personages have proved unsuccessful. On the earliest of the transept portals, however, that of the Coronation on the north, all this is seen to have changed. We immediately recognize the column statues as beings of our own race, idealized and monumentalized, but identifiable by attribute and gesture. They are Old Testament prophets and precursors of the Lord. Bodies have taken on volume and weight; all are of the same height and naturally proportioned. Draperies fall as they would in life. The figures stand firmly balanced on their feet. Indeed, by the action of their draperies, we see that Abraham and Isaiah are executing a contrapposto, as they rest their weight on one leg and bend the other at the knee. This stance appears again in the celebrated Visitation at Reims and in many other of the statues there—they represent the closest approximation to ancient classical forms ever achieved in medieval sculpture.

The column statue, a type unknown before St.-Denis, was the formal means by which this came about. The column provided the link with the architecture; engaged only at the base and summit, it thus released the statue from the mass of the masonry to unfold and develop around its own axis. The serried ranks of these statues across the façades of the cathedrals express perfectly the coherence of a society and a history structured after the very will of God.

Such façades, however, are a peculiarly northern French invention, sometimes exported under certain conditions to other countries. In Germany and the Low Countries, sculpture around 1200 remained largely linked to the traditional needs of the liturgy. Often of monumental size and sometimes freestanding, it consisted of cult statues, Crucifixion groups, baptismal fonts, pulpits, shrines, altars, choir screens, and tomb effigies. In England and Italy, portal sculptures did not attain the character of the full round and are less progressive than French work.

For the history of figure style in Europe around 1200, the most significant development was the assimilation in the last quarter of the twelfth century of Byzantine and ancient classical art, transmitted by portable objects, such as ivories, metalwork, and manuscript illumination. In England, along the Rhine, and in the Meuse valley, this assimilation was very rapid, but it occurred in manuscript illumination and metalwork. In France, however, it is felt most markedly in monumental sculpture, which, of course, involved a translation in scale and medium, sometimes obscuring the nature of the source. Scholars have pointed out that certain English manuscripts of the close of the twelfth century, for example, the Westminster Psalter (ills. 177–179) or the most advanced of the illuminations in the celebrated Winchester Bible, show the closest possible parallel to contemporary sculptures at Laon, Paris, and Reims, revealing their common debt

to Byzantine art. Many French reliefs, moreover, show all the signs of metalwork rendered in stone. A square pillar in the museum at Chartres, perhaps a tomb fragment, embellished with quatrefoils, imitations of carved gems, and medallions, is nothing but a translation of goldsmiths' work into stone. A limestone fountain with circular basin, produced around 1200 for the cloister of St.-Denis, transposes into monumental scale some ancient metal object, a cup perhaps. Decorated with medallions containing very classical heads in relief, representing ancient divinities, it was carried out by an atelier from Sens, which was working at the time on the façade of Notre-Dame in Paris.

Similar classical heads appear in the workshop of Nicholas of Verdun (ill. 116). It is in the accomplishments of this Mosan goldsmith that the interaction between the minor arts and monumental sculpture can be most clearly detected. The earliest work that can be attributed to Nicholas with certainty is the gold and enameled altarpiece, signed and dated 1181, carried out for the abbey of Klosterneuburg near Vienna. The figures in the fifty-one typological scenes are the most classical of their time: the Madonna of the Nativity (ill. 102), in the languor of her pose and her closely clinging, rippling draperies, recalls one of the three Graces on the east pediment of the Parthenon. Equally impressive are the three-dimensional figures of seated prophets on the shrine of the Three Kings at Cologne (ills. 112–115). These works, too, reveal a drapery style peculiar to Nicholas: where the softly flowing, silky material bunches into folds, a kind of loop or hairpin-shaped depression appears. This very drapery convention also appeared a decade later in a number of the most celebrated works of cathedral sculpture. Many scholars believe that there is a direct connection between Nicholas's metalwork and these monumental sculptures, that he trained assistants who worked in stone. But other scholars, who have sought some intermediary work, have called attention to the splendidly illuminated psalter of Queen Ingeborg (ills. 190–193), the unfortunate second wife of Philip Augustus. In this manuscript the looped drapery style appears in another, more courtly blend of the classical and the Byzantine. Only recently it has been demonstrated that the psalter had its origin on the eastern border of the royal domain, near St.Quentin in Vermandois. Around it have been grouped a large number of important monuments from this region, including portal sculptures from Laon Cathedral and the church of St. Yved in Braine (ills. 49, 52, 75). Following a suggestion of Louis Grodecki, one speaks in this connection of a "school of the Aisne." The Ingeborg Psalter, its most distinguished product, represents the beginning of a specifically French court style, dubbed by Florens Deuchler "le style Philippe-Auguste." Confirmation of this view comes unexpectedly from three recently recovered fragments—a head and

two torsos—of apostle figures that formerly adorned the Judgment portal at
Notre-Dame in Paris. They document the appearance of the style of the Ingeborg
Psalter, and indirectly of Nicholas of Verdun, in the capital around the year 1200.

In Paris this style was supplanted around 1205 by another, more specifically
Parisian one, which can be observed on the Coronation portal of the cathedral.
Composed directly out of the architecture, it breaks the link with metalwork and
the art of painting, and Wilhelm Voege once coined the term "architects-sculp-
tors" for the masters who invented it. Sculpture thereafter rapidly outdistanced
the minor arts, and the link between them would not be re-established until after
mid-century. Some masters, however, outside the capital, continued to work in the
style current around 1200 long past that date. The Master of the Visitation at
Reims worked in a late, almost baroque phase of it around 1230, and so did an-
other who came in the 1220s from Sens to Chartres. Of fiery temperament and a
born sculptor, he has been called the Master of the Kings' Heads by Voege on
account of the remarkable busts by his hand on the Job portal of the north transept.
No longer modern by Parisian standards, his intense and lyrical style was carried
by his workshop away from the royal domain into the provinces and even into the
territories of the Holy Roman Empire. In Strasbourg around 1225–1230 it met
and merged with an indigenous, Byzantinizing style, resulting in the dramatic
figures of the Church and Synagogue (ill. 57) from the south transept of the
cathedral. Though their clinging, finely rippled draperies and their noble bearing
belong stylistically to the current around 1200, these figures are among the most
timeless products of the sculptor's chisel.

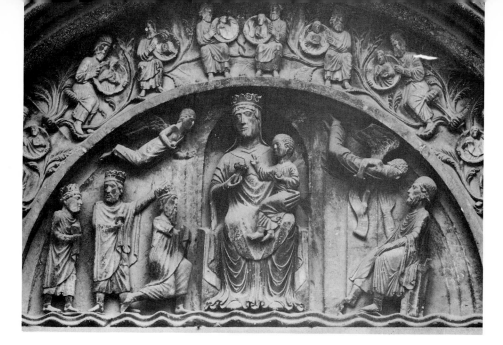

23. *Parma, Baptistery. Tympanum, from the north portal, with the Adoration of the Magi, by Benedetto Antelami. After 1196*

24. *Laon, Cathedral Notre-Dame. Tympanum, from the north portal of the west façade, with the Adoration of the Magi (cast before restoration). About 1200*

A comparison of the two tympana reveals what took place in this kind of relief sculpture around 1200. The Italian example is still Romanesque in its hieratic proportions. The Virgin as the focal point of the composition physically dominates the scene. The stiffness and flatness of the figures is emphasized by the drapery style. In contrast, the contemporary early Gothic French example shows clearly the impact of the new style worked out in Ile-de-France.

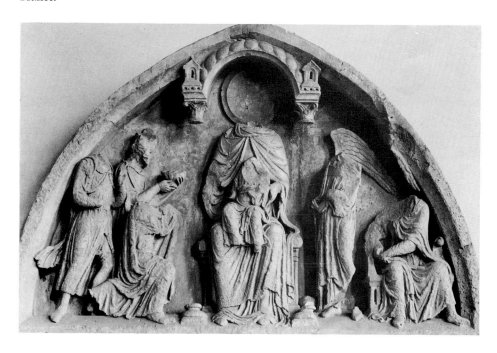

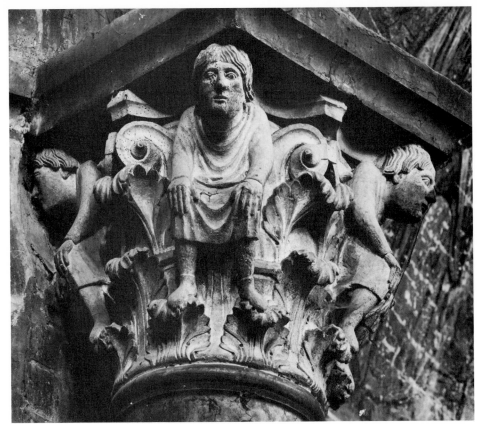

25.

26.

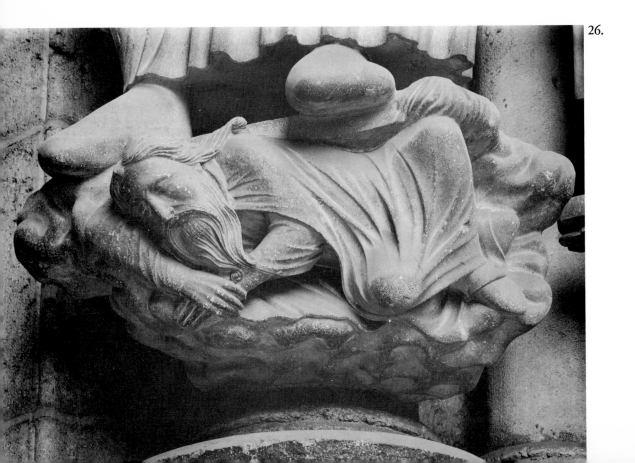

27. 28.

25. *Parma, Baptistery. Capital with seated figures. About 1200*
26. *Chartres, Cathedral Notre-Dame. Console, from the north porch, with sleeping figure beneath the feet of Jesaiah. About 1215–1225*
27. *Maria Laach, Abbey. Capital, from the so-called Paradise area, with fighting animals. About 1200*
28. *Maria Laach, Abbey. Capital, from the so-called Paradise area, with wrestling mythological figures. About 1200*

Capitals and consoles, often inconspicuously placed, are favorite spots for the artist to indulge his imagination. The long Romanesque tradition of grotesques is best illustrated by the capitals from Maria Laach. The piece from Parma, by an artist related to the Antelami workshop, combines heavy, seated figures with an elegant classical composite capital, a combination of the Ionian and Corinthian orders.

29. *Cologne, Schnütgen Museum. Lintel with dragons in foliage. Cologne, about 1200*
30. *Lèves (near Chartres), Josaphat Abbey. Sarcophagus of John of Salisbury, bishop of Chartres (1180), detail. Chartres, about 1210*

The architectural fragment from Cologne shows the degree to which Rhenish sculpture could look Romanesque in the immediate stylistic neighborhood of Nicholas of Verdun (see ills. 118–121).

31. *Braine, church of St.-Yved. Boss. About 1200*
32. *Soissons, Cathedral Notre-Dame. Boss. About 1200*
33, 34. *Braine, church of St.-Yved. Bosses. About 1200*
35. *Chartres, Museum. Boss, from the Hôtel-Dieu. Early 13th century*
36. *Frankfurt am Main, Liebighaus Museum. Carved roundel with fighting birds and beasts. Italy, early 13th century*

The circular form generally underwent a revival during renaissance movements, for example, around 1200. We have from this period an impressive number of circular configurations, filled partly with decorative material and partly with human figures or beasts adapted to the circular form (see also ills. 118–121).

29.

30.

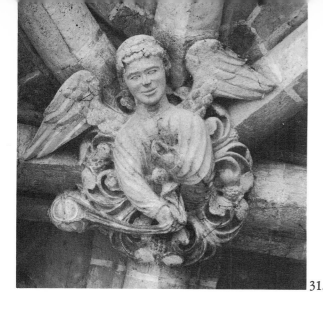

31. 32.

33. 34.

35. 36.

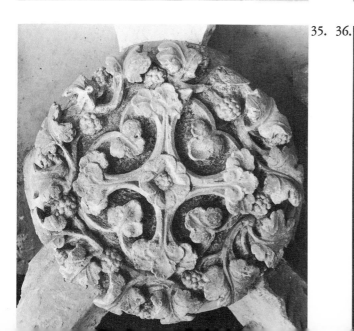 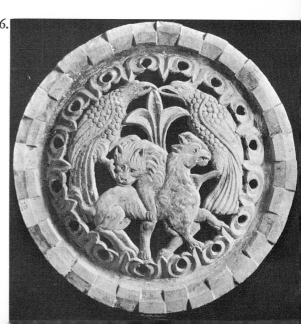

37. *Spoleto, Cathedral S. Maria Assunta. Decorative jamb, signed Gregorio Melioranzio, from the central portal of the west façade. End of the 12th century*

This pilaster testifies to the survival of antique decorative forms. A medieval interpretation of classical modes, it recalls similar Trecento and early Quattrocentro Renaissance examples.

38. *Monreale, Cathedral. Two-winged bronze door, by Master Bonanno from Pisa. 1186*

One of Italy's major contributions to the fine arts around 1200 was a group of cast-bronze doors with elaborate narrative cycles. The Monreale door is framed by antique-looking pilasters close in spirit to the Spoleto example (ill. 37).

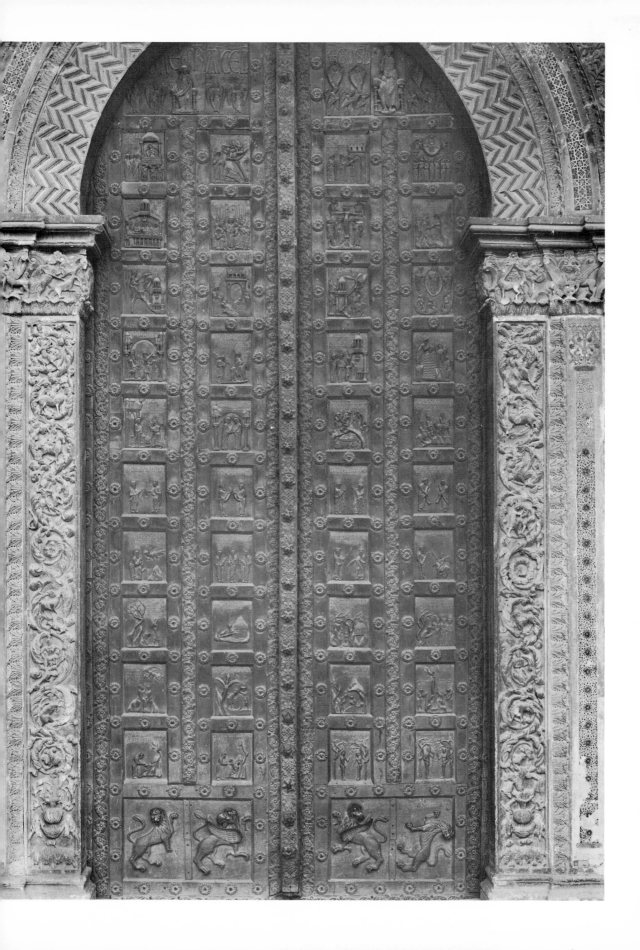

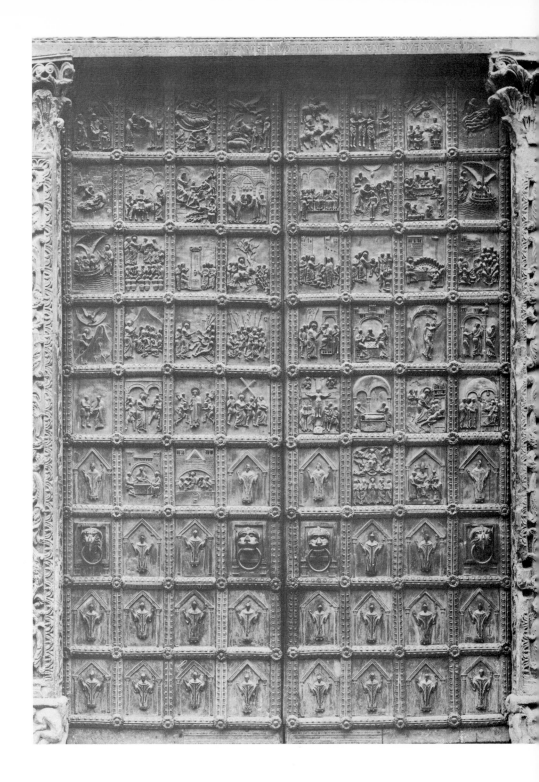

39. *Benevento, Museum. Two-winged bronze door (partly destroyed in World War II), from the*
 cathedral. About 1200

40, 41, 42. *Details of ill. 39: Annunciation; Simon Carrying the Cross; Christ's Harrowing of Hell (photographs taken before World War II)*

This door displayed an extensive cycle of the story of Christ from the Annunciation to the Ascension. The figures of twenty-four archbishops and the pope in the lower panels emphasize the long history of the archbishopric of Benevento.

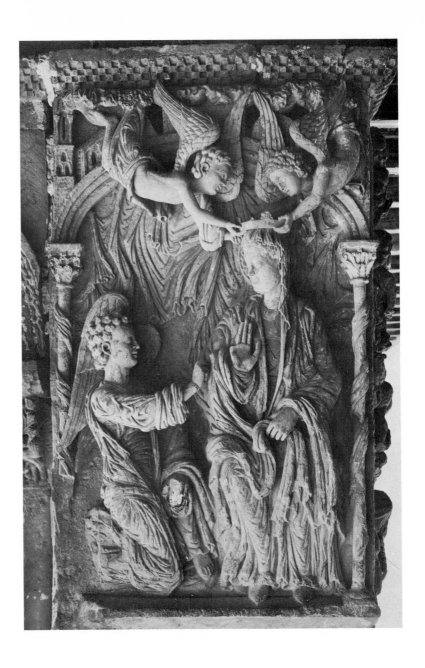

43. *San Domingo de Silos, Cloister. Annunciation. About 1180–1190*
44. *Santiago de Compostela, Cathedral. Pórtico de la Gloria, Christ and apostles. 1188*

Although the style of Spanish monumental sculpture is deeply indebted to French innovations, it remains imbued with a particular Iberian emotionalism. The drapery style of the Silos Annunciation exemplifies this high-keyed dramatic mood. The Pórtico de la Gloria program is a close adaptation of Ile-de-France models.

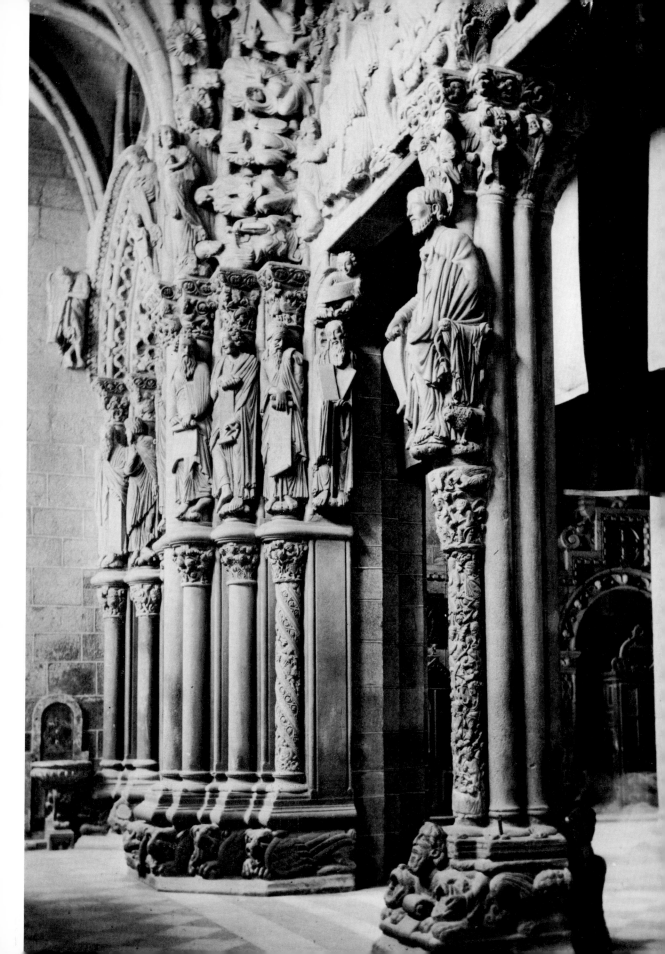

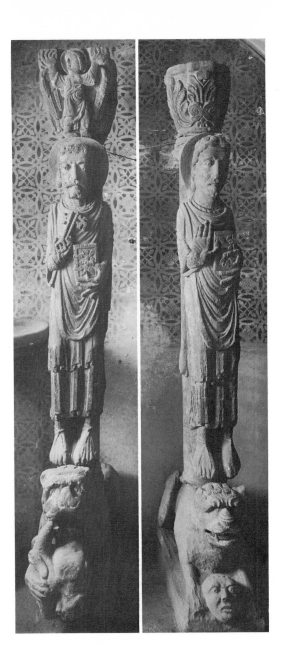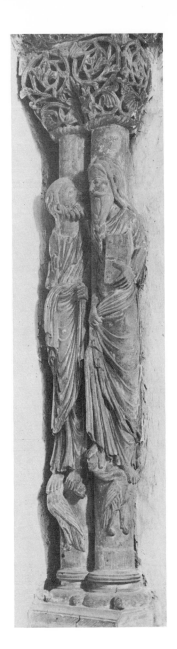

45. *Chur (eastern Switzerland), Cathedral. Two apostles. About 1190*
46. *Oviedo, Cathedral. Two apostles, in the Cámara Santa. About 1200*

The influence of the 12th-century St.-Trophime workshop at Arles spread throughout Europe. It reached even the provincial atelier in the Alps that produced the two columnar figures in Chur, as well as the Spanish workshop responsible for the apostles in the Cámara Santa at Oviedo.

47. *Cologne, Stadtmuseum. Tomb slab of St. Plectrudis. Cologne, about 1180–1190*

48. *Lérida, Museum. Virgin of the Annunciation. About 1190*

These two sculptures further illustrate the international quality of the style between Romanesque and Gothic. The two artists certainly had no personal contact, and yet their works exhibit startling similarities in gestures and, to a lesser degree, similarities in drapery style.

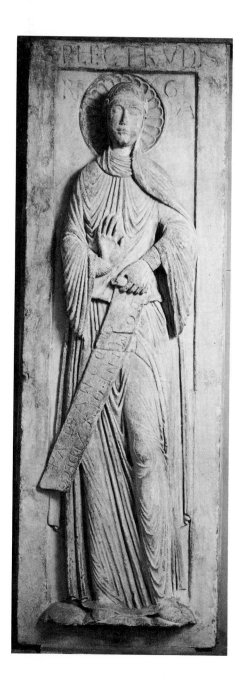
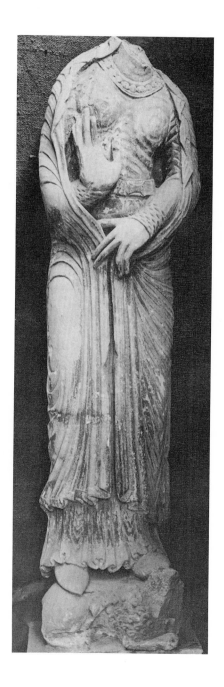

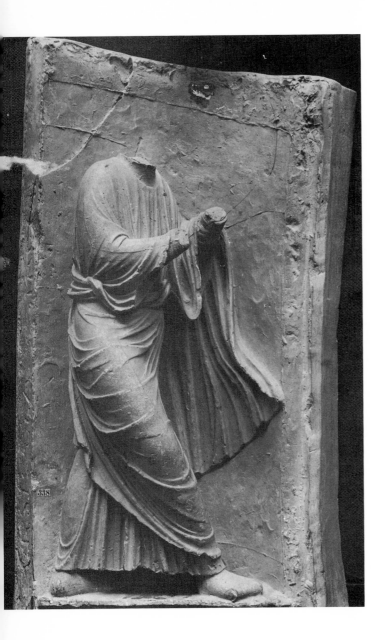 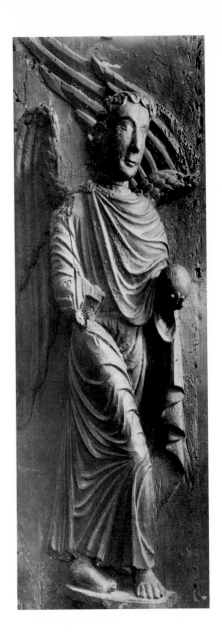

49. *Laon, Cathedral Notre-Dame. Archivolt, from the west façade, detail with standing figure (cast before restoration). Around 1190–1200*

50. *Dresden, Altertümersammlung. Angel, wood. Northern Italy, around 1210–1220*

There are again similarities in these pieces, which, however, exemplify two personal approaches to the interpretation of a walking figure. The artist working at Laon thought in terms of the figure beneath the draperies and arranged the folds according to the volume of the body. His Italian colleague was still tied to the Romanesque reliance on drapery patterns that were not necessarily governed by the actual anatomy of the figure. Because of this, the figure, while more decorative, is less stable.

51. *Cologne, Schnütgen Museum. Angel of the Annunciation, by the Samson Master (see also ills. 76, 77). Maria Laach, about 1190*

52. *Braine, church of St.-Yved. Fragment of a tympanum with angel. About 1200*

These two angels indicate other possible ways of interpreting the walking figure.

53. *Chartres, Cathedral Notre-Dame. Two standing Old Testament figures, from the north porch. About 1215–1225*

These figures illustrate the "classic" resolution to the problem of the two approaches discussed above, that is, the combining of the volumetric and linear interpretations of the figure.

54. *Hildesheim, church of St. Michael. Detail from the stucco choir screen, with the apostle Paul. About 1200*

This apostle and the fragment of the recumbent Virgin (ill. 94) are among the very rare remnants of stucco decoration of this time in Germany. St. Paul and his architectural frame are representative of the important local Hildesheim tradition, which in this case may have relied on an early Christian source. The resurgent classicism is typical of the renaissance movement around 1200.

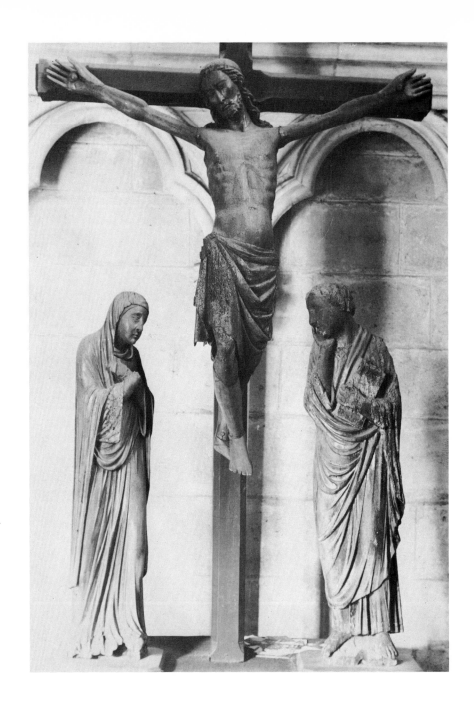

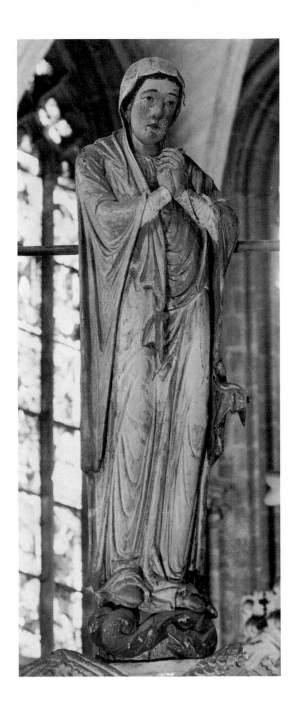 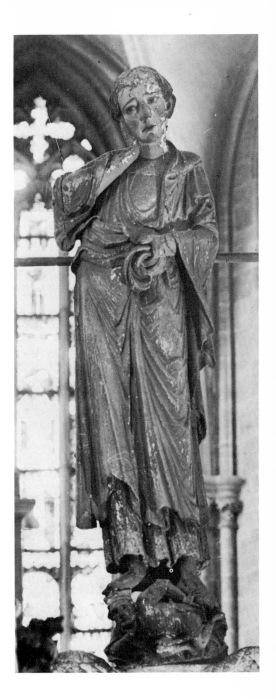

55. *Sens, Cathedral St.-Etienne. Crucifixion with Mary and John, wood. About* 1200
56. *Halberstadt, Cathedral. Mary and John from a Crucifixion group, wood. About* 1220

Monumental figures, as seen in ill. 53, strongly influenced free-standing sculpture, such as calvary groups.

57. *Strasbourg, Musée de l'Oeuvre Notre-Dame. Church and Synagogue. About 1225–1230*

These sculptures are generally regarded as the epitome of the stylistic development begun around 1200. They combine the new volumetric conception of the body, the classical disposition of the draperies, and an emotional, yet realistic, attitude.

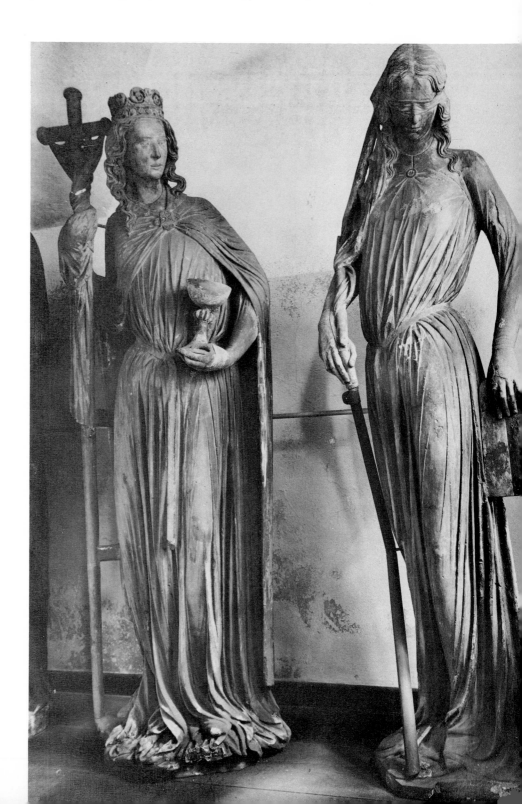

58. *Berlin, Skulpturensammlung der Stiftung Preussischer Kulturbesitz. Weeping Virgin, from a Crucifixion group. Naumburg, about 1230*

The emotional emphasis seen in the two Strasbourg pieces culminated in later German sculptures such as this one.

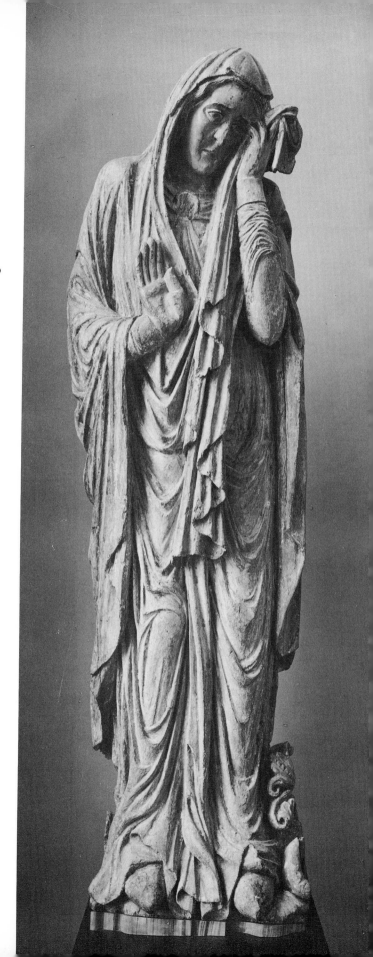

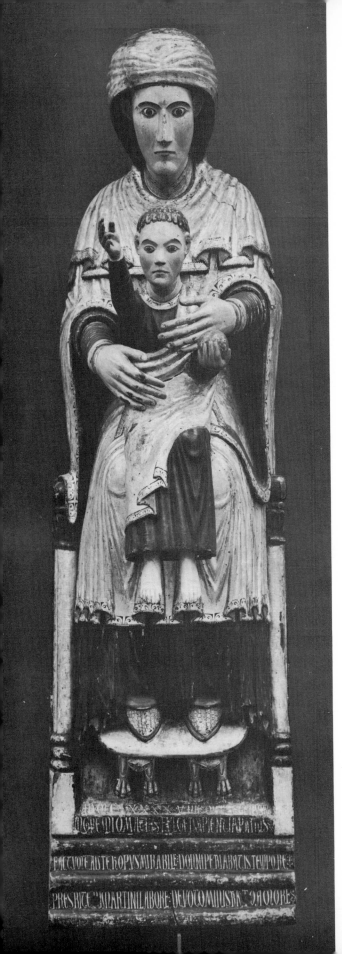

The development of the seated figures paralleled that of the standing ones. The lower part of the seated figure, however, offered greater scope for lavish drapery display.

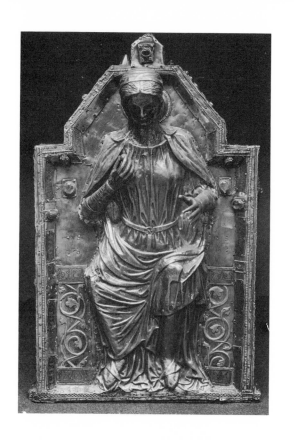

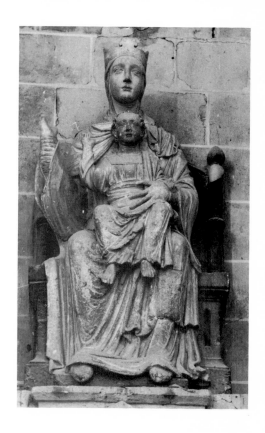

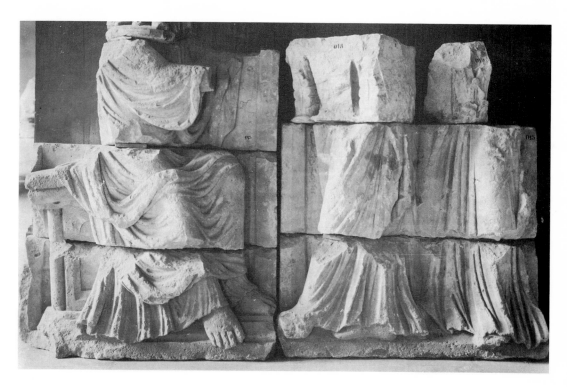

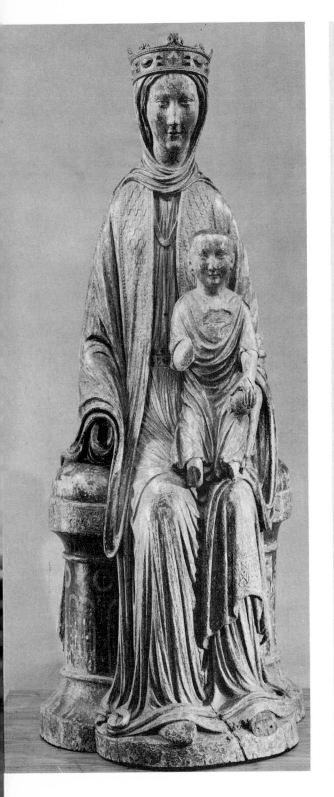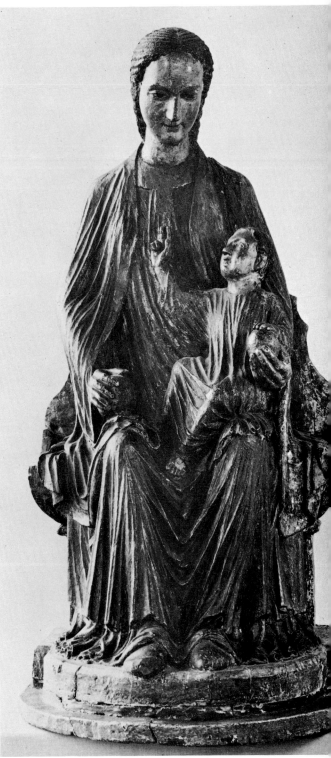

63. *Boston, Museum of Fine Arts. Seated Virgin with Child, wood. Ile-de-France, about 1200*
64. *Cologne, Schnütgen Museum. Seated Virgin with Child, wood. Rhineland, about 1220–1225*
65. *Leningrad, Hermitage. Virgin with Child, ivory. Paris, about 1200*
66. *Stockholm, Historical Museum. Virgin from Hörsne, oak. About 1210–1220*
67. *Besançon, Musée Archéologique. Fragment of a seated figure, stone. About 1210–1220*

It is especially instructive for the investigator of the stylistic development around the year 1200 to examine the way the drapery falls between the legs of seated figures. The parallel V-shaped folds of the Virgin in Cologne changed slowly into the fan-shaped assymetrical type of the figure from Besançon. The latter shows the *Muldenfaltenstil* ("hairpin-looped style") in the drapery.

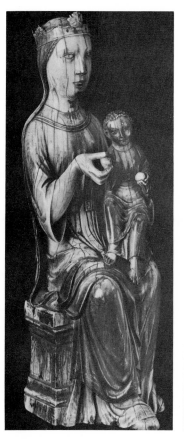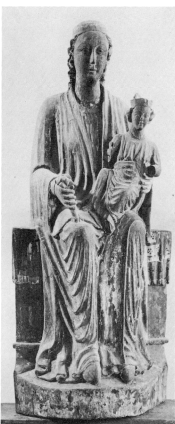

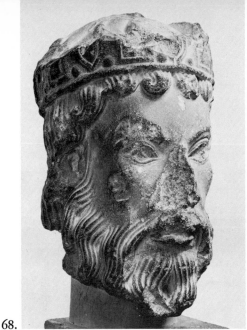

68.

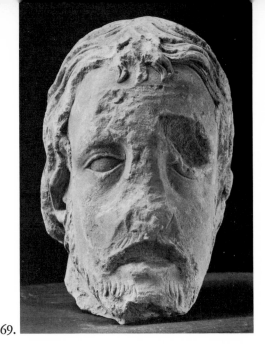

69.

Despite the ravishments of the French Revolution, some heads of great beauty survive in museums. The development of the facial type betwen 1180 (ill. 68) and 1220 (ill. 73) can be seen especially well in the carving of the eyelids and in the forehead, which increased in breadth. The growing naturalism in human expression was combined with increasing idealization.

68. *Paris, Louvre. Head of a king from St.-Denis, stone. Ile-de-France, about 1180–1190*
69. *Laon, Musée Municipal. Bearded head from the cathedral. About 1200*

72. *Lille, Musée des Beaux-Arts. Female head from Cambrai Cathedral, stone. About 1190*
73. *Chartres, Episcopal Palace (Museum). Head, stone. About 1210–1220*

72.

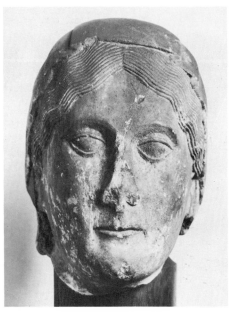

73.

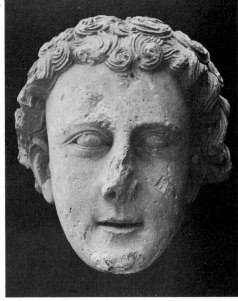

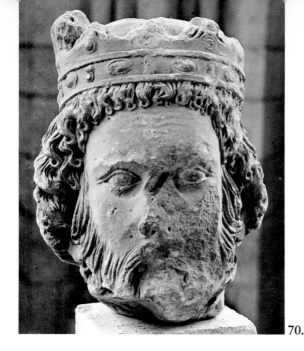
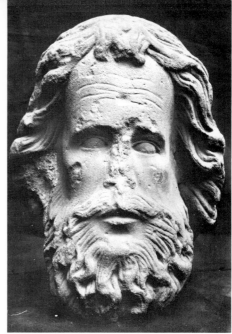

70.

71.

70. *Soissons, Museum. Head of a king from the tomb of Clotaire, originally in St.-Medard, lime-stone. 1225–1230*
71. *Strasbourg, Musée de l'Oeuvre Notre-Dame. Apostle, from the south porch of the cathedral, limestone. 1225–1230*

74. *Chartres, Cathedral Notre-Dame. Head of St. Theodore, from the south porch. About 1215–1220*
75. *Braine, church of St.-Yved. Head of an angel (detail of ill. 52), stone. About 1200*

74.

75.

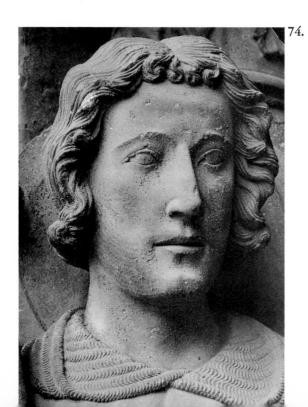

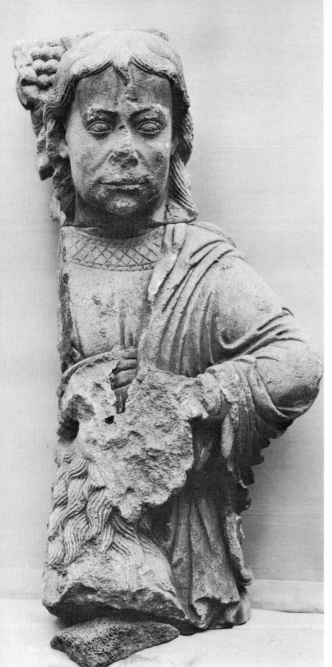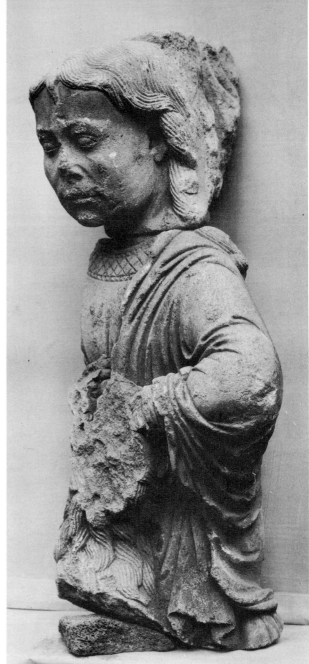

76, 77. *Maria Laach, Abbey. Samson and the Lion, by the Samson Master (see also ill. 51), stone. About 1225*

In contrast to the French sculptors, the Samson Master, who worked in the Rhineland, emphasized the individual characterization of the human face, a German trend that was to lead to the famous heads in Bamberg and Naumburg.

78. *Hildesheim, Cathedral. Head of Gihon, one of the four rivers of Paradise, supporting the baptismal font, bronze. About 1220*

Another link in the chain of the development toward portraiture is this personification of a river of Paradise. His highly individualized expression is all the more surprising in that it belongs to an ideal being.

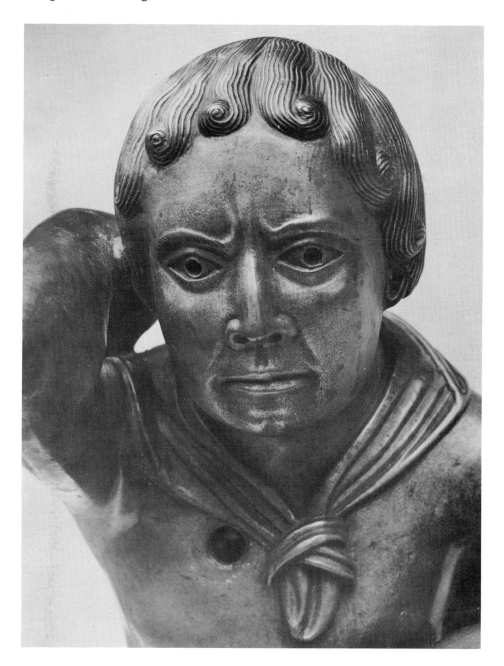

Jane Hayward

STAINED-GLASS WINDOWS

BETWEEN THE YEARS 1190 and 1210 stained glass, a craft that had been known in principle since the early Middle Ages, reached its full potential as a monumental art. The experiments that led to this development began in France, where the new Gothic architecture, with its skeletal system of supporting piers, ribs, and buttresses, provided the perfect environment for the stained-glass window. The new structural principles allowed, for the first time, ample lighting of the interior of the building, and stained glass could be employed as a means of modifying the intensity of the illumination. The shimmering mosaic of colored light filtering through the large glazed windows, placed on two and sometimes three levels of the wall, softened and unified the faceted surfaces of the architecture. Moreover, the functions previously assumed by the painted narrative cycles—to enrich church interiors and to instruct the faithful in sacred history—were taken over in the Gothic building by the stained glass. During the first half of the twelfth century, therefore, basic ideas regarding glazing as a means of illumination and as decoration were formulated. The integration of the medium into the total aesthetic of the Gothic system and the formulation of the unified program of iconography were to be achieved in the years that followed. These considerations involved, on the one hand, conceptual problems, including those of design, scale, tonal values, and style, and on the other, interpretations in visual terms of the philosophical ideas of the time.

The Gothic cathedral with its curtain walls pierced by continuous rows of windows was the perfect means of expressing these philosophical ideas in visual terms. To the Neoplatonists of the twelfth century truth or reality consisted of a series of forms in the mind of God seen and known by mankind only as reflections. Light was the most noble of these reflections since it, being the least material of natural phenomena, was the closest approximation to pure form. It was, in the words of Robert Grosseteste, bishop of Lincoln, "the first corporeal form because of its greater similarity than all other bodies to the forms that exist apart from matter, namely, the intelligences." Light demonstrated the principle of continuity

in nature in that it was transmitted from the firmament through each of the heavenly spheres down to the lowest element, earth. Just as light, created by God before all else, was the factor unifying the physical universe, so divine illumination was the means by which the soul, having its origins in both material and spiritual aspects of being, could, through imagination and intellect, ultimately ascend to God. Light, therefore, existing as both matter and form, conveyed insight into spiritual as well as physical reality. Small wonder that the stained-glass windows, which depicted the Holy Scriptures and through which the sun illuminated the interior of the church, became for Hugo of St. Victor and many of his contemporaries the instruments in symbolic form through which intellectual illumination of the soul and moral illumination of the heart took place.

The Neoplatonic concept of light as symbolized by stained glass is most graphically conveyed in the writings of Abbot Suger, who in 1140 began the rebuilding of the choir of his abbey—the structure that introduced the Gothic style. In his account of the construction, Suger speaks of the choir as "shining with the wonderful and uninterrupted light of most sacred windows" and as "the noble edifice which is pervaded by the new light," and of the windows themselves as "leading from the material to the immaterial." This upward leading, or anagogical, concept of the power of light pervaded the writings of the pseudo-Dionysius, a sixth-century follower of Plotinus. A copy of the work of this anonymous author had been presented to the abbey of St.-Denis by Charles the Bald, since it was thought that he and St. Dionysius, patron of the abbey, were one and the same. Suger's own philosophy was steeped in the theories set down by his erroneous patron, who argued that man could come closer to an understanding of the light of God through the contemplation of the light of material objects in the physical world. This explains Suger's desire to fill his new church with the radiance of jewels and precious metals and with the shimmering light of colored windows. He believed that stained glass had three basic properties: it was the bearer of holy images, an intrinsically rich material resembling precious stones, and a mystery because it glowed without fire.

It remained for the Scholastics of the thirteenth century to impose a new order upon the writing of philosophy and to augment the metaphysical theories of the Neoplatonists with Aristotelian logic. The Summa Theologica, the compendium of human knowledge that began to appear as early as the end of the twelfth century, sought to resolve the age-old conflict between reason and faith within an organized framework and pattern of argument. Symbolism and metaphor gave way to rational synthesis, to the unity of truth. The existence of God was believed

to be demonstrable from His creation, and man's immortal soul was accepted as the organizing principle of the body rather than as independent of it. By its very nature Scholastic writing required a strictly organized literary schema. No less strictly organized was the fully formulated Gothic cathedral. As Panofsky has demonstrated, the Gothic cathedral, in itself, is the Scholastic summa in visual terms both in its architectural conception and in its decoration. The early Gothic experiments of the twelfth century solidified at Chartres into a type that was to prevail with few and minor variations for nearly half a century. Just as the schema of Scholastic writing became the pattern for presenting theological beliefs, so the cathedral structure became the skeleton supporting the pictorial presentation of man's faith, carved in stone on the exterior and radiating in colored light from the stained glass of the interior. All the elements—sculpture, glass, and structure— were united in a totality of meaning. And the parts within each element were just as carefully interrelated. The placement of the sacred histories, the saintly legends, and the images of the prophets and patriarchs that filled the windows was precisely defined within an organized plan. The first instance known of such a comprehensive plan of glazing occurred at St.-Remi-de-Reims in the last decade of the twelfth century at exactly the same moment when Prévostin and Stephen Langton were initiating the concept of the summa.

Previous to 1190 the prevailing type of stained-glass window in France had been composed of a series of superposed narrative scenes, or "histories," framed in simple geometric shapes (ill. 79) and set within a rectangular grid of supporting ironwork. The rigidity of the overall design was relieved by backgrounds and borders of rich foliate ornament. Single figures or groups of monumental scale were exceptions to the concept of the window as a means of narration. In the last years of the twelfth century, the traditional arrangement of the historiated window underwent a transformation, the beginnings of which can be seen in a window installed at that time in the nave of the cathedral of Angers. There, the iron grid that had previously imposed an ordering of the scenes in rows or registers was ignored. Instead, the circular frames of the two central scenes (ill. 80) were linked by intervening segments of circles, the composite arrangement creating a central accent or focus for the design as a whole. From these tentative beginnings, the composite medallion reached its ultimate development in windows dating from the first years of the thirteenth century at Chartres (ill. 81) and Bourges, and in England at Canterbury (ill. 84). At this stage the scenes appeared in clusters, rather than individually, and these clusters were repeated over the entire field of the aperture. The salient factor in the new system was the replacement of

the grid by the newly invented forged-iron supporting frame, which could be curved to fit the outline of the medallion, and thus acted as a delineator for the individual scenes. A further step toward clarity of composition was the replacement of the foliate background by a geometric trellis, diaper, or lozenge ground. Thus a distinct contrast was provided between curvilinear medallions and precisely patterned fields (ill. 82).

The problem of scale, also a factor in the search for definition and clarity of design, was of critical importance in the development of the clerestory window. It was soon apparent that the narrative windows were not legible when placed in the upper apertures of the building. Among the earliest attempts to solve this problem was the choir glazing of the church of St.-Remi de Reims, begun about 1190. There, the large openings of the clerestory were occupied by a double range of superimposed figures, the smaller lights of the tribunes below by single figures, and the ambulatory windows on ground level by narrative cycles. Somewhat later, at Chartres, a scheme for the upper apertures evolved in which large-scale scenes, as well as scenes or donor portraits placed beneath single figures, occupied the clerestory and the lancets below the rose windows of the transept (ill. 83). The gradation of the scale of the images to provide maximum legibility was most successfully employed at Bourges. The apertures of the double clerestory of the cathedral were reserved for single figures, each designed to fill an entire light, and the ambulatory windows were used for recording the sacred histories. A similar arrangement of large- and small-scale images also evolved in the contemporary choir glazing at Canterbury.

During the same period, the rose window became the standard means of illumination for the gables of the nave and transepts of the Gothic church. Though the rose as a type had made its first appearance at the abbey of St.-Denis before the middle of the twelfth century, it was probably not until the development of plate tracery in the early years of the thirteenth century at Laon and Chartres, and bar tracery shortly thereafter, that a standardized architectonic type became possible. From the first hesitant piercing of the western gable at Chartres, with its rosette and surrounding octafoils of plate tracery, to the complete opening of the upper wall of the south transept (ill 83), where the great circular aperture is supposed only by slender bars of masonry, the inventiveness and the command of structural principles that characterized the Gothic style were never more clearly evidenced. What occurred, therefore, in France and in England as well, regarding the relationship of the window to its architectural environment was, first of all, a structural resolution to the problem of lighting and, second, within this system, a

response to the aesthetic need for a scaling of forms proportional to the position
of the aperture in the wall. The solution to this latter problem, as achieved at
Chartres and Bourges, not only accorded maximum legibility to the subject matter
of the windows but also paved the way for a unified iconographic program.

These changes created, in turn, new problems that necessitated a transforma-
tion of color relationships within the window. As the Gothic skeletal system of
architecture developed, permitting ever greater areas for glazing within the indi-
vidual bays, the glass itself became more and more saturated in color, to compen-
sate for the increased amount of light permitted to penetrate the interior (see
color ills.). In place of the pure cobalt of twelfth-century windows, a deep man-
ganese blue, made even darker by washes of vitreous paint on the exterior, became
the predominating color of the thirteenth-century window. The density of this
blue was only slightly relieved by accents of a lighter, grayish tint. The chromatic
scheme itself underwent changes, with a triad of red, blue, and white marking the
primary concept of the design, while other, secondary colors, becoming increas-
ingly light in tonality, accentuated the scenes (I, no. 207, color ill.). In England,
as in France, the blues became darker. At the same time, the ruby glass became
less important. Instead, white glass was used, not only to define the design, but
also to emphasize elements within the scenes and as a flesh tint.

In France, at the beginning of the thirteenth century, the delineation of both
figures and drapery underwent a style change as distinct as that of the overall
design of the window (ill. 85). The heavy lines of the leading acted as a means
of separating and isolating the various hues, while the paint gave both form and
definition to the color. Bold, fluid strokes of the brush, matted halftones, and
broadly executed patterns made details of form legible from great distances and
imparted greater animation to the figures. This new, freer method of painting was
in direct contrast to the small-scale ornament and finely hatched lines that charac-
terized the style of glass painting in the second half of the twelfth century. English
glazing, in contrast, retained many of these decorative elements until much later.

Germany and those parts of Europe influenced by the Holy Roman Empire
pursued their own course in the development of stained glass during the period
around 1200. Few examples remain from the middle Rhineland, especially of
what must have been one of the greatest schools of glass painting, represented by
the glazing programs of the three Kaiser Dome, at Speyer, Mainz, and Worms.
The style of stained glass from the upper Rhineland can be determined from the
monumental series of emperor figures (ill. 86), begun about 1200, that embel-
lished the nave of the cathedral of Strasbourg. Rigid and static in character rather

than expressive of the freedom of movement characterizing French and English glass, these figures are closer to the earlier style of German miniature painting. The glass was profusely embellished with painted ornament and displayed a variety of brilliant colors in which no single hue predominated. The shift to a new style of window design came later in Germany than in the Channel countries and even in its final stages owed little to developments in France.

The rectangular grid plan of the frame was retained in Germany long after it had been replaced by curving forged ironwork in the major centers of France. But the shapes of the scenes in German glass were far more elaborate than even the composite arrangements of French windows. In Germany, as a rule, each scene or single figure was enclosed by a separate frame of painted ornament, these frames consisting of intricately twisted and intertwined ribbonlike bands that surrounded the image in arched or looped patterns. The windows from St. Cunibert at Cologne (ills. 88, 89) are among the finest of this type. With few exceptions, the other areas of the empire tended to follow German trends in window design. The supple, elegant figure type introduced in the first decades of the thirteenth century at Cologne, more Gothic in feeling, soon spread throughout the German lands, replacing the rigid, archaic style of the past.

Another type of window glazing, produced throughout Europe during the Middle Ages, underwent significant changes in style at the turn of the century. Known as grisaille, this colorless, purely decorative glass had been used extensively by the Cistercian monasteries as a means of complying with the ban on figural art imposed on the order in 1134. By the beginning of the thirteenth century, the austerely simple grisaille window had become so embellished by ribbons and bosses of tinted glass and by painted ornamentations (ill. 90) that it rivaled the colored stained-glass window in richness and intricacy of design.

Countless numbers of these fragile paintings made from colored glass and light have been lost, and most existing windows have been either restored many times or partly remade. Even Suger, during his own lifetime, was forced to employ a master-specialist for the preservation of his windows at St.-Denis. Considering the nature of this material, it is remarkable that what is known of Gothic painting today is derived largely from stained glass. Though the medium itself can be studied from what has been preserved throughout the centuries, very little is known about the anonymous craftsmen who created the windows. At first they were in all probability itinerants, master glaziers and assistants who moved from place to place as the need warranted. It is certain that these artisans were highly specialized and few in number, since the style of a particular workshop can often

be distinguished in various locations. Unique in thirteenth-century glazing is the appearance of the name of a glass painter on a window in the cathedral of Rouen. The inscription reads: CLEMENS VITREARIUS CARNOTENSIS M[E FECIT] ("Clement, glazier of Chartres, made me").

The subjects and scenes in the various windows were copied from many sources: illuminated manuscripts, model books, and other works of art. In the later Middle Ages, the *Biblia Pauperum,* a religious picture book depicting the paramount events in the Old and New Testament, most frequently served the glass painter as a model. Windows made from such sources were in themselves a picture Bible for those unable to read. Suger's ideas were repeated at the beginning of the fifteenth century by Jean Gerson, who asserted: "The images in the church windows are put there for no other purpose than to show simple folk ignorant of the Scriptures what they ought to believe." And from an old catechism of the diocese of Treguier, one learns that upon entering a church, a visitor has to "take holy water, adore the Blessed Sacrament, then walk all around the edifice and look at the stained-glass windows." The method by which the glazier adapted his model and the nature of the working sketch from which he prepared his windows are unknown. The monk Theophilus, who wrote his treatise on the making of stained glass in the early years of the twelfth century, merely states that the design was drawn full scale on a whitened board. This method seems to have been followed until the end of the thirteenth century.

In addition to their didactic purposes, the stained-glass windows of a church were part of an elaborate theological program. The iconography of this program, its symbolism and meaning, was derived from many sources—from commentaries on the Bible and other theological writings. In visual terms, the underlying meaning of Christianity, as related in the Bible and interpreted by theologians, was made comprehensible through image and narrative. In all probability, the plan for the decoration of the structure was devised by local churchmen. It is known, for example, that Suger was responsible for the iconography of his windows at St.-Denis.

The innovations in stained glass that occurred in and around the year 1200 marked a shift that was to set the course of the development of the medium over the next half-century. This was the period that marked the beginning of the glazing of most of the great cathedrals of France and many important churches in the rest of Europe. Within this short span of time, the art of glass painting attained an aesthetic coherence that was truly expressive of the Gothic style.

79. *Poitiers, Cathedral. Legend of St. Lawrence window. About 1170*

At the time when this window was produced, circles, semicircles, and squares were used to shape the medallions of the narrative cycles. Although the story is here read from top to bottom, stained-glass windows are usually read from left to right starting at the bottom.

80. *Angers, Cathedral. St. Vincent window. About 1190.* See p. 69.

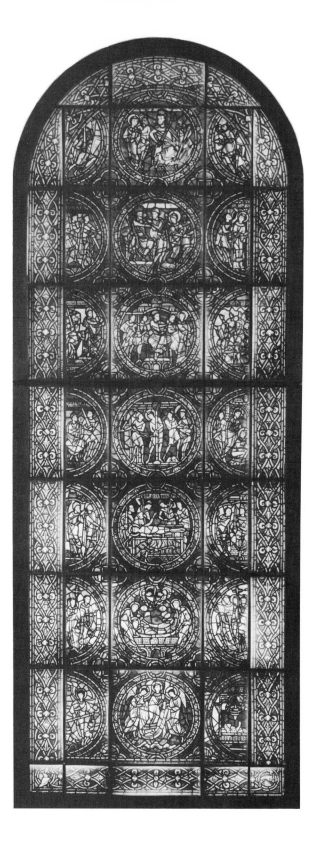
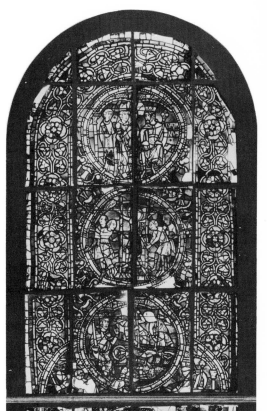
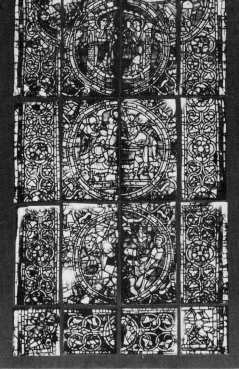

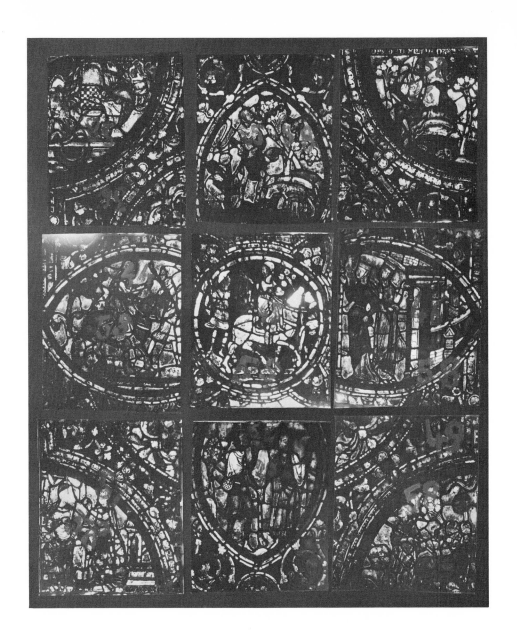

81. *Chartres, Cathedral. Detail of the Prodigal Son window. About* 1210

This arrangement of scenes exemplifies the composite medallion type of design. See pp. 69–70.

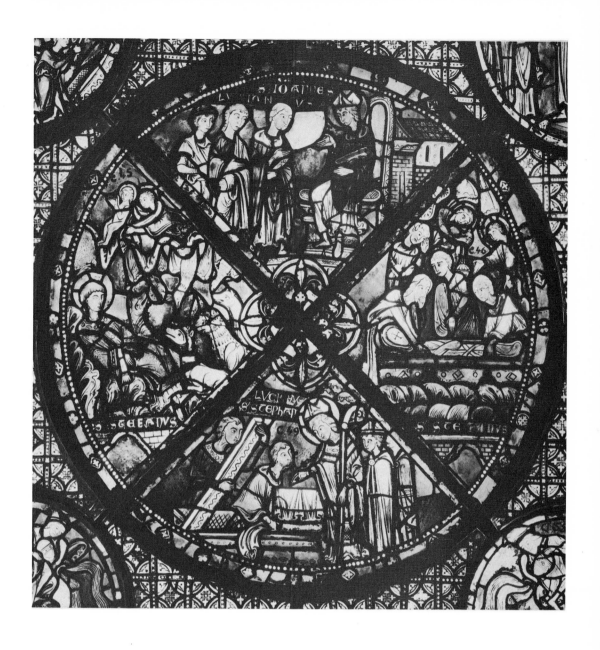

82. *Bourges, Cathedral. Detail of the History of the Relics of St. Stephen window. About 1210.*
See p. 70.

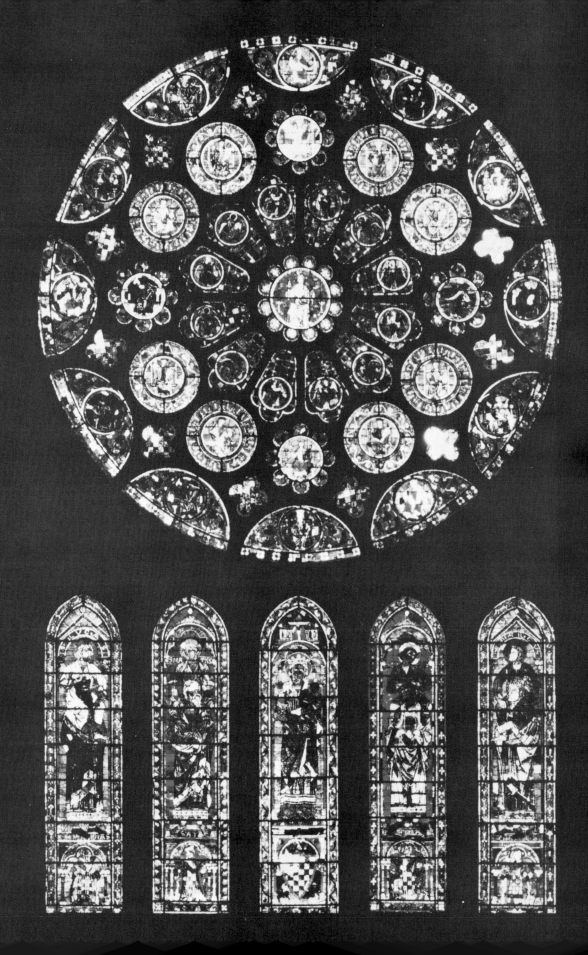

83. *Chartres, Cathedral. Rose and windows in the south transept. About 1220*

In the rose window, Christ triumphant is surrounded by the symbols of the Evangelists, angels, and the twenty-four elders. In the lower windows the crowned Virgin carries the Child, and the prophets carry the evangelists (Jeremiah and Luke; Isaiah and Matthew; Ezekiel and John; Daniel and Mark), symbolizing the relationship between the Old and New Testament; at the bottom are the donors.

84. *Canterbury, Cathedral. Window, in the Trinity Chapel, showing William of Gloucester saved from being buried alive. 1215–1225*

This is one of the series of windows depicting the miracles of St. Thomas Becket and shows the development of the composite medallion in England.

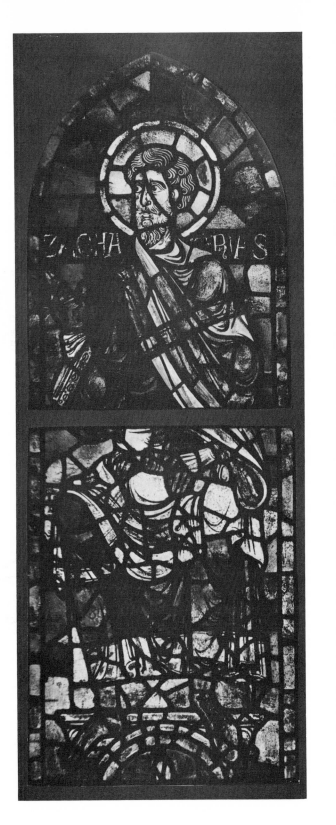
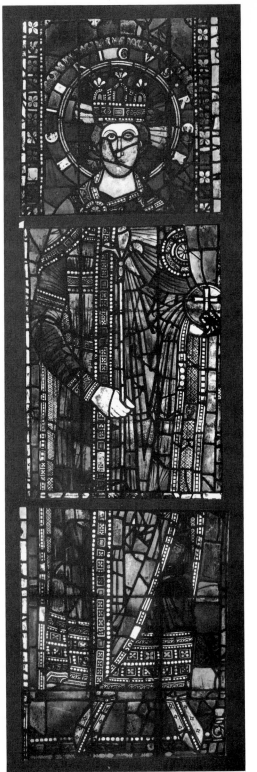

85. *Reims, St.-Remi. The prophet Zechariah, detail of clerestory window. About 1190. See p. 71.*

86. *Strasbourg, Cathedral. Emperor Henry I, detail of nave window. About 1210. See pp. 71–72.*

87. *Stuttgart, Württembergisches Landesmuseum. Samson and the gates of Gaza, stained-glass roundel. Alpirsbach, about 1200*

This is one of the few Upper Rhenish examples of the period.

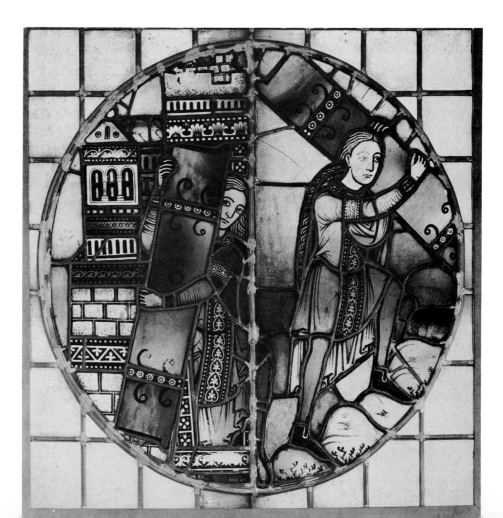

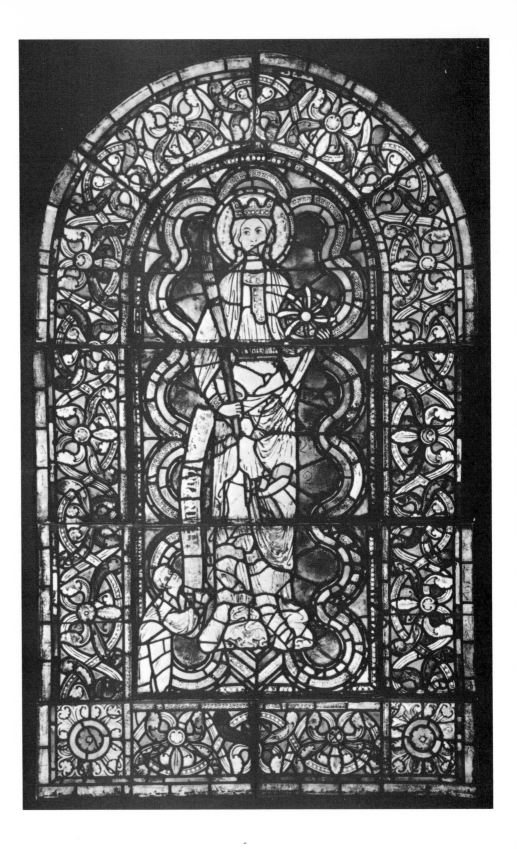

88. *Cologne, St. Cunibert, St. Catherine and donor. About 1220–1225.* See p. 72.

89. *Cologne, St. Cunibert. Detail from the Life of St. Cunibert window. About 1220–1225.* See p. 72.

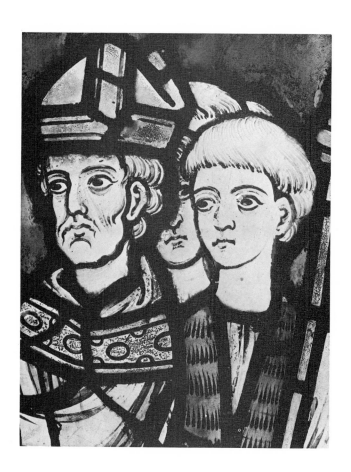

90. *Angers, St.-Serge. Details from*
 three grisaille windows.
 About 1215–1220. See p. 72.

Florens Deuchler

A NOTE ON
MONUMENTAL PAINTING

THERE WAS ONLY one form of monumental painting between Roman-
esque and Gothic with a long tradition and a great future: the stained-glass win-
dow. One of the most important contributions of France to medieval culture, it
has been discussed in Jane Hayward's essay. There are, however, other painted
works of monumental scale all over Western Europe that are worthy of attention.

In Italy, the new type of the *croce dipinta,* the painted cross, was conceived
around 1200. Berlinghiero Berlinghieri's *croce,* at the very beginning of Tuscan
panel painting (ill. 91), was still strongly influenced by Byzantine models. This
persistence of Eastern influence in Italy was an important factor contributing to
the differences in style between north and south. At the time this work was made,
about 1210–1220, Romanesque in France had already given way to Gothic, intro-
duced in Tuscany as a "new style" by Nicola Pisano only. The decorative borders
of Berlinghieri's *croce* bring to mind similar patterns that can be found in the
works of the *Cosmati,* a group of artists working in marble with inlays of colored
stones, mosaic, glass, and gilding. The Roman marble workers, *marmori romani,*
of this period were known collectively as the Cosmati from the name Cosma,
which recurs in several families among them. This kind of decoration was much
employed in Italian Romanesque architecture in the Campagna and Naples. To
the school of Naples belongs the ambo in Salerno Cathedral (ill. 98). This pulpit
was donated to the cathedral about 1175 by the archbishop Romoaldo. The style
of its intarsia marble work is closely linked to the art of Sicily, especially Monreale
(see ill. 38). During the thirteenth century, Italian painters often used these
colorful patterns as sources for their own work.

In the same decade that Berlinghieri painted his powerful cross, an unknown
artist decorated the wooden ceiling of the church of St. Michael in Hildesheim.
He, too, had not yet been touched by the French Gothic (ills. 92, 93, 95). He
worked in the mood of the German angular style (*Zackenstil*), in use up to the

85

middle of the century. This is a contamination of native Romanesque traditions and late twelfth-century Byzantine ingredients. In Germany, right up to the end of the thirteenth century, the Byzantine and early Gothic styles can be seen side by side, for instance, in tapestries not very large in size but monumental in aspect (ills. 96, 97). Although some of the draperies of the figures show the influence of the new Western trends brought to Germany around 1200, works like that derive directly from monumental models, such as late Romanesque frescoes.

All these monuments are unique, isolated pieces. They do not belong to a coherent group. Only the Italian *croce dipinta* would have a considerable future. Coined about 1200, this type of monumental painting survived up to the Renaissance without a radical change in its hieratic aspect.

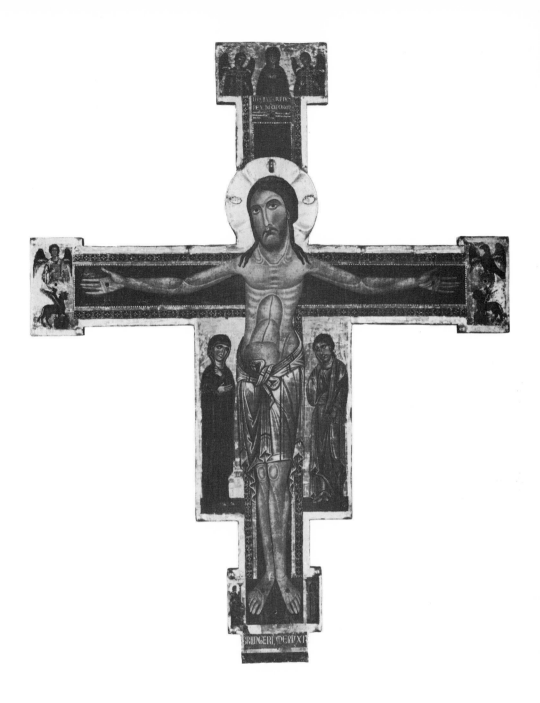

91. *Lucca, Pinacoteca.* Croce dipinta, *no. 226, signed by Berlinghieri Berlinghiero. Tuscany,* *1210–1220*

The Byzantine heritage is partly absorbed and integrated with the local Tuscan style of Lucca. The plasticity and the formal consistency of the figures opened a new age of painting, which would be touched by the French Gothic movement only in a superficial way. The signature *Berlingeri Me Pinxit* appears at the bottom.

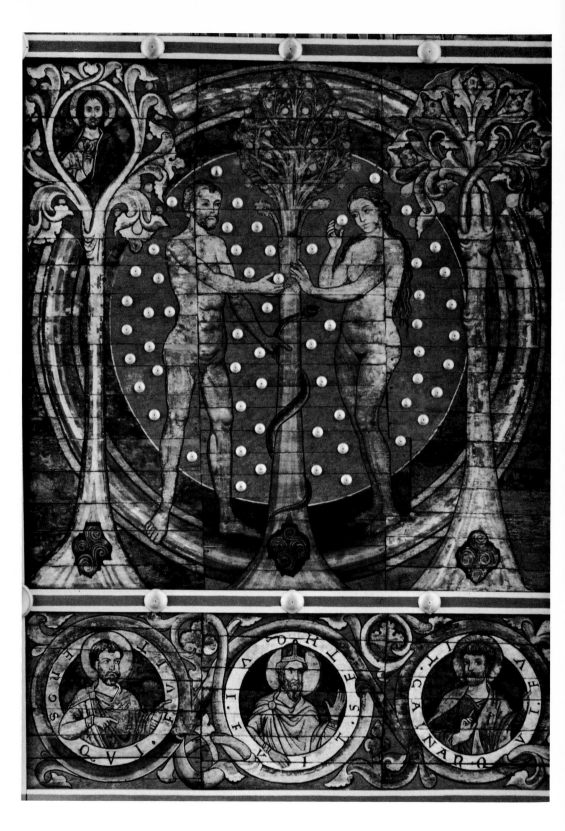

92. *Hildesheim, St. Michael. Detail of the painted wooden ceiling, Adam and Eve. About 1220*

93. *Detail of the Hildesheim ceiling, Jesse asleep*

The famous early 13th-century Hildesheim ceiling shows a Tree of Jesse, Old Testament scenes, kings, and prophets. It is painted in a style that is still basically Byzantine, and the spiky, angular folds are a sort of mannered interpretation of features visible in the late 12th-century mosaics in Sicily (ills. 229–232), although similar, unexpected contortions of the drapery had appeared earlier, around 1180–1190, in Thuringia and Saxony.

94. *Hildesheim, Museum. Fragment of a stucco relief, the Virgin from a Nativity. Hildesheim, about 1200*

The stucco fragment from Hildesheim, although a little earlier than the ceiling, shows a style of graceful modeling in which the drapery falls in more elegant curves.

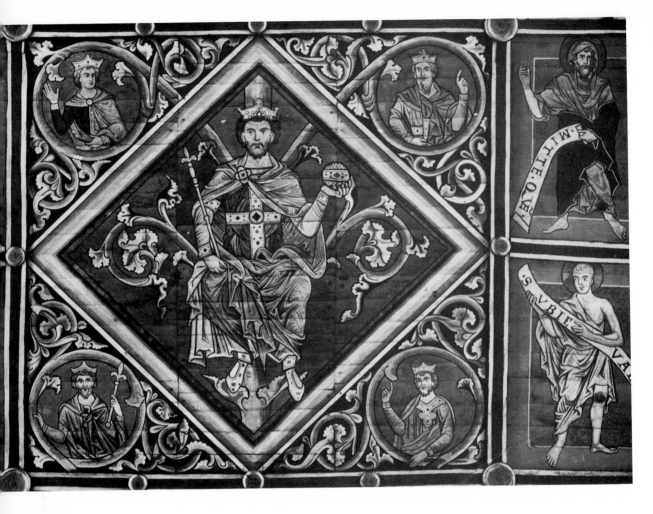

95. *Detail of the Hildesheim ceiling, seated king and prophets.* See discussion of ills. 92, 93.

96. *Halberstadt, Museum. Charlemagne Tapestry. Lower Saxony, about 1200.*

In contrast to the Apostles Tapestry (ill. 97), the Charlemagne Tapestry was deeply influenced by the new French style, which in details of drapery has been misunderstood.

97. *Halberstadt, Cathedral. Detail of the Apostles Tapestry, St. Bartholomew and St. Judas. Lower Saxony, 1190–1200*

The figures still retain the rigid pose of the Romanesque period, but the calm outline and the simple disposition of the draperies anticipate the new Western trends brought to Germany around 1200.

98. *Salerno, Cathedral. Ambo. Italy, about 1175–1180.* See p. 85.

William D. Wixom

THE GREATNESS OF
THE SO-CALLED MINOR ARTS

AS HANNS SWARZENSKI has pointed out, we have no clearly appropriate term for the great works in ivory, gold, silver, bronze, enamel, and inset gems from the early Middle Ages, and when we refer to them, we continue to employ "minor arts," "decorative arts," and other epithets invented during Europe's nineteenth-century industrial revolution. Many major museums to this day shy away from even using simply the word "art" without any qualification in this connection. And also we have no one but ourselves to blame for clinging to the Victorian separation of the medieval arts of architecture, sculpture, and painting from "the humbler and minor crafts." In several ways Swarzenski is quite correct in saying that there is really "no distinction to be drawn between 'minor' and 'major' arts" and that "the monumental quality of the art of this period is in no sense determined by size." Nevertheless, the Cluny Museum in Paris and The Cloisters in New York have remained nearly isolated contributors in the museum field to the unified study and appreciation of medieval art.

While Swarzenski's *Monuments of Romanesque Art* more than proves that separations of size and material can be artificial, this volume still underscores the initial dilemma of terminology and the question of what to call those works that are created in the demanding techniques of precious and semiprecious materials. The purpose and original location of the bulk of these works may provide a solution. These objects were primarily conceived within the context of Christian thought and belief and were used to symbolize, "to enshrine and emphasize the transcendental revelations of the mystery of the liturgy and of the relics." Therefore, we may well adopt Swarzenski's designation of this art as the "art of church treasures," one of the major arts of the early Middle Ages.

The period extending roughly from 1150 to 1250 saw an unprecedented flowering of this art. Quantities of objects, many now lost, were produced from a variety of materials: metal, enamel, ivory, and semiprecious jewels. These in-

cluded portable altars, book covers, crosses, crosiers, chalices, patens, candlesticks, and large casket shrines, the latter often encased in filigree, gems, enamel, and metal relief sculpture. The size, complexity, and quality of the individual objects varied, of course. Some pieces, notable for their exquisite, rich, and colorful surfaces, also gave a monumental effect in their figural elements. On occasion these figural reliefs or metal sculptures anticipated or vied in their expressive power with cathedral façade sculptures. Other more humble treasury objects were produced, some actually manufactured for export, which in time may have had something to do with our modern predilection for relegating all church-treasury art to the realm of "applied arts" or "decorative arts."

The scattered centers responsible during our period for the whole body of European church-treasury art, while rooted in antecedent traditions of Carolingian, Ottonian, and early Romanesque art, came to be distinguished for their own creative thrust and special emphases. This occurred despite many technical, stylistic, and iconographical cross-influences, and, in some instances, movement of particular artists, such as Eilbertus's apparent transfer from Cologne in the lower Rhineland to work at Hildesheim in lower Saxony, or Nicholas of Verdun's working at Klosterneuberg on the Danube as well as in the Rhineland. The valley of the Meuse and its tributaries and the lower Rhine valley, just to the east, contained the foremost of the productive centers important especially in the creation of shrines and altarpieces in metalwork and enamels. Included were Huy, Liège, Maastricht, and Stavelot in the Meuse watershed and Cologne in the lower Rhine valley. The original area of lower Lotharingia, the northern part of the kingdom inherited by Lothair (795–855), encompassed both of these important river-valley systems as well as such venerable centers as Trier, on the Moselle River, and Aachen, on the northern slopes of the Ardennes and long the coronation site of the Holy Roman emperors and German kings. The cast bronze work from lower Lotharingia, especially aquamaniles, censers, and candelabra, is to be admired for its fine contours, appealing animation in figural groups, and clarity of architectural representations.

Lower Saxony to the east continued as a productive area in this period, with the best efforts appearing in Hildesheim, already famous for its earlier work made under the rule of the renowned Bernward, archbishop of Hildesheim (993–1022), and in Braunschweig, which became the residence of the powerful Guelph dukes, the most notable being Henry the Lion (1129–1195). Earlier traditions, as seen in the work of Roger of Helmarshausen, continued in this area, although certain foreign influences from the Rhineland in enameling and from England in figure drawing are observable. Characteristic plaques on portable altars were

given simple colored-enamel backgrounds, sometimes flecked with gilded metal, while the figures were rendered in enamel-filled engraved lines, as in the works from the Welandus workshop. Exquisite figural imagery was embodied in niello-filled lines engraved in silver, as in the Bernward paten or the Oswald reliquary (ills. 145–148).

English enamel work is preserved in a group of enameled caskets, ciboria (for example, the Warwick ciborium, I, no. 172), and other objects with small figural groupings and involved iconographical complications recalling some earlier Mosan work. Also in this vein are some of the English ivories, the most outstanding and sophisticated object being the Bury St. Edmunds Cross (I, no. 60). English metalwork, some of it from the channel area, is noted for its tooled linear intertwining designs of leafwork and fantastic creatures—an inheritance from the earlier Anglo-Saxon period.

The Limousin region in France, especially the town of Limoges, became the center of an enormous output of metalwork and enameled service utensils and containers for relics in church treasuries. Some of this material was inferior in quality and tends today to discredit the whole production despite the mastery of specific artistic personalities and their particular shops. Enamels and ivory work were also made in Spain. Strong stylistic and technical similarities with Limousin enamels have caused some objects to be denied to Spain, a case in point being the oft-reproduced book cover in the Cluny Museum, with its great and monumental image of Christ (I, no. 136). Italy too, especially northern Italy, supplied some of the needs of altar and ecclesiastical treasury, although the preserved works are more isolated, and pieces of quality even rarer, as, for example, the superb silver-gilt pala at Torcello (ills. 213–215) or the handsome classicistic pala in silver with the dedication of Patriarch Pelegrino II (1195–1204) at Cividale Cathedral (ill. 218).

Throughout much of this work, there is a strong attraction not only for the static and abstract elements of Byzantine art but also for Byzantium's Greco-Roman heritage in which, to quote Ernst Kitzinger, "figures may appear in lively action, in three-dimensional corporality, and in spatial settings." Early phases in the emulation of Byzantine forms and iconography may be observed on many works produced during the Carolingian, Ottonian, and early Romanesque periods, the latter being obviously the most immediately relevant to the art of about 1200. More recent Byzantine elements, as shown by Otto Demus and Ernst Kitzinger, may have come via contact with the nearly pure Byzantine styles of the mosaics of Norman Sicily. Kitzinger underscored the probable intermediary role of model books, or "motif books," compendiums of useful artistic excerpts, in conveying

Siculo-Byzantine details and style characteristics to northern Europe and England, a case in point to be seen in Kitzinger's explanation of the Flight into Egypt scene of the châsse of St. Mark from Huy (I, no. 182). Undoubtedly, another source was contact with portable objects (metalwork, enamels, seals, and possibly manuscript paintings) brought directly from Byzantium itself in the age of the Crusades.

Many European artists earnestly grappled with the problems of rendering the plasticity of a draped figural mass and of giving an organic sculptural appearance to the depictions of the human body. Drapery was at first seen fragmentally and almost geometrically, and in part in terms of the Byzantine "damp folds," described by Wilhelm Koehler. As the year 1200 approached, and especially in Nicholas of Verdun's Klosterneuburg ambo of 1181 (ills. 100–104), greater interest was given to a more baroque approach, with complicated, expressive contrapposto movements, gestures, and fluttering of draperies. In the subsequent work of the same artist, this frenzy gave way to a calmer mood and style. The change appears as a restrained and more introspectively expressive classicism, more profound in its impact, as found in the finest and most mature figures from Nicholas's Cologne shop on the shrine of Three Kings (ills. 112–115) or in the relief figures on the shrine of the Virgin in Tournai (I, no. 100).

That this stylistic development is similar to that found in Byzantine art itself is rather startling. Nicholas himself, in following the equation of the damp-fold style, arrived concurrently at a more baroque style just as it was getting under way at Monreale. Therefore, it is important to acknowledge the probable existence of both simultaneous stylistic development and influenced development, the latter resulting in some earlier, formative instances from live contacts with the contemporary Byzantine world, perhaps the outgrowth of the enthusiasms of artists returning from working sojourns in Sicily or in the Crusader states in the East. However, as a qualification of this, the last phase of Romanesque art, the classicistic one, may be explained as influenced development with a time lag, developing in part from emulation of Byzantine objects from much earlier periods.

Popular opinion continues to overemphasize the anonymous character of the precious but often monumental treasury objects. Certainly the reputations of specific masters while they were working must have been more widespread than they are now. However, looking through the dimness of centuries of neglect, it is still possible to isolate the work of specific masters whose names are recorded, and also to recognize the production of shops dominated by a particular outstanding artistic personality. In the Meuse watershed and after the name of Rainer of Huy, there is Godefroid de Claire, also of Huy, who worked in the mid through third quarter of the twelfth century. While he was mentioned in a letter of 1148 by

Wibald, abbot of Stavelot (1130–1158), requesting delivery of overdue objects, we are hindered in a precise identification of his style by not having a single documented work. However, there are many fine pieces in enamel that may be reasonably assigned to his immediate circle. Also in the Meuse region, but from the second quarter of the thirteenth century, we have several masterpieces by the monk Hugo of the monastery of Oignies near Namur. Hugo followed in the artistic wake of the greatest artist of all, Nicholas of Verdun, mentioned previously. But two documented works by Nicholas are known, both signed. The first is the rearranged former ambo at Klosterneuburg, completed in 1181 (ills. 100–104), and the second is the shrine of the Virgin (actually of SS. Piatus and Nicasius) in Tournai Cathedral, finished in 1205 (I, no. 100).

It is not absolutely certain that Verdun was for any length of time the home of this artist, and it seemed unlikely to Hermann Schnitzler that he could be identified with the Nicholas of Tournai whose son was entered in 1217 in the lists of citizens of that city as *vitrarius,* or glass-stainer. However, Otto Demus has suggested that he was an itinerant artist who worked at the place of his commissions, at Klosterneuburg, presumably at Cologne, and then at Tournai. In any case, Nicholas might be considered a giant of the Mosan-Rhenish-Cologne school because of his apparent work and following there. His artistic beginnings are still uncertain.

In Saxony, a certain Welandus was responsible for a group of enameled plaques, chiefly for portable altars. Also in this region the Master of the Oswald reliquary (ills. 145–148) at Hildesheim, who may have come from England, created a group of superbly drawn figures in niello on silver not only for the Oswald reliquary but also for the St. Lawrence arm reliquary and the Bernward paten, the latter two from the Guelph Treasure. Another important personality in this area was the master who did the expressive reliefs with busts of Christ and the apostles on the Cleveland arm reliquary from the Guelph Treasure (I, no. 110), which seem to prefigure the monumental stucco choir reliefs in the Liebfrauenkirche at Halberstadt.

The maligned œuvre of the Limousin includes the work of several first-rate artists whose style is also clearly recognizable and to be valued. The Master of the Grandmont Altar (about 1189) created the two enamel plaques in the Cluny, one showing the Adoration of the Magi (I, no. 141), and the other depicting the monk Hugo Lacerta and St. Etienne de Muret, founder of the order at Grandmont (ill. 99), and a series of sublime enamel crosses, the finest of which are in Cleveland (I, no. 144) and New York. Master Alpais signed a ciborium, formerly in the abbey of Montmajour and now in the Louvre (ill. 141). His firm drawing in

low relief and finely burnished figural surfaces can be appreciated on a number of other works, especially the eucharistic coffret in the museum in Limoges (I, no. 149). Certainly to be given more appreciative acknowledgment is the master of the impressive, classicistic apostle reliefs, divided now between New York, Paris, Florence, and Leningrad. In England the artist who produced the ivory Bury St. Edmunds Cross (I, no. 60), while seemingly known only from this single work, must be regarded as one of the most gifted and fertile masters of the period. Other objects, while not always of the same qualitative importance, have revealed their makers, such as the monk Bertinus, who wrought the handsome silver chalice with his name and the date 1222 (I, no. 127).

One of the intriguing problems of the late Romanesque and early Gothic period and its recurring and creative borrowings from Byzantium is the question of the impact that the Western arts of altar and ecclesiastical treasuries may have had as a source for the "major art" of stone sculpture, particularly as it is seen on church façades. The origins of the columnar figure in France, rooted in early Romanesque sculptures in the southwest and possibly related to certain Burgundian manuscript initial paintings, may also owe a debt to Mosan monuments in enamel and metal. Certainly the developing concept of the organic and revealed mass of the human figure, not only static but in motion, had some of its earliest and sometimes its most innovative treatment in the treasury arts. Of major importance is the lost enameled and metal cross and base by Mosan artists made for Abbot Suger at the royal abbey at St.-Denis about 1140, of which there is an imperfect replica of about 1160–1175 at St.-Omer. This lost monument could not have been without enormous impact on the figural arts and their developing iconography in France. Its inventiveness, treatment of figural mass, and strategic location make this supposition almost inevitable. Willibald Sauerländer and others have postulated such a Mosan influence in France, and it is certainly confirmed in the Valois portal of about 1175 at St.-Denis, in the west portal at Sens of about 1184, and in the rich sculptural program at Châlons-sur-Marne of about 1180. It should be noted that enamels in a Mosan style seem to have been made at Troyes and that the stained glass at Châlons, published by Louis Grodecki, may have been done by Mosan artists. The subsequent tradition of stained glass at Troyes reflects continuing inroads of the Mosan style in Champagne.

Perhaps the most intriguing question of all is: What was the *actual* impact on the next generation or two of the work of Nicholas of Verdun, the greatest and finest exponent of, first, the Byzantine-like baroque, and then, of Byzantine classicism? Nicholas's apparent contributions to Laon, Chartres, and Reims, chronicled by Schnitzler, Sauerländer, and Grodecki, lie at the heart of this question—which

is beyond the scope of the present discussion. Nicholas may have indeed had an ally in France in the form of a manuscript of about 1200, the classicistic psalter of Queen Ingeborg (d. 1236), published in detail recently by Florens Deuchler.

Nicholas's work is, of course, the trump card in the proposal that the so-called "minor arts" can indeed be the "major arts." Nicholas's creations are symbolic of the creative burst of energy of artists of his generation responsible for truly great, cohesive monuments of precious and semiprecious materials of metal, enamel, ivory, and gems.

The monumental aspect of this art did not continue long beyond the first half of the thirteenth century. One of the last major architectural shrines with figures of imposing dimensions and mass was the shrine of St. Elizabeth of around 1236–1249 at Marburg. The succeeding works became more purely exquisite and delicate and remained small in concept, losing all the expressive, sculptural power found in so many of the altar and treasury objects of the earlier era.

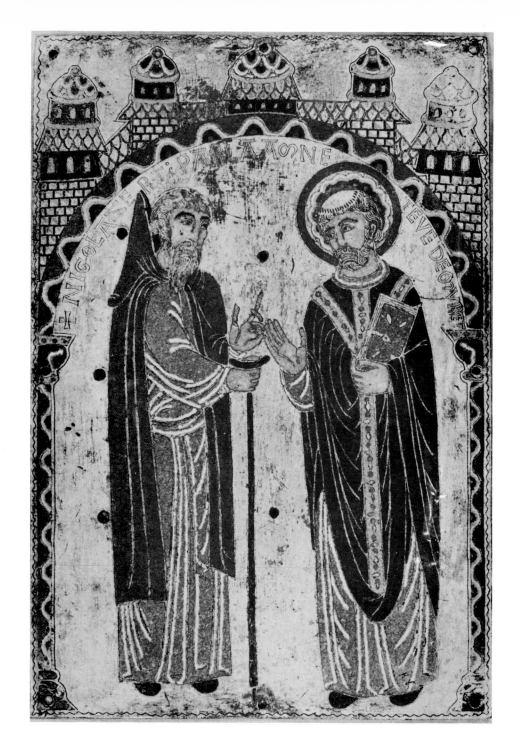

99. *Paris, Cluny Museum. Champlevé enamel plaque, from the altar of Grandmont, with conversation between St. Etienne de Muret and his disciple Hugo Lacerta. Limoges, dated 1189*

This plaque originated in the same workshop as the plaque showing the Adoration of the Magi (I, no. 141).

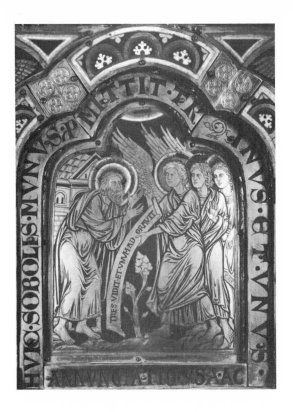

100–104. *Klosterneuburg, Abbey. Details from the altarpiece, made and signed by Nicholas of Verdun, the Annunciation to Isaac, Solomon and Sheba, the Nativity, Christ Enthroned, the Mouth of Hell. 1181*

The Klosterneuburg altarpiece, originally an ambo, displays fifty-one enameled plaques in three rows. The extensive typological program illustrates the parallels between the Old and New Testament. Nicholas's sources are still unknown, but the obvious classicism of some of the figures and scenes has led scholars to postulate that he was closely acquainted with Greek and Roman sculpture.

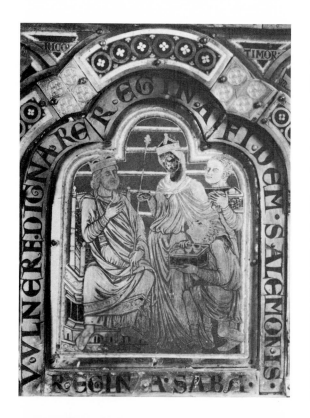

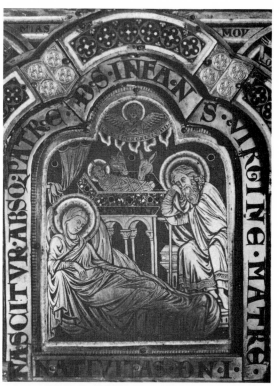

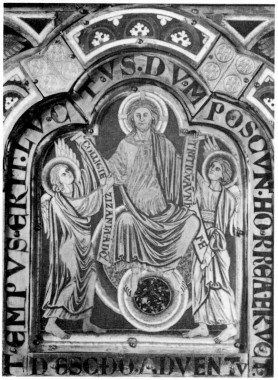

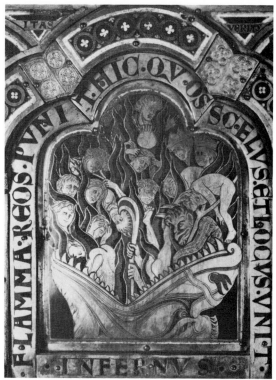

Ills. 105–121 show a group of shrines made around 1200 in western Germany. They adopt the architectural forms of houses and churches and are covered with silver, gold, enamels, precious stones, and filigree work. Particular decorative attention was given to the crests and finials. The walls are articulated with arcades and figures of prophets and apostles, and at the ends the patron saints or the commissioner of the work.

105. *Siegburg, St. Servatius Abbey. Shrine of St. Anno. Cologne, 1175–1183*

106. *Detail of the gable decoration of the Anno shrine*

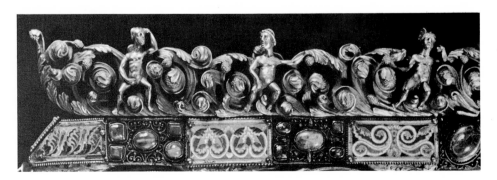

107. *Finial from the Anno shrine*
108. *Cologne, Cathedral. Shrine of the Three Kings, finial (see also ill. 111). About 1200*

109, 110. *Aachen, Cathedral Treasury. Shrine of the Virgin, two finials. 1220–1235*

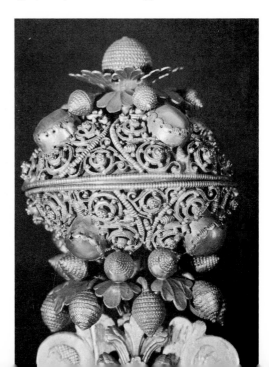

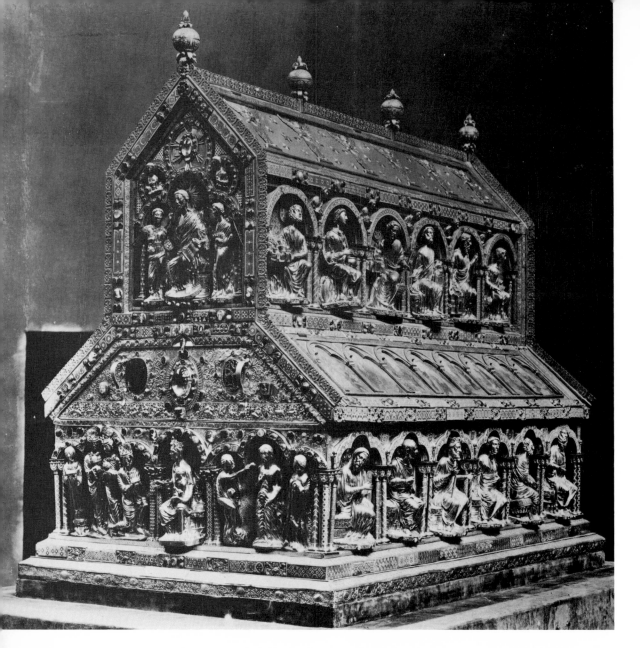

111. *Cologne, Cathedral. Shrine of the Three Kings, by Nicholas of Verdun and his workshop, gold and silver repoussé, copper, champlevé and cloisonné enamel, niello, precious stones, gems, pearls. The entire conception and the execution of the long sides between 1181 and 1191; front terminal about 1198–1206; rear terminal about 1220–1230*

112–115. *Prophets and apostles from the long sides of the shrine of the Three Kings: Bartholomew, Jonah, Simon, and Jeremiah. About 1200*

The shrine of the Three Kings was planned by Nicholas of Verdun. The series of silver-gilt, embossed prophets and apostles, from his own hand, are paramount examples of the art of this period outside Ile-de-France.

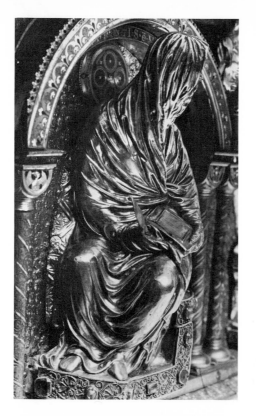

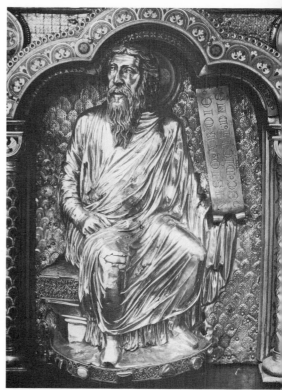

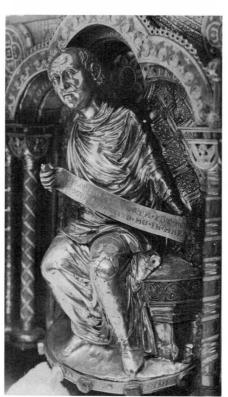

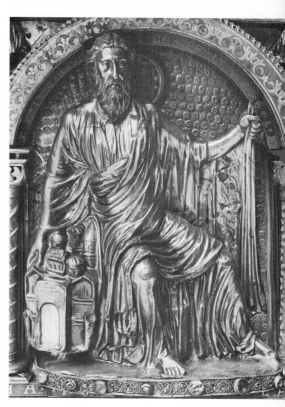

116. *Details from the shrine of the Three Kings, heads in medallions. About 1200*

Among the decorative motifs of the Cologne shrine, the friezes with heads in medallions call for special attention. The variety of types is almost unique; the scheme was probably inspired by classical works. See also p. 35.

117. *Details from the shrine of the Three Kings, allegorical figures and musicians among scrolls. About 1200*

The smoothly sweeping draperies of these figures are characteristic of Nicholas's workshop around 1200.

118–121. *Scrolls with figures from the shrine of the Three Kings: dragon and lion, Samson on the lion; knights on horseback; hunter and boar; hunter and centaur. About 1200*

The centaur, popular as a decorative element, may also be seen in ill. 169. For Samson and the lion, see I, no. 179.

122. *Stockholm, Historical Museum. Buckle with lady and mounted knight, seated couple. Cologne (?), about 1200*

This delightful silver-gilt *à jour* buckle is closely related in style to the Cologne workshop of Nicholas of Verdun. The representation on the right has been tentatively interpreted by Hanns Swarzenski as the Entry into Jerusalem.

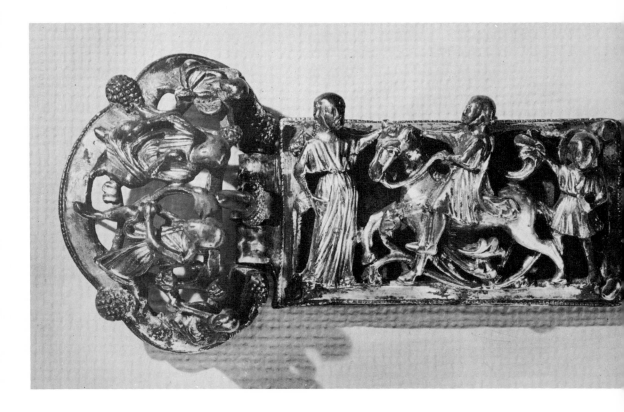

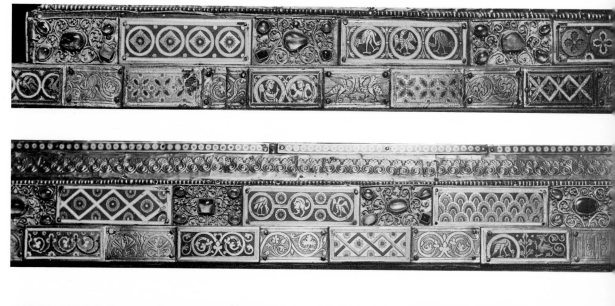

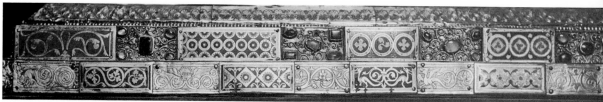

123–126. *Aachen, Cathedral Treasury. Enameled decorative frieze and filigree work from the shrine of Charlemagne. About 1200–1215*

These details show a variety of decorative patterns and an imaginative use of heraldic motifs and classical quotations (note especially the medallions with heads and grotesques).

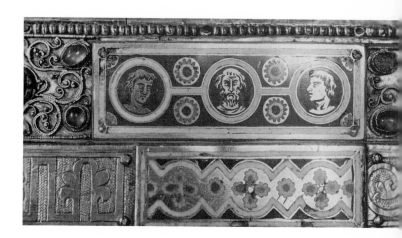

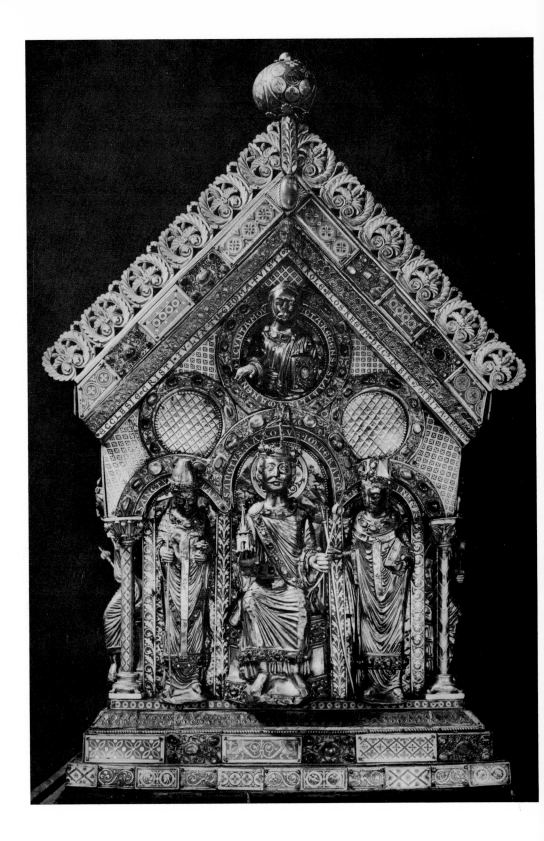

127. *Aachen, Cathedral Treasury. Shrine of Charlemagne: Charlemagne, Pope Leo III, and Bishop Tuopin. About 1200–1215*

128, 129. *Details from the shrine of Charlemagne, Charlemagne offers the church of Aachen to the Virgin, the siege of Pamplona. About 1200–1215*

The style of drapery used here is typical for the decade after the triumph of the so-called hairpin folds. The linear mannerism has been replaced by a new plastic conception.

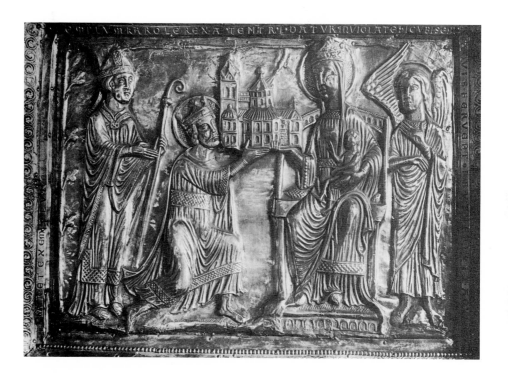

130. *Aachen, Cathedral Treasury. Shrine of the Virgin, Pope Leo III. About 1220*
131. *Detail from the shrine of the Virgin, Annunciation to the Virgin and Visitation. About 1200*
132. *Detail from the shrine of the Virgin, Deposition. About 1235*

This shrine has embossed plaques, dating from about 1220 (ill. 131), that show the fully developed style of parallel folds as seen in ill. 128; other plaques (ill. 132) belong to a later workshop, active shortly before 1238.

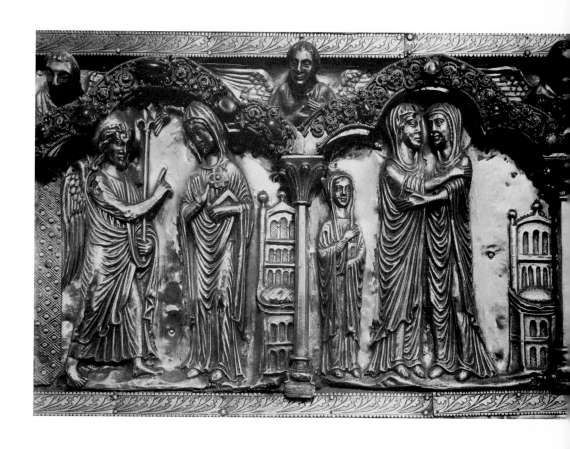

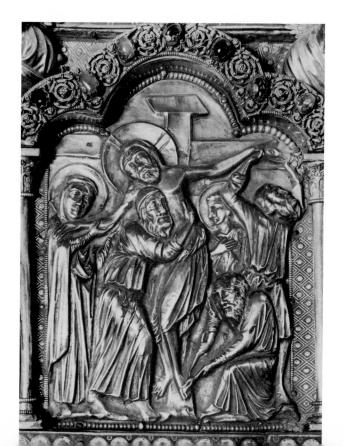

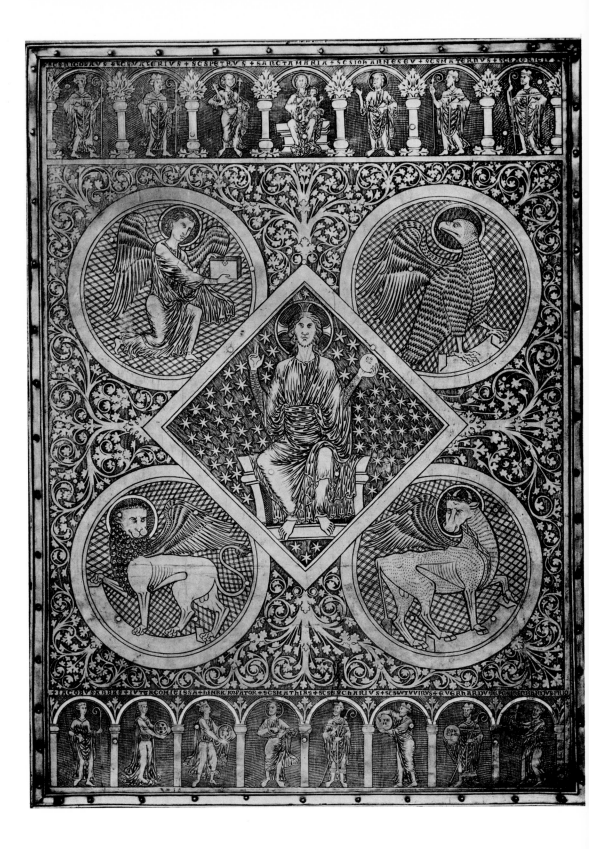

133. *Trier, St. Matthias. Detail of the reliquary of the cross, Christ and the symbols of the Evangelists, donors. Trier, about 1220*

The Trier reliquary is a work in the tradition of Nicholas of Verdun, as is the more modest reliquary in Mettlach (ills. 136, 137). In these two works, the use of the hairpin folds (*Muldenfaltenstil*) reached its peak in terms of its closeness to antique art. Louis Grodecki calls this tendency a neoclassicism.

134. *Detail of the Trier reliquary, Christ enthroned. About 1220*

The position of Christ and the stars that surround him are like those in the Ascension mosaic in Venice (ill. 242).

135. *Cologne, Cathedral Treasury. Roundel with Christ. Cologne, about 1200*

These figures of Christ both stem from the Byzantine iconography of the Pantocrator. The face on the Cologne roundel, a little earlier than the Trier one, is closer to the Eastern canon of the mid-12th century.

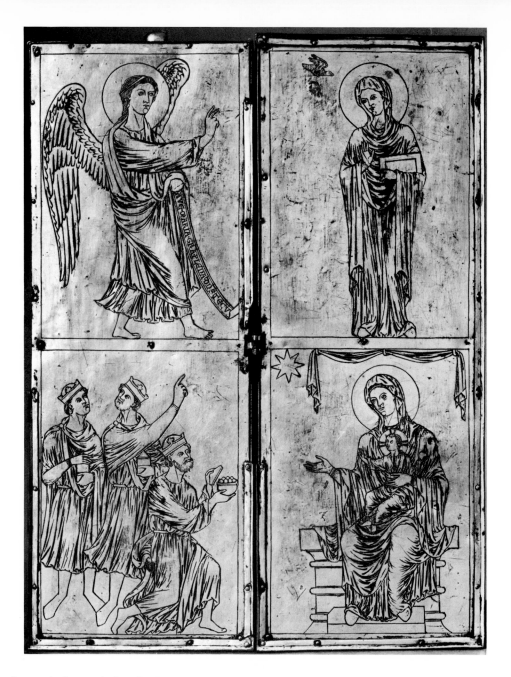

136. *Mettlach, parish church. The wings of the reliquary triptych of the true cross, Annunciation to the Virgin, Adoration of the Magi. Trier, about 1220–1230*

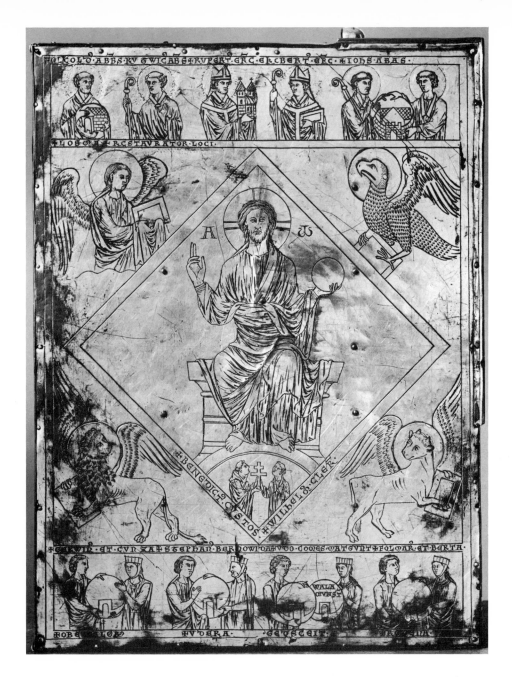

137. *Detail of the reliquary triptych in Mettlach, Christ, symbols of the four Evangelists, donors. Trier, about 1220–1230*

The classical style of the sumptuous hairpin folds was a common feature during the transition from Romanesque to Gothic. It can be observed in the Ingeborg Psalter (ills. 190–193) and in much Mosan and Rhenish goldsmiths' work. The Tournai drawings (ills. 186, 187) can be considered as forerunners of this style. The hairpin variations are less precise in the Mettlach reliquary than in the Trier one. This is due to a younger hand in the Trier workshop and does not mean lower quality.

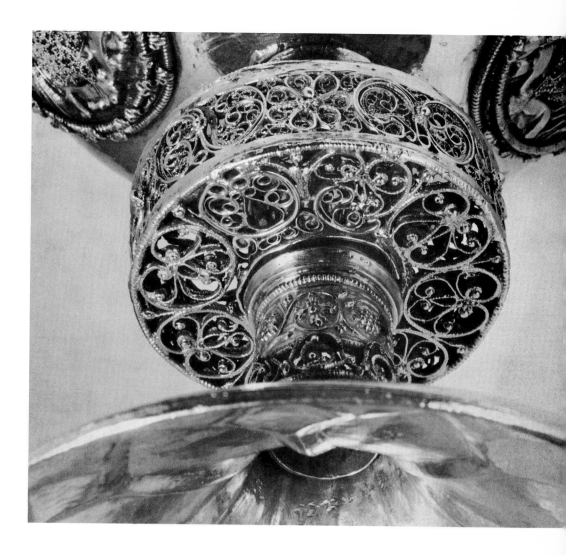

138. *Cologne, St. Cunibert. Arm reliquary. Cologne, about 1222*

139. *Detail of the arm reliquary from Cologne with filigree work*

140. *Lucerne, Hofkirche, Treasury. Detail of a chalice, circular nodule. Sicily (?), about 1200*

The Cologne arm reliquary and the Lucerne nodule are typical examples of richly decorated filigree work and elaborated foliated lattice design. In the reliquary the relic is inserted into the medallion of crystal, which can be opened.

141. *Paris, Louvre. Ciborium, by Master Alpais. Limoges, about 1200*

A diaper pattern, with angels and saints, decorates this ciborium. Encircling the lower rim is a band of pseudo-Kufic script, a popular decorative motif. The foot is adorned by openwork scrolls with figures .

142. *Tremessen (Poland), abbey church. Chalice. Lower Saxony, about 1180*
143. *Paten of the Tremessen chalice*
144. *Cup of the Tremessen chalice, Moses at the burning bush, Annunciation, Aaron*

The silver-gilt chalice in Tremessen is engraved and worked in the niello technique. The cup is decorated with alternating scenes from the Old and New Testament (for instance, Moses and the burning bush acts as a counterpart to the Annunciation to the Virgin) and the four beasts, symbols of the Evangelists. On the knob are the rivers of Paradise (embossed); on the base, the Beatitudes; on the handle, the Virtues. The chalice was probably a gift of Henry the Lion to the abbey of Tremessen.

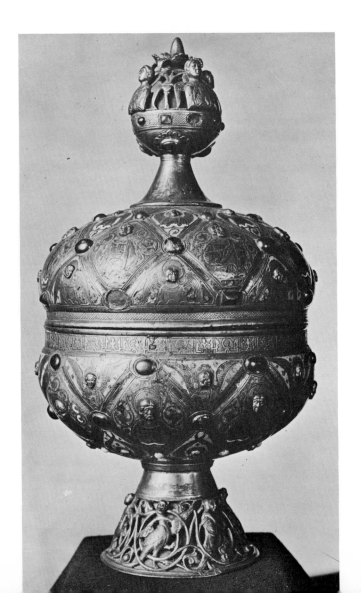

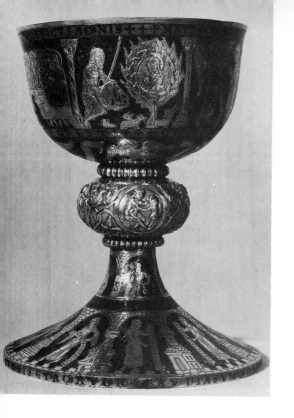

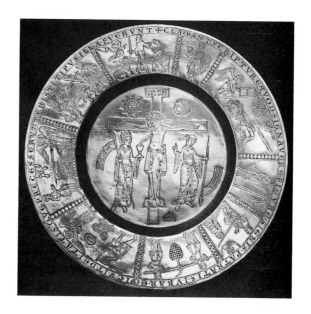

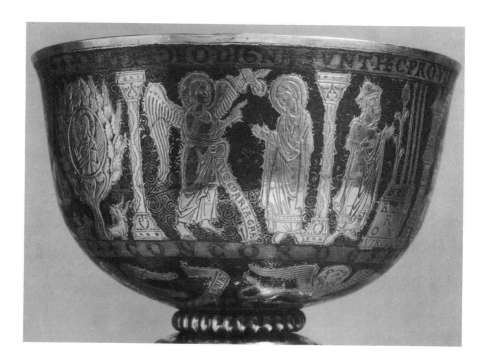

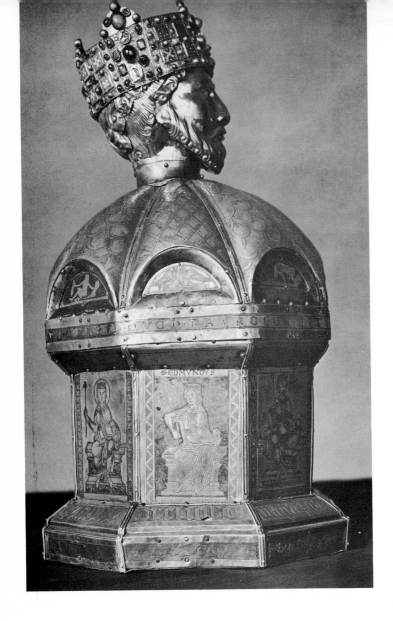

145. *Hildesheim, Cathedral Treasury. Silver reliquary head of St. Oswald. Braunschweig or England, about 1176*

146–148. *Details of the reliquary head of St. Oswald*

St. Oswald and a series of Anglo-Saxon kings are represented on the base. For the type of the seated figure and the related problems of the drapery, see ill. 67. In the tympanum-like endings of the roof are the symbols of the Evangelists and the four rivers of Paradise (see also ill. 78).

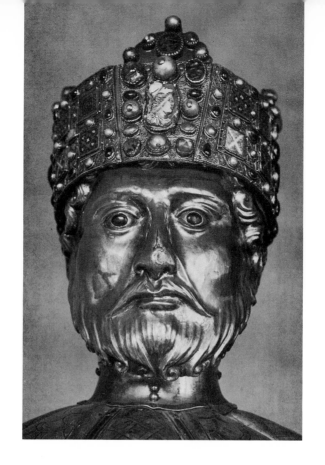

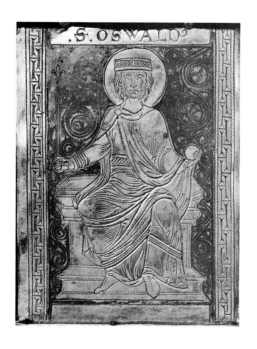

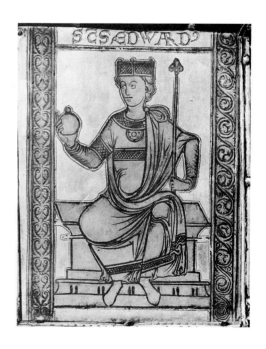

149. *Engelberg (Switzerland), Abbey. Silver cross. About 1200*

This cross is still in liturgical use. The seated Virgin with child occupies the middle medallion; in the outer medallions are shown the four elements (on the right, for instance, Ganymede is depicted riding on the eagle as the symbol for the air).

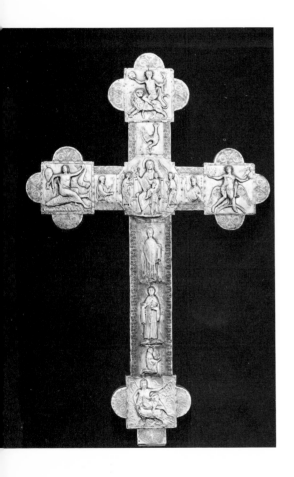

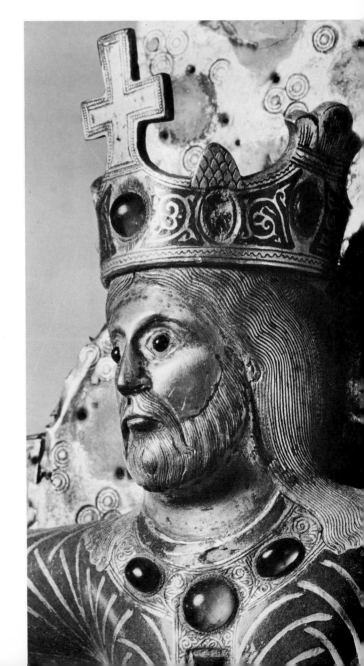

150. *Stockholm, Historical Museum. Detail of the cross from Navelsjö, enameled copper. Limoges, about 1200*

151. *Herlufsholm (Denmark), abbey church. Head of an ivory Christ. England, about 1210*

These approximately contemporary figures show two ways of representing the crucified Lord: the older type, with open eyes and crowned, as *Christus Victor;* the upcoming type, with closed eyes, as *Christus patiens.*

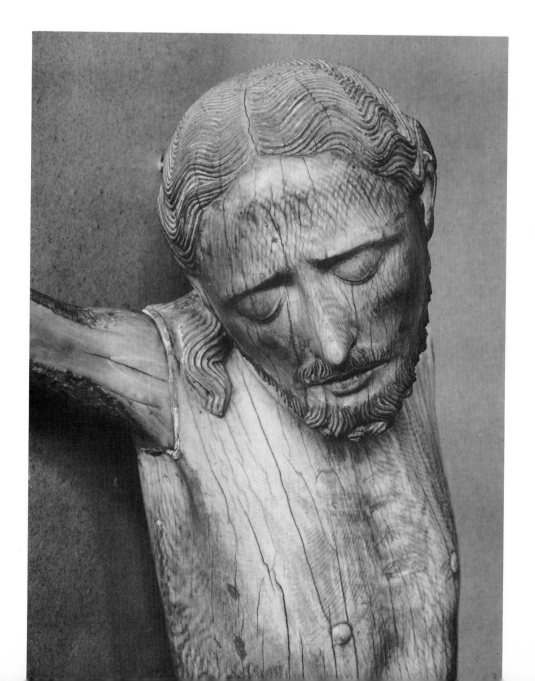

152. *Halberstadt, Cathedral. Jew stoning Stephen. Halberstadt, about 1208*

This is one of four figures of Jews applied to a silver Byzantine bowl that Bishop Konrad of Krosigk brought from the Holy Land to his see in 1208.

153. *Dublin, John Hunt Collection. Ivory chessman. England, about 1200*

This small ivory chess piece probably represents the murder of St. Thomas Becket, a popular theme around 1200 (see also ill. 175).

154. *Milan, Cathedral. Trivulzio candlestick, detail, river of Paradise. Lorraine, England, or Milan (?), about 1200*

This river of Paradise (see also ill. 78) belongs to the so-called Milan candlestick, perhaps commissioned to replace an older one transferred by Emperor Frederick Barbarossa in 1162 to Prague Cathedral. The candlestick shows the classical mood at its most accomplished; this figure was probably derived from an antique model.

155. *Detail of the knob of the Milan candlestick, one of the Magi on horseback*

The majestic pose of this equestrian figure indicates direct inspiration from a classical source.

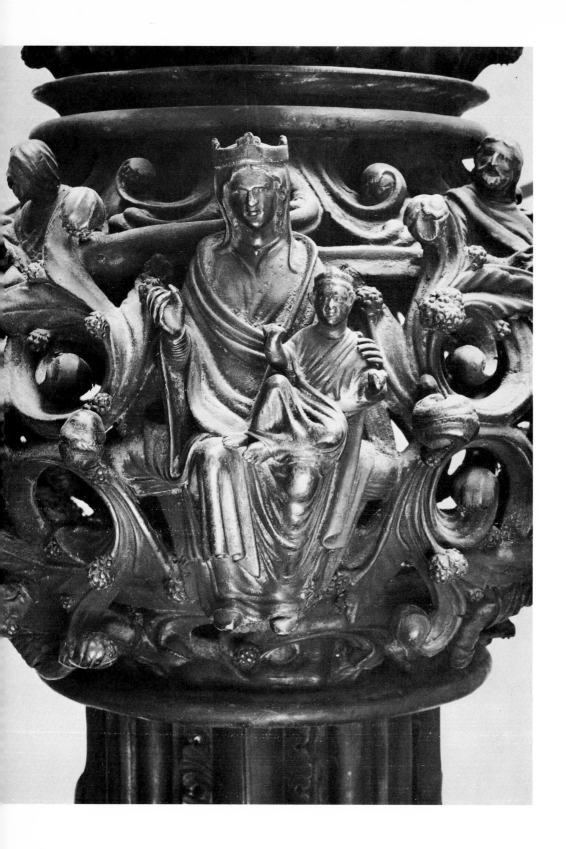

156. *Detail of the Milan candlestick, the seated Virgin with Child*

157. *Aachen, Cathedral Treasury. Seated Virgin from the shrine of the Virgin (see also ill. 130). Aachen, about 1200*

158. *Hildesheim, Cathedral. Seated Virgin from the baptismal font. Hildesheim, about 1220*

This group of enthroned Virgins illustrates three types: the first in the context of the Adoration of the Magi; the second as an iconic image of the Queen of Heaven; the third as the intermediary between the donor as worshiper and Christ. The three works show the different styles employed around the same time in three separate regions: the Meuse, Aachen, and Lower Saxony. In ill. 156 the unusually relaxed pose of Christ and his heavy proportions are reminiscent of antique Roman figures.

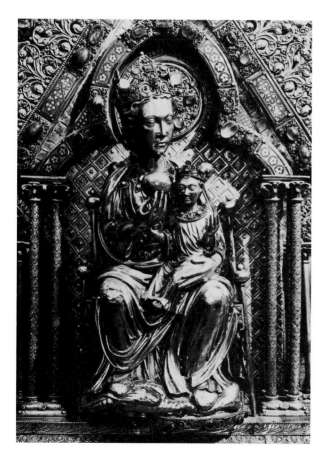

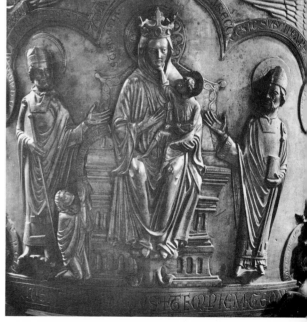

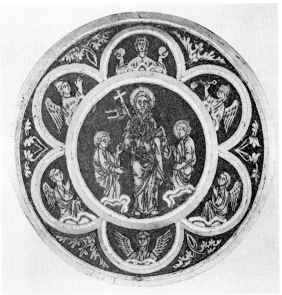

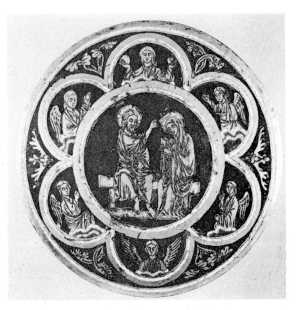

159–162. *Cologne, Schnütgen Museum. Four circular plaques with scenes from the story of Christ after his death: the Virgins at the Tomb; the Resurrection; Christ's Harrowing of Hell; Coronation of the Virgin. Cologne, about 1200*

These plaques belong to a stylistic trend that originated in such works as the bands of the shrine of the Three Kings (ills. 116, 117), but simplified in the hands of a less accomplished artist.

D. H. Turner

MANUSCRIPT ILLUMINATION

THERE IS A GREAT NEED for reconsideration and redefinition of the stylistic periods of the visual arts in the Middle Ages. Much has already been done in this direction, but far more is required before a true appreciation will be possible of the place of the Middle Ages in the history of painting, sculpture and architecture. It is the mutation from Romanesque to Gothic which particularly calls for investigation, for the progress of research is making abundantly clear how decisive an event this was and, further, that it gave rise to something which was a style in its own right, not just a postlude to Romanesque or a prelude to Gothic. *Faute-de-mieux* this style is known as 'Transitional', but despite the considerable amount of experimentation in it and the variety of its manifestations, it was far more than merely an expression of a confused period of change. Experimentation was indeed its key-note, but successful experimentation is anything but confused and the experiments of the artists of the Transitional period certainly led to remarkable successes. This is as true in the graphic arts as in sculpture and architecture, and in manuscript illumination, which was the main medium of painting and drawing, the student is immediately struck by the number of examples of amazingly high quality amongst those that have survived to us. He cannot but become conscious of being in the presence of a style full of vitality and independence.

The Transitional period occupies the twenty years or so on either side of the year 1200. Like Romanesque its style is predominantly apparent in Europe north of the Pyrenees and the Alps. In Romanesque illumination the two extremes were to be found in England and Bavaria (the latter of which included the modern Austria). Bavarian illumination had had at Salzburg a centre where intelligent assimilation of Byzantine influence had resulted in a 'neo-classicism' which was more humanistic than any Byzantine painting of the twelfth century or later. True to this tradition Salzburg produced in the Transitional period in such a manuscript as the Collectar from the nunnery of St. Ehrentrud on the Nonnberg (Munich, Bayerische Staatsbibliothek, Clm. 15902; *circa* 1200; ill. 202) illumination

133

which is a most happy alliance of western and eastern influences. Fresh inspiration from the best that the Byzantine world could offer must have been available and is at once recognizable in the heightened interest in form. Faces have become plastic instead of sculpturesque—which was the most that Romanesque could achieve anywhere—and a tendency to pathos of expression and lowering countenances demonstrates the close connections with Byzantium. We find an angry-looking St. Benedict who is first cousin to any typical, contemporary Byzantine saint; whilst a sad faced Virgin and rather petulant Child are rightly accompanied by a Greco-Latin inscription. Plastic faces: 'Classical' at their best—and there are some in the Nonnberg Collectar—more often 'Byzantinesque', appear as one of the constants of Transitional illumination everywhere. More varied is the treatment of drapery. At Salzburg we see broad, flat folds, which aim to emphasize the contours of the body beneath. A similar attempt had been made in the Romanesque period, but the drapery had inevitably become abstract patterning, whereas now there is an understanding of naturalism, and ornamental details are kept in check. What gives the Nonnberg Collectar supreme effectiveness is its expert combination of figural and decorative illumination. The Salzburg version of Transitional illumination is a very pleasing one, the influences of which on the rest of Europe need examination. The most obvious of them are in the Thuringian-Saxon school of illumination, the productions of which extend well into the thirteenth century. Its two earliest and best manuscripts are within our period. Both are psalters made for the Landgrave Hermann of Thuringia and his wife, probably not long before the former's death in 1217. The first is named after him and is now in the Landesbibliothek at Stuttgart (Bibl. fol. 24); the second is known as the 'Psalter of St. Elisabeth' (Cividale, Biblioteca Comunale, Cod. Sac. 7), because of its sometime ownership by Hermann's daughter-in-law Elisabeth of Hungary. The two psalters promptly awake recollections of Salzburg, but their illumination is less distinguished, and marked by a hardness and angularity in the treatment of drapery which announce the 'jagged' quality that was to be so characteristic of the Thuringian-Saxon School later. 'Classical' faces are attempted, but the result is too often a childishness of expression, verging on comicality.

At the other end of what had been the Romanesque world we find Byzantine influences and humanization in conflict, it might be said, with strong English tendencies to linearism and abstraction. We are fortunate in being able to watch the emergence of Transitional here in a book which also contains some of the finest Romanesque painting in England. This is the Bible apparently made for the cathedral monastery at Winchester and now in the possession of the Dean and Chapter there. Some six artists have been credited with its illumination, which

may have been begun about 1160 but not finished for about forty years. Four of the illuminators worked in the Transitional rather than the Romanesque idiom and they have been called the Masters of the Amalekite, the Genesis Initial, the Morgan Leaf and the Gothic Majesty (ill. 166). The distinction between them is blurred and it may be that the first three at least were only one person progressively freeing himself from the trammels of Romanesque. What is certain is that there is Transitional work completing Romanesque designs and whilst the later artists had little difficulty in effecting Transitional type faces, they had more trouble with adapting draperies. Eventually the problem was solved by abandoning Byzantinesque techniques as well as Romanesque ones and adopting an impressionism which spread even to faces in those attributed to the Master of the Gothic Majesty. The best Transitional illumination in the Winchester Bible, however, is that associated with the so-called Master of the Morgan Leaf. He owes his name to a superb full-page miniature with scenes from the life of David, which is in the Pierpont Morgan Library, New York (MS. 619 recto; I, no. 256) and which was again originally designed by a Romanesque hand. The making of the Morgan Leaf is somehow connected with that of the Winchester Bible, but exactly how so far defies explanation. The size of the composition in New York allows proper appreciation of an especial importance of its illuminator, namely his feeling for spacial design, for the introduction of which into English painting he deserves the credit. The Morgan Master clearly thought in 'full scale', so that we are not surprised that wall-paintings have been attributed to him, although these were done in Spain, for the chapter-house at Sigena, between 1183 and 1200. Returning to illumination and England it seems plausible that the Master may have been responsible for the original work on the third and last of the copies surviving (Paris, Bibliothèque Nationale, MS, lat. 8846; I, no. 257) of the Carolingian Utrecht Psalter. This copy is usually thought to have been written and its decoration begun at Canterbury *circa* 1200. Its original illustrations show expert use of space to create dramatic effect. Figures are largely conceived with well-modelled, Byzantinesque faces and draperies which are a humanized version of Romanesque conventions, without reaching the impressionism of the latest work in the Winchester Bible. Colors in the Paris Psalter are rich and contrasts between them well managed. The general effect is one of great magnificence. Personally we would like to suggest an earlier date for the manuscript than that just mentioned, one towards the beginning of Transitional.

The most 'Classical' painting in England in this period is in a psalter (London, British Museum, Royal MS. 2 A. xxii; ills. 177–179), made possibly at St. Albans Abbey *circa* 1200 for use at Westminster Abbey. The five preliminary miniatures

in the manuscript exhibit an understanding of form which surpasses even that found at Salzburg in the Nonnberg Collectar. We become very aware of the 'roundness' of the figures in the Westminster miniatures. Their faces are fully plastic, restrained and dignified in their expressions. In this connection the representation of the Virgin and Child should be compared with the one we have cited from the Nonnberg Collectar. Draperies are rendered in a freer manner than in either the Winchester Bible or the Paris Psalter. The body they cover is unmistakably suggested, but never emphasized. The Romanesque English illuminators had been second to none in the use of line, now in the Westminster Psalter a new technique has been perfected, which is just as successful and shows a freedom from any mannerism—something which is both rare in the Middle Ages and impermanent. The uniqueness of the Westminster achievement may be judged by contrasting it with any 'ordinary' Transitional illumination. For this there is a good source in England itself in the products of an atelier, possibly situated at Oxford, which number no less than six psalters and provide us with valuable material for the study of workshop practice in our period. Moreover, the workshop was probably a professional and commercial one. Chief of the six manuscripts is that known as the 'Gloucester Psalter' (Munich, Bayerische Staatsbibliothek, Clm. 835; ills. 172–174) and two other leading ones are in the British Museum (Arundel MS. 157; I, no. 260; and Royal MS. I D. x; I, no. 261). The 'Gloucester Psalter' was written probably for an Augustinian nunnery in the west of England and two further members of the group (Imola, Biblioteca Comunale, MS. 100 and Oxford, Bodleian Library, MS. liturg. 407) were executed for the nunnery of Amesbury, in Wiltshire. The miniatures from the 'Oxford' atelier have all the techniques of English Transitional, but employed as conventions. There is a distinct hardness, even coarseness on occasion, and comparison of the output of the 'Oxford' atelier with the Westminster Psalter serves to remind us that if Transitional was a 'liberalizing' style, it was not an essentially naturalistic one.

The quest for new methods of treating drapery, which led Transitional artists to feel through Byzantine techniques towards the Classical ones behind them, had its most notable result in fact in a mannerism, which is also one of the most well-known and influential features of Transitional. It consisted in a rendering of folds as incised ridges and troughs which has been baptized in German the 'Muldenfaltenstil'. Particularly appropriate to sculpture and metal-work, it first appears fully fledged on the Klosterneuburg Altar of 1181 by Nicolas of Verdun (ills. 80–84). Its native territory was the Rhineland, the Low Countries and northern France. In illumination we find its most successful manifestation on German soil in the Gospel-book (Karlsruhe, Badische Landesbibliothek, MS.

Bruchsal 1; ill. 204), made about 1197 in a Rhenish workshop for Conrad von Tanne, then Custos of Neuhausen, near Worms. Subsequently (1223–26) Conrad was bishop of Speyer and gave the manuscript to his cathedral. Its illumination is divided between three hands, two of whom can be described as Romanesque rather than Transitional. The third, who was responsible for the majority (fourteen) of the miniatures, made expert use of ridged drapery to give vitality to his compositions. The faces of his figures are in the most 'Classical' type of Byzantinesque, whilst still demanding the latter label, but space he did not manage over well. However, there is no denying the vigour of representations such as his of the Dream and Sea Voyage of the Magi. For a later Rhenish example of ridged drapery we may look at the Gospel-book from St. Martin's, Cologne (Brussels, Bibliothèque Royale, MS. 9222; ills. 211–212), which is assigned to the first quarter of the thirteenth century. Its miniatures lack the freshness of those in the Speyer Lectionary, for now the drapery technique has become weaker and obscures rather than emphasizes. Faces are 'Classical' rather than Byzantinesque, but apt to fail in their intention and lapse into a childishness similar to that noticed in the Thuringian-Saxon School.

Undeniably the greatest painting to employ ridged drapery is in the Psalter (Chantilly, Musée Condé, MS. 1695; ills. 190–193) made for Queen Ingeborg of France. The standard of the manuscript's illumination is such as can only be described by epithets of superlativeness. Its twenty-seven full-page miniatures are by two illuminators, one working in an older tradition than the other, but throughout there is a stylistic development which ignores this division and is presumably due to the common enterprise. The earlier miniatures, by the 'older' Master, have flatter, Byzantinesque folds akin to those in Salzburg illumination, but these soon sharpen into ridges and troughs and the newer technique dominates the work of the 'younger' Master, being developed to its furthest extent in his miniature of Pentecost. In all the Ingeborg miniatures faces are particularly plastic and rounded, but always with a certain pathos or strain in their expressions; they never exhibit the calm observable in the Westminster Psalter. Only the 'younger' Master, however, manages to give a convincing plasticity to covered bodies. As might be expected of a book of its importance, much discussion has raged about the date and provenance of the Ingeborg Psalter. The most recent definitive suggestion is *circa* 1195 in north-eastern France, possibly in the diocese of Noyon; but the debate continues. Personally we have not yet been convinced by the arguments against the early dating and we would like to comment here that we see no grounds for the old idea of a stylistic connection with England. Ridged drapery played no part in English illumination before the fourth decade of the thirteenth century, whereas

it, or rather the heritage of the Ingeborg Psalter, was all important *circa* 1200–1240 in France. Here, outside the sphere that centers on the famous manuscript at Chantilly, there is no Transitional illumination of comparable quality or progressiveness. We should not omit mention of the Bible (Paris, Bibliothèque Sainte-Geneviève, MSS. 8–10; last quarter of the twelfth century; ills. 167, 169–171), written by a Canterbury scribe named Manerius, but illuminated possibly in Normandy; but it, and certain related manuscripts, show a conservativeness which suggests an attempt to reinvigorate Romanesque rather than pursue new paths. A more positive move in this direction resulted in a version of Transitional which we may call 'neo-Romanesque' and of which a particularly interesting example is provided by the eight miniatures of the life of Christ inserted into Cotton MS. Caligula A. vii in the British Museum (I, no. 284). These are of the late twelfth century in date and executed probably in north-western France or Flanders. The ones with which we are concerned show a remarkable linear version of Byzantism—as can be best seen in the representation of the Visitation—in which the illuminator neither really deserts Romanesque tradition nor is submerged by Eastern influences.

'Neo-Romanesque' may be properly defined as a maintenance of Romanesque drapery techniques without giving up the interest and experimentation in form which emerge as the chief preoccupation of painters around the year 1200. Fine examples of it are in the Codex Aureus of Erfurt (Pommersfelden, Gräfliche Schönbornsche Bibliothek, MS. 2869) and the 'earlier' work in the Brandenburg Gospel-book in the Domarchiv there, both from Lower Saxony. This latter manuscript also contains some figural illumination in the 'Classical' manner which ranks as the most beautiful to survive from Germany in this version of Transitional. The best 'neo-Romanesque' however is in the Missal (New York, Pierpont Morgan Library, MS. 710; I, no. 275) made for Berthold, abbot of Weingarten, in Swabia, 1200–1235. Throughout its miniatures Romanesque conventions of drapery are employed, but nobody can fail to be impressed by the pronounced roundness of the shapes thus clothed. Indeed it exceeds that in the Ingeborg Psalter, and the Westminster Psalter must be brought into comparison in order to evaluate properly the Berthold Master's feeling for form. We see then how extremely interested he was in curves and how well he gives effect to them by drapery techniques already old-fashioned by the standard of the Ingeborg and Westminster Psalters. The faces of his figures are Byzantinesque rather than 'Classical', but the Master has evolved his own variation on the Byzantinesque type. His has a firmness and strength of expression which contrasts with the emotionalism of the source. There is a very considerable dynamism in the Berthold Missal and a desire

for dramatic presentation, which is as obvious in the depiction of the confrontation of Zacharias and the Angel Gabriel as in that of the Adoration and Journeyings of the Magi, with its different views of them on horseback. Always the Berthold Master seeks to 'humanize' his representations and his success at this, as much as anything, places him amongst the foremost Transitional painters.

The most important legacy of Transitional to the visual arts was the ridged drapery style. We once described the Ingeborg Psalter as 'that great "first Gothic" manuscript'. This was before we had become so aware of the independence of Transitional *vis-à-vis* both Romanesque and Gothic. In the present essay we have slanted our remarks towards discerning development from Romanesque, but distinction from Gothic is of no less, if not more, eventual importance. A great mistake in art history has been the attempt to commence the Gothic period too early. This has led to some strange contortions, from which admission of the reality of the Transitional style will save us. It will also make possible the much needed definition of Gothic's true characteristics. We therefore qualify our dictum on the Ingeborg Psalter and will call it now 'that great harbinger of Gothic'. Of the different versions of Transitional its humanized mannerism was the experiment most in tune with the spirit of the time and the one which most seems to point the way towards Gothic. The Transitional period was not ready for a general renaissance of Classical aims and qualities, whilst 'neo-Romanesque' was ultimately sterile. However, our period was one when the so far prevalent traditions of mediaeval art had become exhausted and in looking for fresh modes of expression artists permitted the disciplines of their craft to be decisively loosened. The psychological climate in which they lived meant that what most appealed to them was still an attempt to idealize according to canons rather than to represent nature freely, and in due course the Early Gothic period saw a tightening again of disciplines. Nevertheless, the effect of the loosening that had taken place cannot be overestimated. The road leading to the Northern Renaissance in painting begins in the years around 1200.

163. *London, British Museum. Harley Roll Y. 6, detail of the Guthlac Roll. England, about 1196*

This vellum roll, made at or for Crowland Abbey, near Peterborough, contains eighteen outline drawings in roundels illustrating the life of St. Guthlac. In 699 Guthlac became an anchorite on the island of Crowland, in the Lincolnshire marshes. The roundel reproduced here depicts him being conveyed to Crowland in a fishing boat. The drawings, with their heavy, firm, continuous contours and sparing use of color, suggest designs for stained glass or, possibly, enamels.

164. *London, British Museum. Harley Ms. 4751, fol. 6 verso, detail from a bestiary, the hunting of the unicorn. England, about 1200*

Bestiaries are important sources for animal subjects. This roundel shows the trend toward a naturalistic approach and an exactness of observation.

165. *Paris, Bibliothèque Nationale, Ms. lat. 16730, fol. 66 verso, detail from a Flavius Josephus, initial D, David and Bathsheba. France, about 1185*
166. *Winchester, Cathedral Library. Detail from the Winchester Bible, fol. 131 recto, initial U to Isaiah, the prophet and the Almighty. Winchester, about 1195–1200*

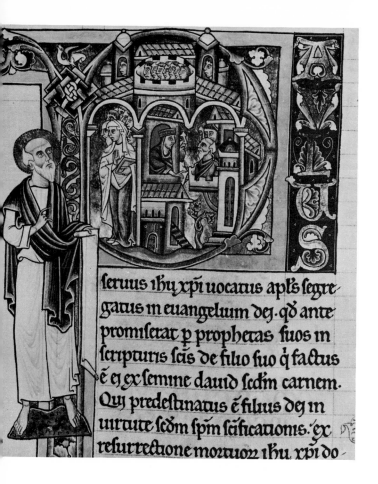

167. *Paris, Bibliothèque Ste.-Geneviève. Ms. 10, fol. 247 verso, detail from the Manerius Bible, initial P with St. Paul. Paris(?), about 1190*

168. *Munich, Bayerische Staatsbibliothek. Clm. 835, fol. 150 recto, detail from the Munich Psalter, initial C. England, before 1222*

These illustrations show four types of initials. The body of the letter C (ill. 168) is totally filled with a pattern composed of spiraling plant tendrils interlaced with petals, typical of northern French and English book illumination around 1200. The initial U (ill. 166) is the work of the Master of the Gothic Majesty, the last hand in the great Bible. It shows the mood of a new classical revival, since a new Byzantine impulse had exerted its influence. The older generation is well represented by the initial D (ill. 165), still in a pure Romanesque mood. The initial P in the Manerius Bible (ill. 167; see also ills. 169–171) is, however, a bit more advanced stylistically.

| CANON | PO | MO | IIII | CANON | PO | MO | IIII |
MATHS	MARC	LYCAS	IOHS	MATHS	MARC	LYCAS	IOHS
viii	ii	vii	x	cclxxiii	clxv	cclxvi	lxiii
xi	iiii	x	vi	cclxxiiii	clxv	cclxvi	lxv
xi	iiii	x	xii	cclxxiiii	clxv	cclxvi	lxvii
xi	iiii	x	xiii	cclxxix	clxx	cclxxv	cxxvi
xi	iiii	x	xxviii	ccxci	clxxii	cclxxix	clvi
xiiii	v	xiii	xv	ccxciii	clxxv	cclxxxi	clxi
xxiii	xxvii	xvii	xlvi	ccxcv	clxxvi	cclxxxii	lvii

169, 170, 171. *Paris, Bibliothèque Ste.-Geneviève. Ms. 10, fols. 127 verso and 128 recto, details from the Manerius Bible, tympana of the canon tables: miracles of Christ, Balaam and the angel*

The so-called Manerius Bible was written, according to the colophon, by "Manerius scriptor cantuariensis." This documents the connection with Canterbury, though the style does not seem to tie up with the Canterbury style as seen in the Paris Psalter (I, no. 257). The illustrations include historiated (ill. 167) and decorative initials. The tympana of the canon tables show remarkably accomplished scenes, in which a new naturalism had begun to supersede Romanesque conventions.

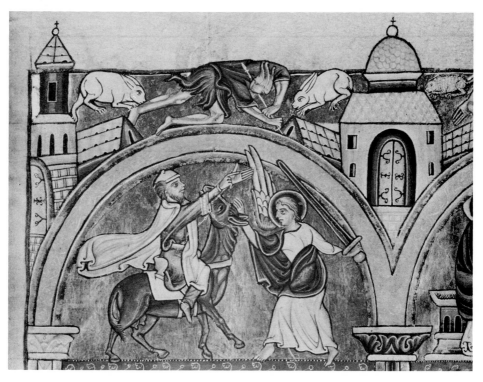

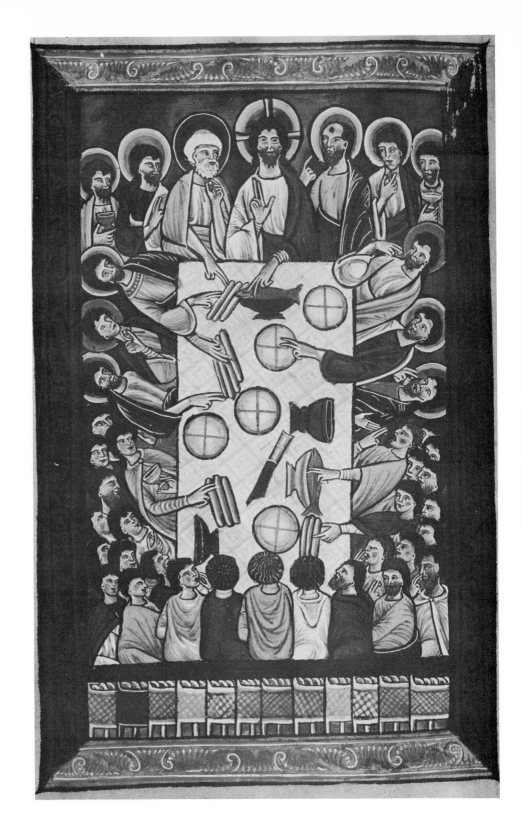

172. *Page from the Munich Psalter, fol. 66 verso, the feeding of the Five Thousand*

173. *Page from the Munich Psalter, fol. 13 recto, Jacob's vision of the heavenly ladder, Jacob wrestling with the angel*

174. *Page from the Munich Psalter, fol. 17 verso, Moses's birth, Moses kills an Egyptian and buries him*

According to liturgical evidence, the so-called Munich Psalter was written and illuminated in England before 1222. The manuscript possesses the extraordinary number of eighty full-page illustrations.

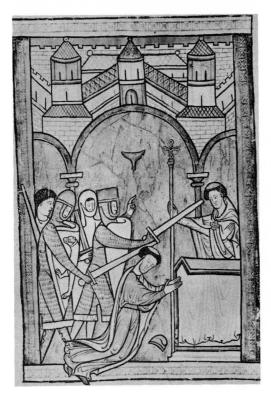

175. *London, British Museum. Harley Ms. 5102, fol. 32 recto, martyrdom of St. Thomas Becket. England, about 1200*

This is perhaps the earliest surviving representation of the murder of the archbishop. A somewhat wooden treatment characterizes this illumination, "for it is the work of a dull artist without any model before him" (T. S. R. Boase). (See also ill. 153).

176. *London, British Museum. Yates Thompson Ms. 26 (formerly Add. Ms. 39943), fol. 42 verso, detail of the life of St. Cuthbert: Cuthbert, by admonishment, persuades birds to leave off feeding on his barley. Durham, about 1190*

In these miniatures, a new sense of volume is clearly apparent. The monumental simplicity "irresistibly recalls the work of Giotto" (T. S. R. Boase). The figures were carefully placed within a defined and localized space even though the artist still employed the old trick of giving depth to his scene by inserting as background a panel of a different color, in most instances lighter.

177. *London, British Museum. Royal Ms. 2 A. XXII, fol. 14 recto, page from the Westminster Psalter, seated Christ. England, about 1200*

The pictures in the Westminster Psalter (see also ills. 178, 179) are very close in style and feeling to the work of the Master of the Gothic Majesty of the Winchester Bible (ill. 166). "The style of the Westminster miniature is magnificent in the firmness and clarity of the drawing and in the richness of the gold and colors. Against a burnished gold ground within a framed mandorla Christ is seated frontally on a red and green rainbow, his feet resting on a similar smaller one. He is clothed in a deep blue tunic having a red embroidered neck band and powdered with groups of tiny white dots. His mantle is pale tan shaded with deeper tones of the same. The border of the miniature is in blue monochrome. The flesh of the face, hands, and feet of Christ is modelled on a yellowish ground with shadows in brown or green; his hair and beard are reddish brown" (Margaret Rickert).

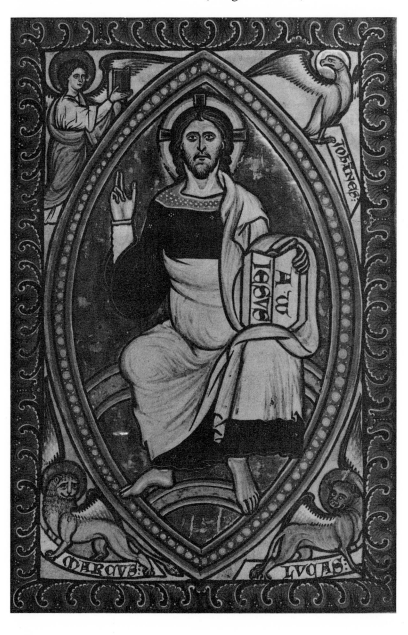

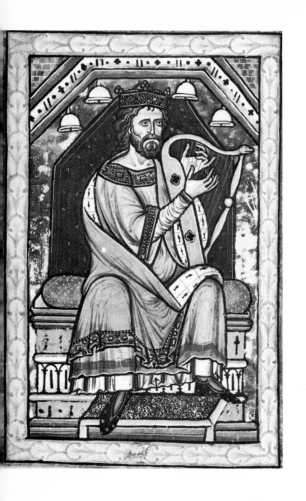 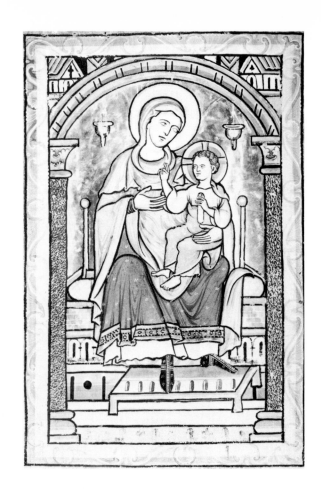

178. *Page from the Westminster Psalter, fol. 14 verso, King David*
179. *Page from the Westminster Psalter, fol. 13 verso, seated Virgin with Child*
180. *Paris, Bibliothèque Nationale. Ms. lat. 16745, fol. 127 recto, seated Christ. France, about 1180*
181. *Tours, Bibliothèque Municipale. Ms. 193, fol. 69 verso, page from a missal, seated Christ. France, 1183*

These four illuminations show further solutions to the problem of how to represent the seated figure and the related problem of how to treat the drapery (see ills. 63–67).

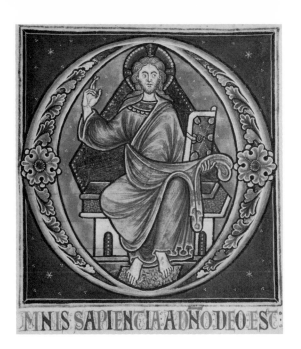

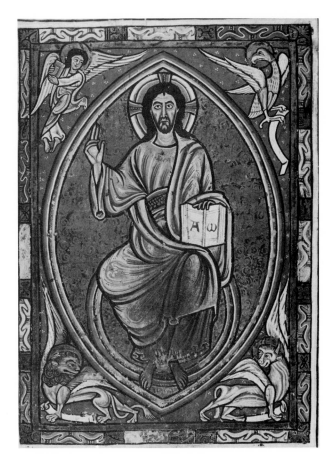

182, 183, 184. *Three 19th-century drawings after the* Hortus Deliciarum, *the creation of Eve, the sacrifice of Isaac, the annunciation to the shepherds. Alsace, about 1185–1190*

The *Hortus Deliciarum* was written and illustrated in the Alsatian abbey of Hohenburg during the abbacy of Herrade of Landsberg. The codex was destroyed in the Strasbourg fire of 1870, but fortunately several complete sets of copies of its illustrations had been made earlier in the century. Even these copies reveal something of the original's greatness, illustrating the Byzantine impact in the upper Rhine region (see also the page of a model book from Freiburg, ill. 236). To the same upper Rhenish center can be assigned a rotulus on vellum in the British Museum. Another related manuscript is the Gospel book formerly in Speyer Cathedral (see ill. 204).

185. *Reims, Bibliothèque Municipale. Ms. 672, fol. 1 recto, page from the so-called False Decretals, the harmony of the spheres. Reims, about 1180*

On this page are depicted the following: Air (AER) controlling the winds; Arion on the dolphin (representing literature); Pythagoras (representing science); Orpheus (representing music); in medallions the nine muses (after Martianus Capella).

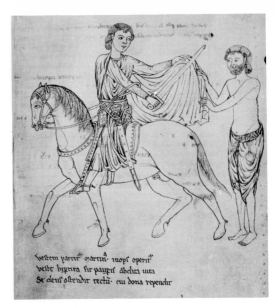

186, 187. *London, British Museum. Add. Ms. 15219, fols. 11 verso and 12 recto, Martin and his companions out hawking and Martin dividing his cloak. Tournai, about 1200*

For the art-historical importance of these outline drawings see the discussion of ills. 136, 137.

188, 189. *Cambridge, University Library. Ms. Kk.4.25, fols. 44 verso and 45 recto, details from a bestiary, the angel healing the blind Tobit, the Annunciation to the Virgin, St. Albans(?), about 1210–1220*

The Cambridge drawings, in a shaded-line technique with colored washes applied over parts of the figures, show an intermediate step toward the work in a similar style that is associated with the mid-thirteenth-century artist Matthew Paris.

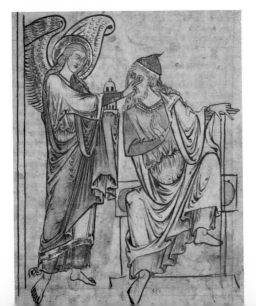

190. *Chantilly, Museé Condé. Ms. 1695, fol. 37 verso, Beatus initial from the Ingeborg Psalter. Ile-de-France, about 1195*

The Ingeborg Psalter contains an introductory picture cycle painted by two hands. The older master, who was responsible for the Beatus initial, was reluctant to adopt the new style that the younger master used so successfully in the well-known Pentecost page, the Crucifixion, and the Deposition. They both, however, were deeply influenced by Byzantine iconography and facial types. The monumental figures, in their classical serenity and certainty and their wide sweep of movement, were to be stylistically paralleled in the sculptures of the south porch of Chartres (ills. 4, 6) and in the Church and Synagogue in Strasbourg (ill. 57).

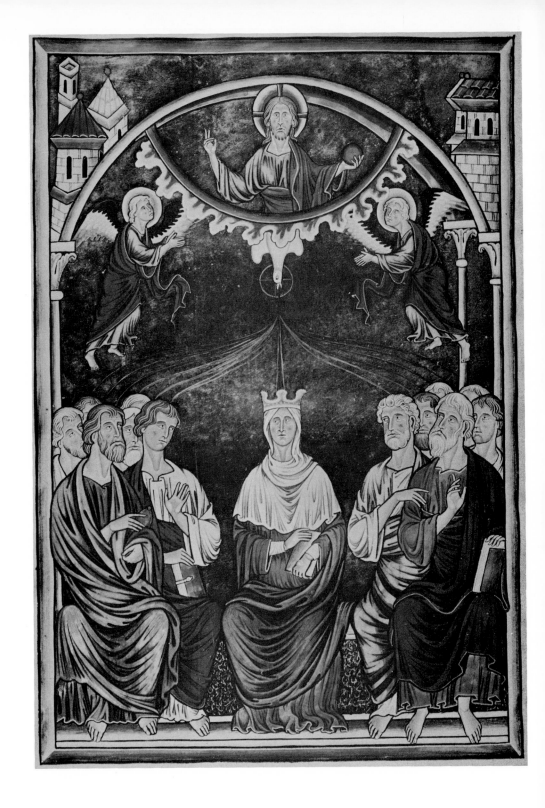

191. *Detail from the Ingeborg Psalter, fol. 32 verso, Pentecost*

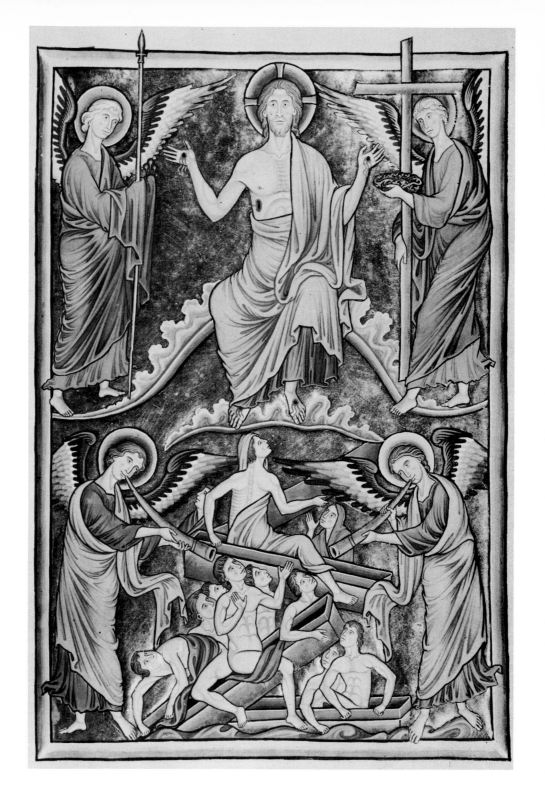

192. *Detail from the Ingeborg Psalter, fol. 33 recto, the Last Judgment*

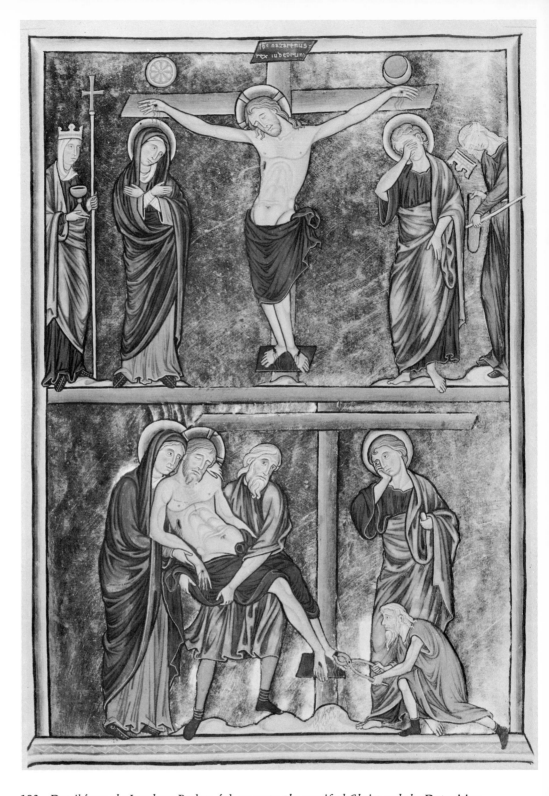

193. *Detail from the Ingeborg Psalter, fol. 27 recto, the crucified Christ and the Deposition*

194–201. *Decorated initials from the Ingeborg Psalter, fols. 151 verso, 121 recto, 81 verso, 133 verso, 123 verso, 110 verso, 159 verso, 40 verso*

These previously unpublished decorative initials from the Ingeborg Psalter portray the wealth of abstract foliate patterning used not only in book illuminations, but also in architectural bosses (see ills. 31–34) and metalwork.

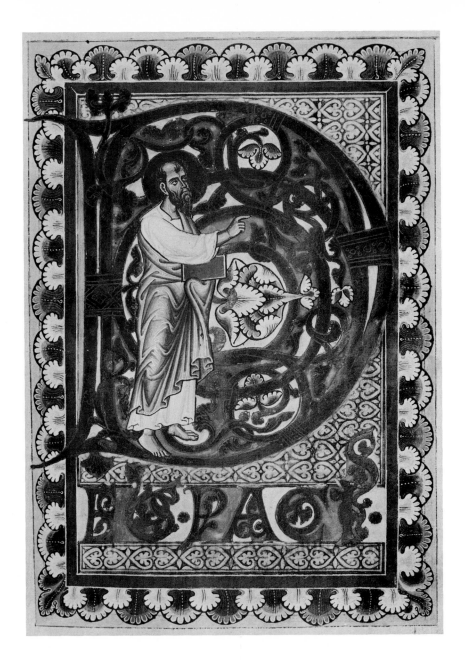

202. *Munich, Bayerische Staatsbibliothek. Clm. 15902, fol. 8 recto, page from the collectar from the nunnery of St. Ehrentrud on the Nonnberg, initial D with St. Paul. Salzburg, about 1200*

For a discussion of this manuscript, see pp. 133–134.

203. *Munich, Bayerische Staatsbibliothek. Cod. lat. 935, fol. 26 verso, page from the so-called Prayer Book of St. Hildegard, miracle of Christ. Germany, about 1180–1190*

This page shows Christ healing the hunchbacked woman (for similar scenes, see ills. 169, 170). The style stands midway between the Romanesque and the first Gothic wave in Germany.

204. *Karlsruhe, Landesbibliothek. Cod. Bruchsal 1, fol. 13 recto, page from the Gospel book from Speyer, the dream of the Magi and their voyage. Germany, about 1210*

The story of the three kings, part of a larger narrative cycle, is artistically conveyed more through graphic than through painterly means. This predilection for line as a descriptive medium is typical of the Germanic approach to pictorial art. It later reached a climax in such illuminations as those reproduced as ills. 207–209.

205. *Munich, Bayerische Staatsbibliothek. Cod. lat. 17401, fol. 25 recto, page from Conrad von Scheyern's* Liber matutinalis, *seated Virgin with Child, model of a church, and the donor Abbot Conrad. Germany, about 1210–1225*

This drawing is characteristic of German book illumination in the early 13th century. The use of angular, sharp folds for the Virgin's draperies is typically Germanic.

206. *Hanover, Kestner Museum. Single illuminated leaf showing Alexander the Great fighting with Darius III of Persia and Porus V of India. Rhineland, about 1200*

207. *Munich, Bayerische Staatsbibliothek. Clm. 4660, fol. 89 recto, detail of the* Carmina Burana, *the "Potatores", or wine drinkers. Benediktbeuren Abbey, about 1220–1225*

208. *Detail from the* Carmina Burana, *fol. 91 verso, the chess players*

209. *Page from the* Carmina Burana, *fol. 64 verso, the woods with animals*

The *Carmina Burana,* a collection of secular songs, was put together about 1200. Some of the texts are political and anticlerical, while others deal with the power of love and money, and the evils of drinking and gaming ("Amatoria", "Potatoria", "Lusoria"). The famous page reproduced as ill. 209 accompanies a poem depicting the delights and beauties of nature in summertime. Secular iconography frequently treated ancient history. Alexander's deeds were illustrated throughout the late Middle Ages. The Hanover leaf, in which the famous conqueror of Persia and India who belonged to the "Nine Heroes" group is exalted, is an early example.

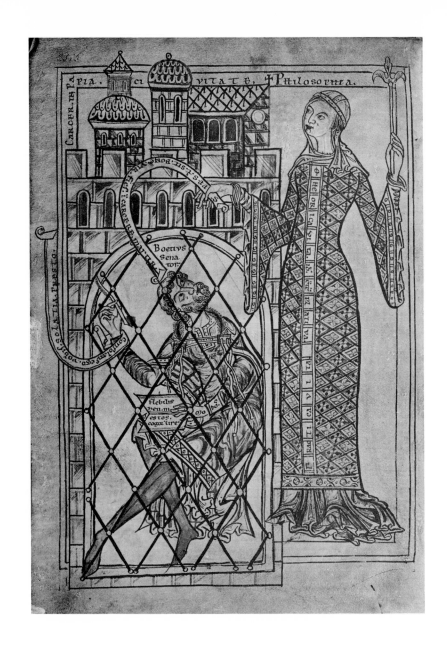

210. *Munich, Bayerische Staatsbibliothek. Cod. lat. 2599, fol. 106 verso, detail of a manuscript from Aldersbach Abbey,* Philosophia *comforting Boethius Senator. Germany, about 1200*

The technique here is a combination of outline drawing with thin colored washes.

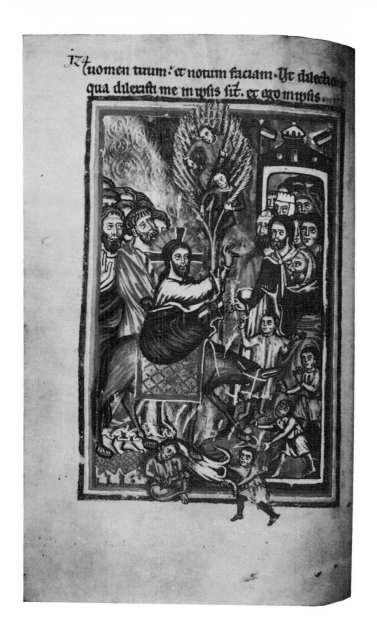

211. *Brussels, Bibliothèque Royale. Ms. 9222, fol. 24 recto, page from the Gospel book* **from the** *Benedictine Abbey of Gross-St.-Martin in Cologne, the entry into Jerusalem. Cologne,* **about** *1210–1220*

The thorn puller *(spinarius)*, an antique subject that survives in the seated figure on the lower frame of this illumination, deserves special mention. Arbitrarily substituted for one of the children who greet Christ, he provides an element of genre. For another of the many instances of the survival of classical motifs, see ill. 121.

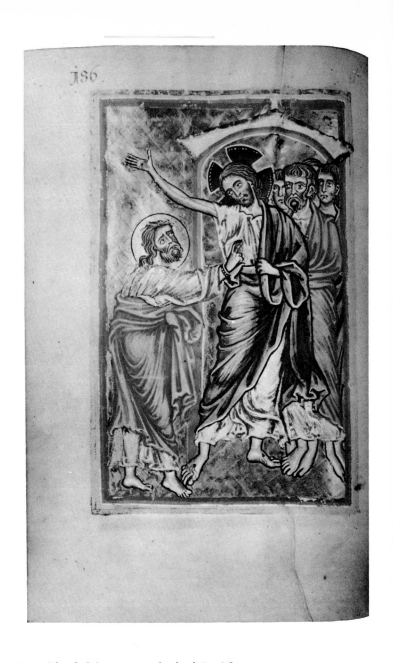

212. *Page from the Cologne Gospel book, fol. 98 verso, the doubting Thomas*

The style of the Cologne Gospel book shows the local tradition in the early 13th century. Compare this miniature with the earlier ones in the Ingeborg Psalter (ills. 190–193).

Francis Wormald

THE MONASTIC LIBRARY

ALTHOUGH THE MONASTIC libraries of the Middle Ages were of out-standing importance for the preservation of ancient and medieval learning, the years between 1180 and 1220 are not of special significance and cannot be compared with the ninth century, when they had been virtually the sole centers of learning. Nevertheless, during our period books were still being copied in monastic houses and the expansion of their holdings increased, even if the initiative of scholarship had passed from them and was now to be found in the secular schools and the rising universities of France, Italy, and England. In connection with this it must be remembered that the monasteries were not founded in the first place as centers of scholarship and that the *Opus Dei,* the Divine Office, was not primarily concerned with learning, though without it altogether monastic life could not have survived. During the twelfth century the services performed in the abbey churches had increased in length and complexity so that there became less time for manual work, of which the copying of manuscripts was a part, and probably equally less time for study. As will be seen, the main contribution to intellectual life at this time was the acquisition and preservation of books rather than their composition.

Anyone who imagines that a monastic library of about 1200 in any way resembled those glorious rooms which are still to be seen in Austrian and German abbeys, with magnificent furnishings and towering shelves of books, is greatly mistaken. In the first place the collections even in the biggest houses numbered only a few hundred volumes and many libraries contained far less. There was, therefore, no need for rooms to be set apart for reading and study, and the libraries seem to have been for the most part kept in cupboards or presses which stood in the walks of the cloister, usually on the side nearest the great church, which was sheltered and often faced to the south. It is possible that in some monasteries there were small storerooms leading off the cloister, but they can never have been used as studies. The provision of separate rooms set apart for the library does not begin until the beginning of the fourteenth century and was not very usual before the fifteenth century.

In most monasteries books were to be found in two repositories: the abbey church and the cloister. Those kept in the church were the Service Books necessary for the saying of the Divine Office, such as Missals, Breviaries, Graduals, and Antiphonaries, and also such books as Legendaries and Homiliaries, where these had not been superseded by the Breviaries. They probably stood on the desks before the seats of the community, or, when they were for the use of the singers, on great lecterns in the middle of the choir. Precious volumes with covers of jewels and metalwork were kept in the treasuries with the sacred vessels and the reliquaries. They were brought out only on the great festivals, and for special occasions and processions. Normally they cannot have been very accessible to the ordinary members of the community. This may account for their fine state of preservation and for the fact that many of them do not possess pressmarks, though they may contain some mention of their donor. Occasionally there are references to books kept in the refectory and the infirmary, but neither of these can be thought of as permanent libraries.

Both in the Rule of St. Benedict (sixth century) and in other later monastic customs there are directions setting out how books should be read in the monastery. The Constitutions of Archbishop Lanfranc—composed before 1089—provide a good account of the arrangements for the giving out of the books to the brethren on Monday after the first Sunday in Lent: "Before the brethren go in to chapter, the librarian should have all the books save those given out for reading the previous year collected on a carpet in the chapter-house; last year's books should be carried in by those who have had them and the librarian must warn them that this is to be done, in chapter on the previous day . . . the librarian shall then read out the list of the books which the brethren had in the previous year. When each hears his name read out he shall return the book which was given him to read, and anyone who has not read in full the book he received shall confess his fault prostrate and ask for pardon. Then the aforesaid librarian shall give to each of the brethren another book to read, and when the books have been distributed in order he shall at the same chapter write a list of the books and those who have received them." Similar directions are to be found in most monastic ordinals for men and women alike. It is improbable that the reading in monasteries was solely confined to the books solemnly given out in the way just described. This was the minimal requirement and those who had time and inclination could have access to other books. It must always be remembered that reading was not an easy matter in the Middle Ages and was often a slow business, for private reading was mumbled in a low voice.

Unlike modern books, which are confined to a single author or subject, the me-

dieval book might contain works of quite miscellaneous subjects and by various authors all in one pair of covers. Cataloging also was extremely elementary and at this time often took the form of a book list written into one of the manuscripts in the library. Occasionally the lists are found written into the chartularies where a record was kept of all the title deeds of the properties of the house. Thus the books of the great abbey of Reading in England are listed in the chartulary and the earliest list of the Rochester library is to be found in the *Textus Roffensis,* a collection of legal and documentary material compiled in the abbey of Rochester, England, between 1115 and 1124. A second Rochester list, made De 1202, is found written on a few leaves in one of the library books.

The arrangement of the books was rather rough, though at times some semblance of order was followed. The list of the collection often begins with the word "Bibliotheca," which does not mean the library, but the Bible. An entry such as "Bibliotheca in duobus voluminibus" probably refers to one of those large Bibles which still may be found in libraries with collections of their ancient books. In England one thinks of Durham Cathedral, which still has the Bibles of William of Saint Calais, 1081–1096, and Hugh du Puiset, 1153–1195, both early bishops. The French, Italian, and Spanish abbeys also possessed them; the León Bible of 960 and its later companion of 1162 being other examples.

All monastic libraries very naturally had a strong theological, or rather patristic, basis. After the Bible and the glossed copies of individual books and groups of books of the Bible by far the largest section was likely to be devoted to patristic theology. During the course of the twelfth century innumerable copies of the works of St. Augustine, St. Gregory, St. Ambrose, and St. Jerome were produced in finely written large folio copies, very elegant and often provided with beautifully illuminated initial letters. Manuscripts of this kind are to be found coming from monasteries as far apart as southern Italy and northern Germany. The production of such volumes in such quantities was undoubtedly inspired by the great revival of monastic life in the eleventh century and the growth of the new orders in the twelfth century. Stately volumes of patristic and other texts were still being produced at the end of the twelfth century, the glossed books of Scripture being particularly striking with their main text written in the beautiful Romanesque hand, of Caroline derivation, by this time rather pointed but still impressive, and with the small hand in which the glosses are written showing certain new, rather rounded features, which become marked in the thirteenth century.

Apart from the patristic and theological sections the library was almost certain to have some of the old standard books which had survived the course of centuries. Foremost among these were the works of Boethius, particularly the *De Consola-*

tione Philosophiae and, almost equally important, his translation of the *Categories* and the *De Interpretatione* of Aristotle. For Grammar Priscian provided the handbook, and the *Etymologies* of Isidore, with Bede's *De Natura Rerum,* valuable sources of encyclopedic knowledge. There were also usually some medical texts.

During the course of the twelfth century as the result of the revival of learning a number of important works, particularly translations of scientific and philosophical works, found their way into the monastic library, but with few exceptions these were not multiplied in a great number of copies in the manner of the patristic texts. The chief exceptions were manifestations of the century's love of codification. They were the *Decretals* of Gratian covering the Canon Law, the *Historia Scholastica* (a Bible History), and the *Sentences* of Peter Lombard, which was the great theological handbook composed in the middle of the twelfth century. Innumerable copies of all three works must have been produced, for more and more they became essential tools of learning.

The writing of manuscripts had been an activity of the monasteries ever since the earliest times and schools of writing had been formed in them. During the twelfth century this continued and probably went on well into the thirteenth century, though the rise of the universities saw a decline, since the place of the monastic scriptorium was now mainly taken by professional scribes, working in connection with the stationers. In the twelfth century we hear already of professional scribes working side by side with the monastic ones. Thus Faritius, abbot of Abingdon, in England, at the beginning of the twelfth century, employed scribes besides those who were members of his own community. Whether these were clerics is not specified. The Abingdon monks appear to have written the liturgical books and the non-monastic scribes such works as St. Augustine's *City of God* and other necessary patristic texts, as well as many medical ones. In connection with the latter it must be recalled that Faritius was a noted physician.

There were, therefore, three main ways in which a monastic library could be built up: by writing the books in the house itself, using either monks or paid scribes; by gift; and by purchase. During our particular period of 1180–1220 it would seem that, though home production continued, particularly for Service Books, much came by way of the second and third alternatives. There is an important passage in the thirteenth-century Evesham Chronicle describing the benefactions of Thomas of Marleberge to that monastery, of which he was successively monk from about 1202, prior in 1218, and abbot in 1229, dying in 1236. Marleberge, before becoming a monk, had studied in Paris with Stephen Langton, and after had taught in the schools of Exeter and Oxford. He was, therefore, in touch with the latest intellectual movements. When he came to Evesham he brought

with him a number of books to swell the library. Naturally there were volumes of
Canon and Civil Law, his main subjects, some medicine, and several works of
Cicero as well as Lucan and Juvenal. There were also some theological *quaestiones*
and many writings on grammar. During his period as prior he refurbished the
monastery's collection of liturgical books and it is clear that he used outside scribes.
Among these books was a fine Psalter which was destined for the use of the priors.
Finally he made a number of purchases. Besides some glossed copies of bibli-
cal books he bought two nearly contemporary works. One was Innocent III's
Exposition of the Mass and another what may have been the second part of the
Corragationes Promethei of Alexander Nequam (1157–1217). From the list of
his benefactions it appears that Marleberge was chiefly interested in law, grammar,
and rhetoric; all related subjects, and ones which must have stood him in good
stead when he fought so valiantly in a lawsuit before the Papal Curia and there
defended his abbey against the claims of the bishop of Worcester.

It is important to take note of Marleberge's interests and gifts because it must
have been through such personal predilections that unusual texts as well as new
ones got into the collections. Marleberge was, as we have seen, a lawyer by train-
ing and this is reflected in what he brought with him to Evesham: Law, Rhetoric,
and Grammar. On the other hand someone else might bring quite another kind
of text. An early copy of Aristotle's *Metaphysics* got to St. Albans, while Ralph,
priest of Whitchurch, brought to Reading in the late twelfth century the *Bucolics*
and *Georgics* of Virgil, the *Odes,* the *Ars Poetica,* the *Satires* and *Epistles* of
Horace, and a Juvenal, thereby enriching the classical holdings of the house. This
was happening to all monastic libraries, though the nature of the gifts varied.

Although the monasteries at the end of the twelfth century were no longer in
the vanguard of intellectual enterprise there were two activities of literary produc-
tion which still bore good fruit and thereby retained some importance. The first
was the production of historical writings. Many of these were naturally concerned
with the doings of the house in which they were written. Thus the Chronicle of
Evesham, produced under Thomas de Marleberge, tells in great detail of the
struggles of his days. In some religious houses the production of historical writing
continued well after our period and some kind of a school of history survived. The
second and very useful activity was the production of "florilegia" or collections of
quotations from a wide series of writings, through which much valuable matter
was preserved. In their most elaborate form they turn into encyclopedias of the
kind seen in the *Liber Floridus* of Lambert of St.-Omer, made about 1120. At the
end of the century there was also produced that wonderful collection of miscella-
neous theology, the *Hortus Deliciarum* of Herrade of Landsberg. This love of col-

lecting was also the cause of the survival of that treasure house of medieval secular poetry, the *Carmina Burana.*

Throughout the Middle Ages, then, the monastic libraries were to function as the great preservers of literature. Though they may have remained rather exclusive, nevertheless many treasures were to be found on their shelves. About the year 1200 the monastic library was what it remained: a well from which much sustenance could be drawn.

Leonard E. Boyle, O.P.

THE EMERGENCE OF
GOTHIC HANDWRITING

THE YEAR 1200 marks the end of a period of some four hundred years during which the predominant script in Europe was the graceful and unambiguous book hand we now call *Caroline.* This had been introduced a little before 800, in the time of Charlemagne (hence the name), in order to put an end to the medley of scripts, most of them too contorted for easy private or public reading, that had developed out of the late Roman business cursive in the former provinces of the Roman Empire. Devised after some thirty years of experimentation, possibly at Charlemagne's instigation, the pleasant, controlled, and generally unabbreviated Caroline form of writing was in fact based directly on the legible, unligatured minuscule book hand (semiuncial) of the late Roman period (fourth to sixth centuries). By the year 900, this new hand had conquered most of continental Europe.

About 1050, however, the Caroline script began to undergo small but significant changes. For example, instead of employing the graceful curves and the sharply pointed finishing strokes of pure Caroline writing, scribes now developed a tendency to break and to stagger the strokes of a letter. Thus the top parts of *m* and *n,* which were straight in Caroline writing, took on a humped look; similarly, the ends of minim strokes (as in *i* or *m* or *n*) began to turn up lazily and to resemble the trunk of an elephant. These marked departures from standard Caroline practice first appeared in Normandy around 1050. Probably the shift from sharp finials to a broader, rather snub finishing stroke was due to the adoption in Normandy (and elsewhere, later on) of the obliquely cut pen, which scribes in England and Ireland had been using for their *insular* script. The Caroline

que sintilla que cum
greca consentiant uen
tate decerna · bfhkpxyz

*Caroline writing,
9th–10th centuries*

Ego qs amo arguo & casti-
go. Emulare g& penitenti
aage. Ecc sto · bdfhkpxyzz

*Caroline writing,
11th–12th centuries*

considenet · &tuncilla
naturiam quesupenip
sam est · In · bpghkxyz ·

*Anglo-Saxon insular
writing, 8th century*

All of the illustrations in this essay were drawn by Hs. Ed. Meyer and appear in his book *Die Schriftentwicklung* (Zurich, Graphis Press, 1958).

style of writing had been challenging the insular form in England from about 950, when Benedictine monks from Normandy were invited into southern England to promote monastic reform; in turn, the broad insular pen seems to have gained a foothold in Normandy in the next century. It was also in Normandy in the middle of the eleventh century that a further departure from the Caroline canon of writing was to be seen. Where Caroline insisted on letter separation in order to make reading (and reading in public in particular) less subject to hesitation or error, there began at that time the practice of joining certain letters and, indeed, making some letters (e.g. *pp, bb*) overlap to form a monogram.

These changes heralded the beginnings of that non-Caroline form of writing to which the humanists of the fifteenth century, despising it as barbarous when compared to Caroline, attached the label *Gothic*. However, the era of full-blown Gothic did not commence much before 1200. Caroline writing, but with the intimations of Gothic noted above, dominated the eleventh and twelfth centuries: the script continued to be clear and spacious, and abbreviations were kept to a minimum. Yet there were definite indications from 1150 onward that a growing demand for books, a widening readership, and the increasing use of the written document for business transactions were bringing about a general abandonment of the leisurely Caroline hand. The twelfth-century renaissance, a direct result of the quest for original sources and a scientific methodology begun during the Gregorian reform (1050–1100), saw a multiplication of schools, scholars, and treatises. After the publication of the two most influential syntheses of the twelfth century—the *Decretum* of Gratian for church law about 1140, and the *Sentences* of Peter Lombard for theology some fifteen years later—whole new classes of legal and theological literature come into being: glosses and commentaries, questions and repetitions, summae and distinctiones, and the like. In addition, the growing literacy of the clergy, a process hastened by educational decrees of the Third Lateran Council (1179), especially that which established chairs of grammar in every cathedral church, occasioned a demand outside of the schools for cheap, portable books of a none too professional nature; and it is significant that the first popular manuals of theology and law began to appear about 1200.

Given this growing market for writings, both academic and popular, it was only a matter of time before the generously spaced and uncluttered pages of a typical Caroline manuscript gave way to a more economical layout and to more parsimonious methods of writing. Further, the great upsurge of scholastic learning at Bologna, Paris, and Oxford had brought about the eclipse of monasteries as the chief centers of book production. Professional non-monastic *scriptores* were now emerging as a class; and what these scribes needed in order to meet the rising

demand for the written word was an expeditious and profitable yet legible method of writing as much as possible in the smallest possible area. In fact such a method lay readily to hand in the small, clear, and highly abbreviated style of writing that had developed out of the Caroline book hand in chanceries and business centers of the twelfth century. This neat, "cursive" hand enabled a lot of ground to be covered quickly with a freely flowing pen, and was ideal for recording or for preserving file copies (rolls, registers) of business transactions, state and legal affairs, and ecclesiastical correspondence; by 1200 it was an established form of writing, best seen in the earliest extant series of registers of papal letters (1198–1216: Innocent III), or in the earliest groups of English administrative documents from the same period (1199–1216: King John).

The influence of this cursive or documentary hand is clearly reflected in the changeover in literary productions about 1200 from the large, expansive Caroline

Caroline writing, late 12th century

hand to a minute and sometimes crabbed style of writing. The script now became smaller and more compressed than Caroline, and abbreviations began to abound, all in the interests of time, space, and increase of output. The disruption of the Caroline canon of writing, which had been threatening for some one hundred and fifty years, was complete.

In this new, Gothic script, the most significant and far-reaching departure from Caroline—the mark, indeed, of pure Gothic—was the phenomenon of combining or fusing the opposite curves of letters where these were found back to back. The breakdown of Caroline had begun with the introduction of the obliquely cut insular pen and with the overlapping of certain rounded letters; now, the better to save space, scribes began to fuse opposing curves where possible. Thus, when a letters such as *o* was preceded by a letter such as *p,* or was succeeded by a letter such

as *c,* the bow or curve of one letter was merged with the opposite bow or curve of the other (e.g. *po, oc; bc, bd, be, bg*). By 1220 this was a steady (and for dating purposes, invaluable) feature of the new book hand. Not every word, of course, provided a ready-made juxtaposition, back to back, of opposite curves, but a judicious use of abbreviations offered over a hundred combinations of bows and curves (thus the opposing curves of *o* and *e* in *omne* could be merged in the abbreviated form *o͞e*). The fashion became so popular, indeed, that scribes often imposed curves on uncurved letters, forcing them to merge with the curves of naturally curved letters. The wide use of the old "uncial" form of *d* (∂) as an alternative to the regular minuscule *d,* probably was due to the fact that the availability of two forms of *d* almost doubled the range of fusion of *d* with bowed letters.

This phenomenon of the "fusion of opposite curves" is at its most elegant in the *scriptura rotunda* of Italy (and especially of Bologna) from 1250 onward. In centers outside of Italy, however, there developed a form of compression that made the bows of letters more angular than round, so that the merging of curves in the Gothic of northern countries was more often than not a merging of angled bows.

In fully developed Gothic, whether curved or angled, letters follow one another with mathematical precision. Generally the writing tends to be heavy, but there is always a harmony of angle with angle and curve with curve; the almost invariable use of a Gothic *r* (a letter resembling the Arabic number 2) after the letter *o* instead of the straight Caroline *r,* is a good example of the preoccupation with symmetry, for the 2 form of *r,* with its pleasant curves, blends more agreeably than the plain *r* with the bows of *o,* as in *o2.* The use of the broad pen heightens the impression of weight and solidity, echoing to some extent the Gothic architecture of the period. A page written in the full, disciplined Gothic looks very much like a woven pattern or *textus,* suggesting the name *text hand* to some scholars. Capital letters, too, underwent a change because of the general use of the broad insular pen, and the shallow "rustic" capitals of the pure Caroline period gradually gave way in the late twelfth century to more rounded or squat forms. In Caroline writing, capital letters were chosen from some obsolete majuscule script, such as rustic or square or uncial, in order to set them off from the minuscule script used in the body of the text. After 1200, however, it became the fashion to turn capitals into larger versions of the letters of the text itself, and to single them out by a generous use of ornamental strokes. As a result, Gothic capitals are often so elaborate that they are more difficult to decipher than the sentences or names to which they are prefixed.

It is, then, to this solid if monotonous script that we owe the transmission to

coz. Idem profecto funt se-
meet nepotes. Meminif-
tis. credo. aghklqvvwxyzs

*Early Gothic, 13th
century. Note the feet of*
m *and* n, *the fusion of
curves* (de), *and the
Gothic* r *in the first line*

Magnus dominus et
laudabilis nimus: in ci
vitas. fh kklp qrrsvvrxx

*Angled Gothic,
15th century*

Gloria laudis resonet in oze
omniu Patri genitoqz proli
spiritui sancto pariter Resul
tet laude perhenni Labozi
bus dei vendunt nobis om

*Rotunda, printed type,
15th century. Note the
Gothic* r *and capitals*

oblationem seruitutis nostre: sz z
cũcte familie tue. Onesimus do
mine ut placatus accipias: dieslog
nros i tua pace disponas. atqz ab
eterna damnatiõe nos eripi: et in
electroz tuoz iubeas grege nume
rari. Per xpm dũm nrm Amen.

Textura, printed type, 15th century

Superis habeo gratiam
quorum maiestate sug
gerente mihi fauorum
opperfici· djksvwxyzi

Humanistic script: a return to Caroline, 15th century

Sic splendente domo, claris na-
talibus orta Scintillas, raraque
tuos virtu & ffghjkwxyz œæ?
RARAQUE TUOS VIR-
TUTE PARENTES ILLU
FGKHW JXMYDBNCIZ
1234567890

*Humanistic type,
about 1500*

our day of much of ancient and medieval literature. The great period of the script
was from 1250 to 1350, and it was the classic text hand of those years that the first
generations of printers adopted as their typeface in the second half of the fifteenth
century. By that time, however, Gothic had degenerated considerably, and was in
fact on its last legs. From 1400 onward, the new humanist learning, with Florence
as its focal point, had been arguing successfully for the revival of the *antiqua littera*
(Caroline) that had preceded the Gothic era.

By 1500, printers, too, were abandoning Gothic, with all its abbreviations and
ligatures. Today it is the modified Caroline minuscule promoted by the humanists
that we write and print. But Gothic is not forgotten. The vast riches of medieval
manuscripts and monuments, the script used in some book titles, not to speak of
display scripts of "Ye olde tea shoppe" variety, all serve to remind us vividly of the
Gothic turn that Caroline writing took around 1200.

Margaret Frazer

BYZANTINE ART AND THE WEST

BYZANTINE ART had a profound effect on the art of Western Europe in the twelfth and early thirteenth centuries. Even when Western artists developed a new indigenous style, late in the twelfth century, they continued to be fascinated by the character of Byzantine art and borrowed from it extensively. The richness of its fabric and the skill of its craftsmanship reflected the wealth and splendor of Byzantine palaces and churches in Constantinople. Western artists adopted Byzantine iconography for its majestic compositions, its emotional content, and its distinctive way of depicting Christian scenes. Furthermore, Byzantine art preserved, albeit in reduced form, the language of Hellenistic art, particularly its system of drapery folds that revealed the volume of the human body, and its varied repertory of postures and facial types.

Byzantine art had influenced Western art long before the twelfth century, but it was then that political events encouraged an unprecedented flow of Byzantine works into Western Europe. Increasing security at home allowed pilgrims and merchants to travel in great numbers to Constantinople and the Holy Land, bringing back relics—and reliquaries. The twelfth century saw the rise of ambitious rulers who wished to legitimize their power by association with, and sometimes preemption of, the Roman traditions of the Byzantine Empire. The Norman kings of Sicily, for example, donned Byzantine court costume and imported Byzantine artists to re-create for them an imperial environment. The Crusades brought thousands of Westerners across vast tracts of the Byzantine Empire to the Holy Land, and since the warriors' journey was seldom peaceable, the Byzantine emperors Alexius Comnenus (1081–1118), John Comnenus (1118–1143), and Manuel Comnenus (1143–1180) relied heavily on diplomacy, supplemented by lavish hospitality and rich gifts, to avert open conflict. The cupidity of the crusaders, aroused by the wealth of Constantinople and its court, was at last sated in 1204 when the armies of the Fourth Crusade captured the city and pillaged it mercilessly. Many of the Byzantine objects now in Western churches and museums are part of that booty.

The specific character of the influence of Byzantine art on Western art at the end of the twelfth and the beginning of the thirteenth century can be traced back to the second half of the eleventh century, when Desiderius, abbot of Monte Cassino in Italy, ordered numerous works from Constantinople to decorate his new basilica of St. Benedict. He also imported Byzantine artists to train local artists in Greek skills. He wanted to provide the Monte Cassinan artists with a strong basis from which they could gradually assume the responsibility for the abbey's decorative needs. A similar reliance on Byzantine resources appears in French, English, and Italian art of the first half of the twelfth century. The illuminator of the lectionary of the monastery of Cluny in Burgundy (Paris, Bibliothèque Nationale, Ms. lat. 2246) adopted the Byzantine manner of rendering drapery folds (christened "damp folds" by Wilhelm Koehler; see also Vatican, cod. lat. 12958). They are smooth, geometrically shaped surfaces of cloth, defined by slender, tubular folds, which cling to such prominent parts of the body as the thigh and calf, revealing and highlighting their shapes. The adoption of this drapery style caused a virtual revolution in English art. The two-dimensional, linear figures of earlier Anglo-Saxon art gave way in the Albani Psalter (Hildesheim, Godehardskirche) and in the Bury St. Edmunds Bible (Cambridge, Corpus Christi College, Ms. 2) to comparatively solid figures whose draperies reveal coherently the major portions of the body. From their Greek models, the artists adopted a greater variety of expressive facial types as well as certain details, like the long, thin Byzantine nose.

The first half of the twelfth century, therefore, saw a widespread acceptance of Byzantine style in the West. The exact quality of Byzantine influence in the second half of the twelfth and in the early thirteenth century is more difficult to define. On the scale of dependence, there were at one extreme the Norman kings of Sicily, who imported Byzantine artists to fill their new buildings with mosaics, while at the other there were the sculptors of the great French cathedrals and goldsmiths, such as Nicholas of Verdun, whose art grew out of earlier Byzantine-oriented Western art, but who also drew on other sources, such as Greek and Roman relief sculptures, in developing a totally new style. Most artists, of course, reacted to the ever increasing flow of Byzantine art into Western Europe to a degree varying between these two poles.

Roger II (1130–1154), William I (1154–1166), and William II (1166–1180) of Sicily imported groups of Greek artists to decorate their new churches and palaces. The development of Byzantine art over a period of some fifty years can be followed in their works. The mosaics at the cathedral of Cefalù and in

Palermo at the Palatine Chapel and the church of the Martorana, all of Roger's time, typify the style of the middle Comnenian period, in which a tightness of organization characterizes the placement of figures and patterns of draperies. The overall impression, however, is still not one of total abstraction. The style of William I's mosaics, which completed the cycles in the Palatine Chapel and in the apse at Cefalù, shows an increasing dependence on line for description of action and facial expression. Through an emphasis on patterned drapery and anatomical detail, the figures became schematized. Although the style of the decoration of the cathedral at Monreale for William II also depends heavily on line, the pattern of drapery and anatomy produce a different effect. The figures are animated by a nervous energy that spurs into action such figures as the Angel of the Expulsion (ill. 232) through the swirling draperies at thigh and hip.

Never before had such a large arena for the display of Byzantine monumental art been available in the West to Western artists. One would expect the influence of the mosaics to be extensive, and Sicilian art did in fact inspire such works as the architecture and probably the painted decoration of the Allerheiligenskapelle in Regensburg (about 1150–1160), the manuscript of *Hortus Deliciarum*, illustrated by Herrade, abbess of Hohenbourg in Alsace (1167–1195) (ills. 182–184), artists' sketches in German manuscripts in Freiburg im Breisgau (ill. 236) and Vienna (I, no. 279), and some manuscripts and frescoes in England. By an examination of the English works alone, one comes to realize, however, that the artists, especially toward the end of the twelfth century, approached their models selectively. Two of the earliest illustrations in the Winchester Psalter (London, British Museum, Cotton Ms. Nero C. iv, fols. 29, 30) may directly reflect Siculo-Byzantine models (ills. 233, 234). The figure of St. Paul on Malta in a fresco in St. Anselm's Chapel at Canterbury Cathedral closely resembles the figure of St. Paul in the scene of his conversion in the Palatine Chapel. The illuminations in the Winchester Bible (Winchester, Cathedral Library) and the early thirteenth-century frescoes of an English artist at Sigena in Spain (I, no. 238), however, combine details of specific Sicilian and English iconography; the whole is expressed in a classicizing style foreign to the Sicilian mosaics. This classicism may be due to independent developments in England and France, but since the Sigena master's style is so Byzantinesque, it is perhaps better to look to contemporary Byzantine art as a source.

Early in the thirteenth century in Constantinople, the style of Monreale (ills. 231ff.) and its later development in the frescoes at Lagoudera (ill. 247) and Kurbinovo were already passé. Byzantine art was undergoing its own classical

phase, which is well illustrated by the calm, statuesque, more softly modeled figures in a lectionary in Athens (National Library, Ms. 2645) and by the frescoes in the church of the Mother of God at Studenica in Yugoslavia (ill. 248). It was probably from similar Byzantine works, which came to the West after the conquest of Constantinople, that the Sigena master drew his inspiration.

A similar, if more emphatically local, use of Byzantine models characterizes the work of the artists of the Meuse valley. Abbot Wibald returned from Constantinople to his monastery at Stavelot in 1155 with two Byzantine staurotheks, or reliquaries of the true cross. He commissioned a local master, perhaps Godefroid de Huy, to incorporate them into a single reliquary (ill. 223). The artist adapted the standard Byzantine triptych form from his models and placed the two reliquaries in the central panel. Instead of portraying apostles or saints on the interior of the wings, as would have been appropriate in Byzantium, however, he executed a series of medallions with scenes of the discovery of the true cross in champlevé, the Western technique of enameling, rather than cloisonné, the Eastern type. In a later staurothek at Liège, perhaps also by Godefroid, the Byzantine iconography of two angels with instruments of the Crucifixion standing on either side of a cross was translated in a particularly Western fashion into high-relief sculpture. This mature approach to Byzantine and Sicilian art is also reflected in a leaf from an artist's notebook now in Freiburg im Breisgau (ill. 236). The page is divided into two registers: the upper depicts Christ talking to Zacchaeus in a style clearly derived from Monreale, while the lower represents two equestrian figures in Western fashion. The artist seems to have thought that both images might be equally intriguing additions to his art.

The work of Nicholas of Verdun, the most famous goldsmith of the Meuse valley at the end of the twelfth century, demonstrates an even more independent personality. The iconography and facial types of his enameled ambo of 1181, now an altar, in the monastery of Klosterneuburg in Austria retain elements reflecting the Byzantine influence on artistic production in the land where he received his training (ills. 100–104, 238). Yet the artist's dynamism, and especially his drapery style of multiple, deeply shadowed, thin, but sculptural, folds (see p. 35), do not stem from known Byzantine prototypes. The animated, linear style rather complements that of the contemporary mosaics at Monreale (compare ills. 237 and 238), while the drapery style derives from antique models, either by direct study or via early Christian or Carolingian intermediaries. A few years later Nicholas executed a series of prophets in the round for the gold, silver, and enamel shrine of the Three Kings in Cologne (ills. 112–115). These expressive, massive,

fully three-dimensional figures owe nothing to contemporary Byzantine art. They, with Nicholas's later Mary reliquary in Tournai (I, no. 100), stand at the threshold of the new Gothic, envisioned in contemporary monumental cathedral sculpture.

Nicholas's contemporaries and immediate successors in manuscript illumination and goldsmiths' work introduced fresh borrowings from Byzantine art into the newly emerging Gothic style. The illuminators of the Ingeborg Psalter (about 1195) in Ile-de-France used the type of draperies found in Nicholas's work and subsequent cathedral sculpture, but copied Byzantine iconography accurately for several scenes from the life of Christ (for example, the Deposition, ill. 193, the position of Christ in the Last Supper, ill. 240). The monumentality of their figures may be traced either to Byzantium or to Ile-de-France, for a certain parallelism did exist between the developments in Eastern and Western art.

We have seen that many Byzantine objects were brought to the West as loot from the Latin conquest. Some also were specifically commissioned from Greek ateliers in Constantinople by Latin patrons. The work of one such shop is represented by Gospel books now in Athens (National Library, Ms. 118) and Princeton (University Library, Codex Andreaskiti 753). At least one of the manuscripts of this workshop was brought to Saxony about 1230, where it was seen and copied by a German artist in his sketchbook, now in the library at Wolfenbüttel. The seated evangelists on fol. 91 recto (ill. 262) closely resemble the evangelists in the Athens Gospel. The character of other drawings in the sketchbook, as well as several related contemporary Saxon manuscripts, for example, the Gospels in the Goslar Rathaus, suggests that more than one Byzantine manuscript was brought to Germany at this time.

In a way paralleling its influence on Italian panel painting in the thirteenth century, which laid the foundation for the Renaissance style, Byzantine art in the twelfth century provided the West with important elements for the artistic vocabulary from which the Gothic style was born.

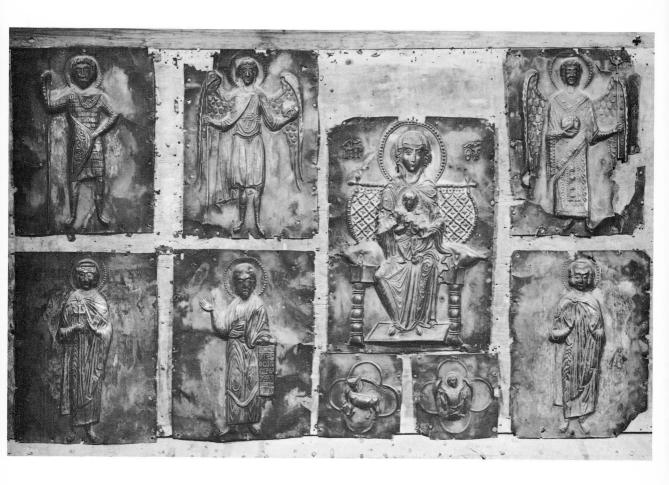

213. *Torcello, Museo Provinciale. Fragment of a silver repoussé pala. Venice, about 1200*

The fragment with the seated Virgin and Child, saints, angels, and the symbols of SS. Luke and Matthew is inspired in both its iconography (with the exception of the Evangelists' symbols) and its figural composition—in which single saints appear in rows—by a popular Byzantine representation of the litany of saints.

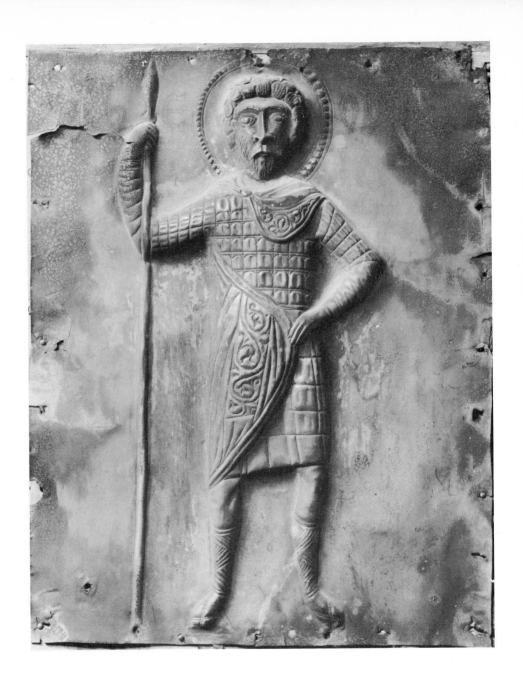

214. *Detail of the pala in Torcello, St. Theodore*

Both in the East and in the West, Theodore was a popular military saint. The portrayal of his hair in well-defined separate curls is typical of 12th-century Byzantine art.

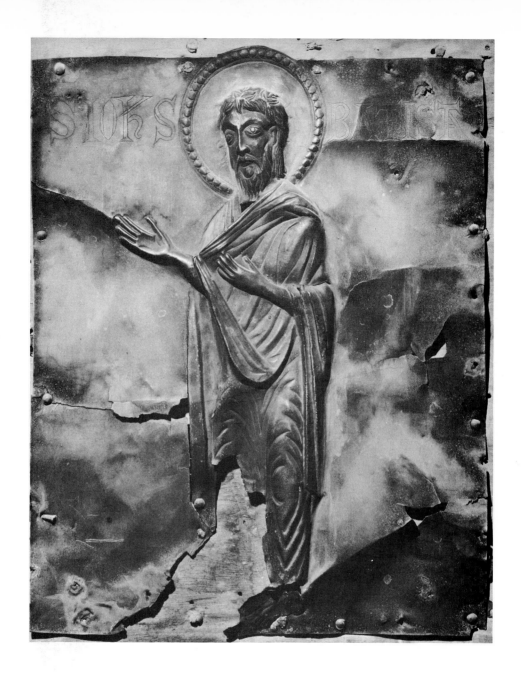

215. *Detail of the pala in Torcello, St. John the Baptist*

The portrayal of St. John in the Byzantine attitude of intercession indicates that this figure formed part of a Deesis, a typical Byzantine composition in which St. John and the Virgin stand on either side of Christ and intercede with him for the salvation of souls (see ill. 250).

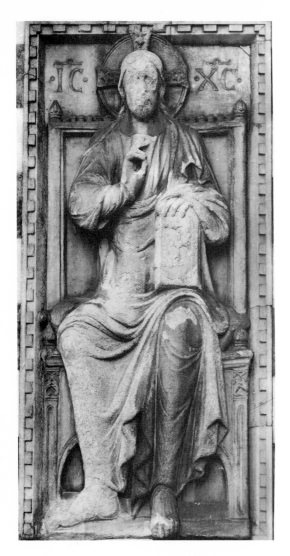

216. *Venice, church of San Marco. Marble relief walled into the west exterior of the north transept, Christ enthroned. Venice, about 1230*

This relief was part of a sculptured iconostasis, perhaps erected in San Marco after a fire in 1231. The elegant, slender figure of Christ closely resembles the enthroned Christ on the back of the grosso of the doge Enrico Dandolo (reigned 1192–1205). Both portrayals, rather mannered in their pose and drapery style, depend upon a local Venetian style that was well established by the end of the 12th century and that shows the influence of late Comnenian Byzantine art.

217. *Venice, church of San Marco. Marble relief walled into the west façade, St. Demetrius. Constantinople, early 13th century*

This relief was probably made for a Venetian patron during the Latin occupation of Constantinople, since it is carved in an accomplished Byzantine style but inscribed in Latin. In Venice it later served as a model for the marble relief of St. George that is today its counterpart on the façade.

218. *Cividale, Cathedral. Silver repoussé pala with Virgin enthroned, angels, and saints. Northern Italy, 1195–1204*

This pala, originally a paliotto, was donated to the cathedral by Patriarch Pellegrino. The iconography was inspired by a Byzantine prototype (compare the Virgin and Child group to similar groups in the apse at Monreale, ill. 230, and the tiers of saints to those on the ivory triptych in the Museo Cristiano in the Vatican), but the style of the figures and the concept of the paliotto stem from local artistic traditions.

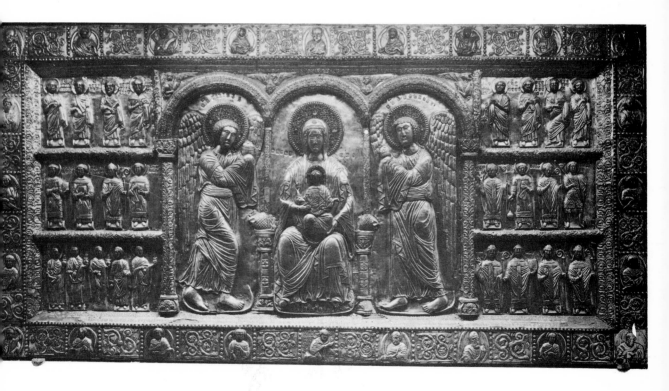

219. *London, Victoria and Albert Museum. Ivory plaque, St. John the Baptist and SS. Philip, Stephen, Andrew, and Thomas. Constantinople, around 1190*

This plaque has been dated in the 10th, 11th, and 12th centuries. The style of the draperies, especially the thin, flat folds drawn tightly across the body, and the precise, almost mannered depiction of the human body, however, bring to mind the mosaics at Monreale of about 1180–1190 (ills. 229–232, 237, 239). The plaque was probably carved in the same workshop as the ivory casket with saints in the Museo Nazionale in Florence.

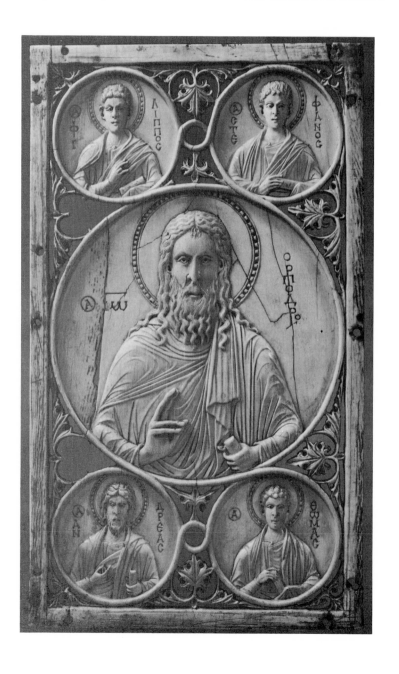

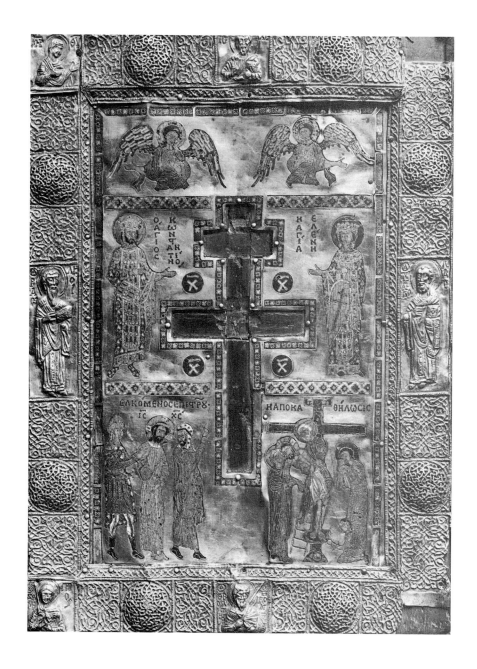

220. *Esztergom (Hungary), Cathedral Treasury. Gold, enamel, and jeweled reliquary of the true cross. Constantinople, second half of the 12th century (perhaps around 1190)*

This reliquary provides a splendid example of the geometricizing style of drapery in 12th-century Byzantine cloisonné enamels, which inspired such Italian cloisonné enamels as the well-known book cover from Capua and the cross from Cosenza (ill. 227).

221. *Limburg an der Lahn, Cathedral Treasury. Gold, enamel, and jeweled reliquary of the true cross, exterior, Deesis, angels, and apostles. Constantinople, 920–921 or 948–955, and 964–965*

The Limburg reliquary was made for the emperor Constantine VII Porphyrogenitus and the emperor Romanus and was completed by the proedros Basil after 963. Heinrich von Ülmen brought it to Stuben am der Mosel in 1207 after the Latin conquest of Constantinople. It provided an important iconographical model for the artist of the Mettlach reliquary (ills. 136, 137, 222), and part of its actual cross relic was used in a reliquary at St. Matthäus in Trier.

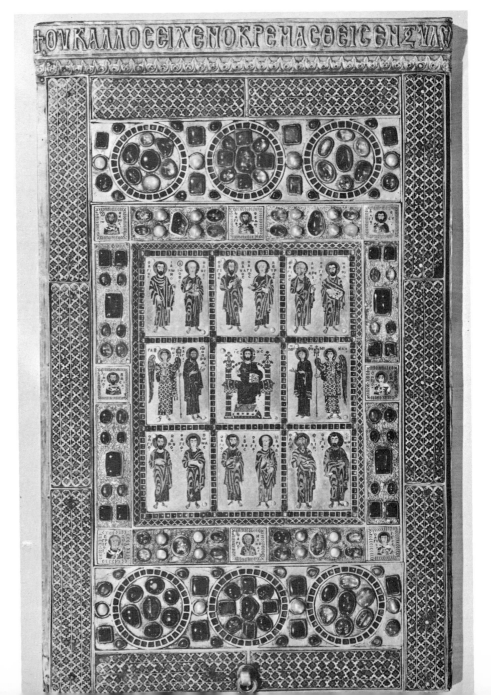

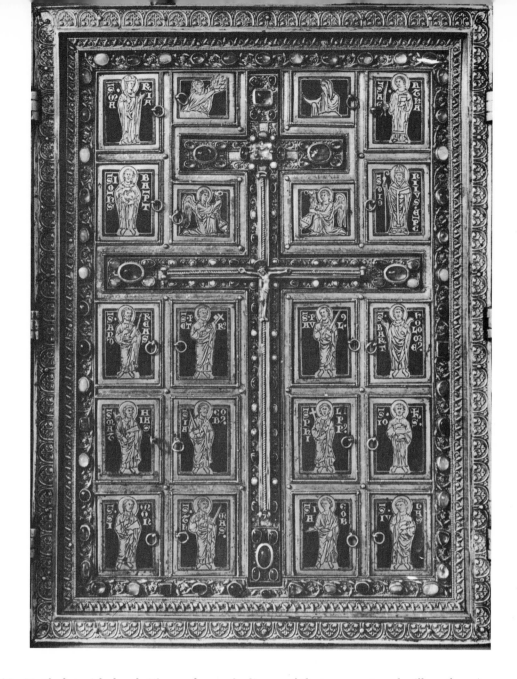

222. *Mettlach, parish church. Silver and enamel reliquary of the true cross (see also ills. 136, 137), interior, angels, saints, and apostles. Germany, about 1220–1230*

The iconography of this reliquary and the disposition of the figures in rectangular compartments were drawn directly from the Limburg staurothek (ill. 221). Notable, however, is the use of the new Western drapery folds and of Western iconographical features, for example, the instruments of martyrdom, instead of the scroll or book of the Byzantine prototype, being held by the apostles.

223. *New York, Pierpont Morgan Library. Gold, enamel, and jeweled reliquary of the true cross, called the Stavelot Triptych. Constantinople and the Meuse valley, about 1155*

224. *Cologne, Cathedral Treasury. Gold repoussé reliquary of the true cross, interior, angels censing the cross, Emperor Constantine and Empress Helena. Constantinople and Cologne, 11th century and around 1200*

The artists of these two staurotheks physically incorporated Byzantine reliquaries, in part or completely, in their work. The Stavelot triptych was made by order of Wibald, abbot of the monastery of Stavelot, with two Byzantine reliquaries he brought from Constantinople in 1155 (see p. 188). The reliquary in Cologne was made by a local artist, who used the cross and the figures of Constantine and Helena from a Byzantine reliquary.

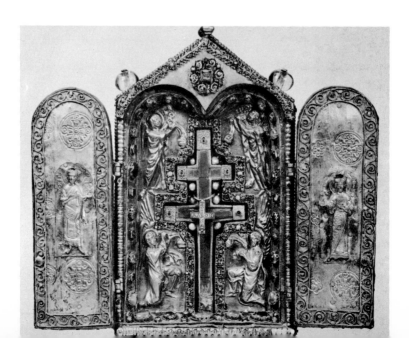

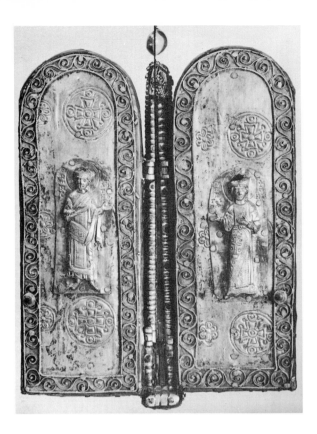 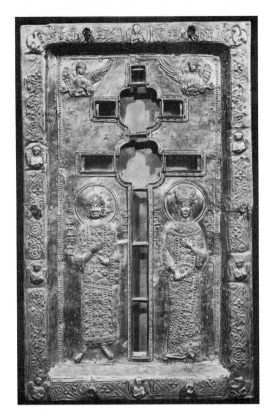

225. *Detail of the reliquary in Cologne, interior of the wings, Constantine and Helena*

The figures of Constantine and Helena were originally part of a Byzantine reliquary of the 11th century. The original arrangement of the cross and figures would probably have resembled that on the reliquary at Urbino (ill. 226).

226. *Urbino, Galleria Nazionale delle Marche. Silver repoussé reliquary of the true cross from the monastery of the archangel Michael at Murano, angels, cross, and Constantine and Helena. Byzantium, second half of the 12th century*

The decoration of this reliquary is typical of a large group of Byzantine stauroteks. The emperor Constantine and his mother, the empress Helena, who discovered the cross of Christ on a pilgrimage to Jerusalem, stand on either side of a double-armed cross, which held the fragment of the true cross. They are dressed in the richly jeweled imperial costume of the Constantinopolitan court. The frame of the reliquary is a later Italian addition.

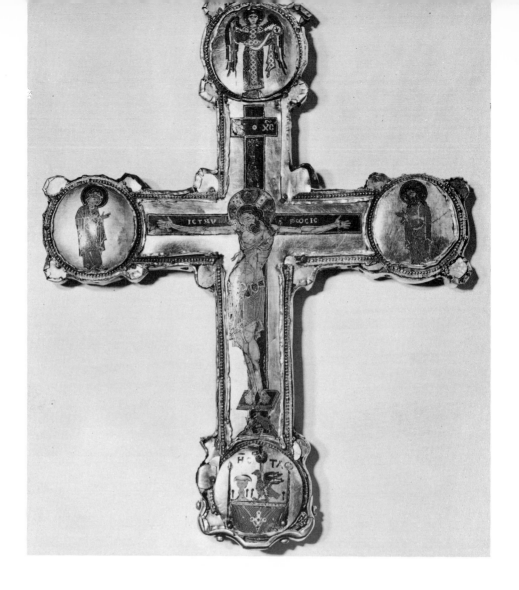

227. *Cosenza, Cathedral Treasury. Gold and enamel reliquary cross. Italy (Sicily?), late 12th century*

The cross is decorated on one side with the crucified Christ and medallions of the Virgin, St. John the Baptist, an archangel, and the prepared throne, or Hetoimasia, and on the other with Christ enthroned and medallions of the four seated Evangelists. For its expression of pathos, the slender, contorted body of Christ may be compared to the Christ of the Deposition fresco at Aquileia (ill. 244), another Italian work produced under strong Byzantine influence. The emphatic geometric patterning of the Cosenza Christ's draperies is a typical Italian exaggeration of the style of 12th-century Byzantine cloisonné enamels.

228. *Washington, D.C., Dumbarton Oaks Collection. Gold and enameled reliquary cross. Saloni-ka, about 1200*

Christ's pose and draperies on this reliquary are much calmer than those on the Cosenza cross (ill. 227). The loincloth, for example, is more naturalistically portrayed by cloisons that correspond to the vertical folds of the cloth. This cross may, therefore, be grouped with such works as the frescoes at Studenica of 1208–1209 (ill. 248) and the lectionary from Athens of the late 12th century (National Library, Ms. 2645).

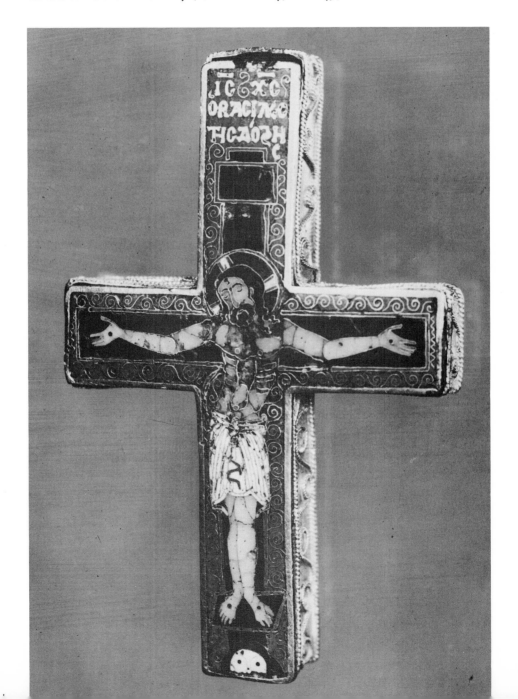

229. *Monreale, Cathedral. Mosaics on the west wall of the nave.* 1180–1190

An Old Testament narrative cycle extends around the interior of the nave in the top two registers, beginning in each register at the eastern end of the south wall and terminating at the eastern end of the north wall. The scenes from this cycle shown here are, above, the creation of Eve and the presentation of Eve to Adam, and, below, two angels visiting Lot and the destruction of Sodom. The central panel of the second register and the two in the lower register portray scenes from the life and martyrdom of SS. Cassius and Castus, both of whom were venerated locally.

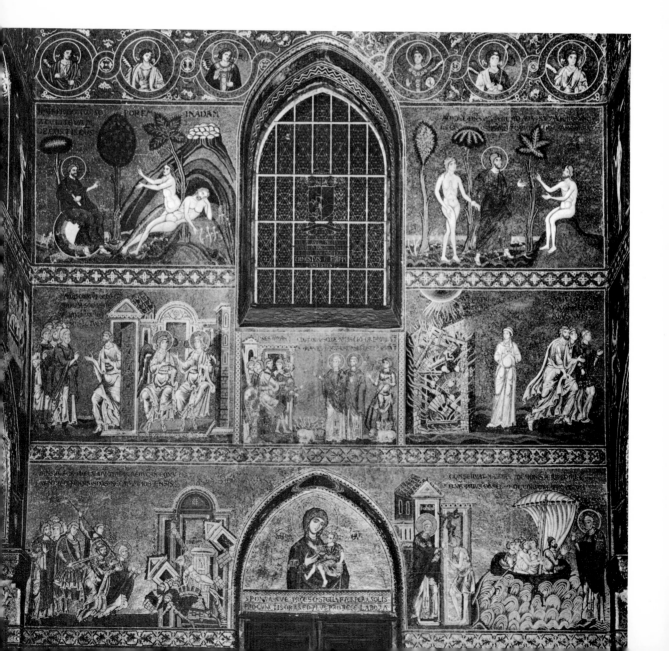

230. *Detail of the mosaics at Monreale, the apse*

The Byzantine mosaicists at Monreale adapted the scheme of decoration of centrally planned, domed, Greek churches to the Latin basilical plan. They placed the Pantocrator, normally in the dome in Byzantium, in the conch of the apse. Since the Virgin's normal place was thus preempted, she was moved to the second register to join the apostles. The third register, below them, was reserved for the bishops, saints, and martyrs popular in Sicily.

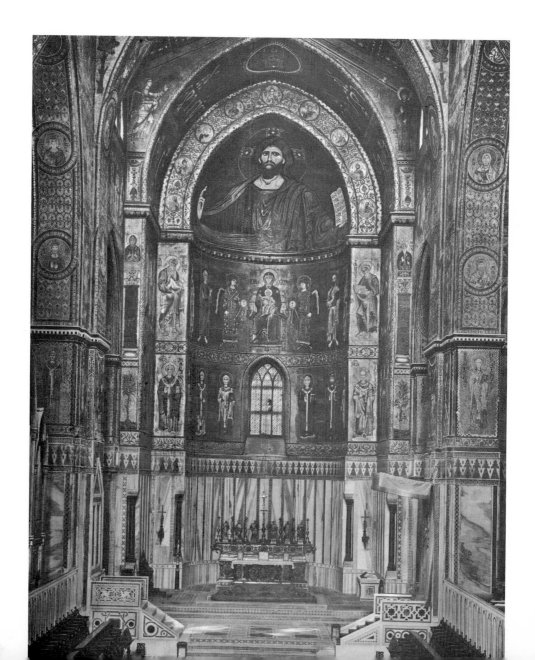

231. *Detail from the mosaics at Monreale, south side of the northeast pier in front of the apse, Christ crowning William II*

William II commissioned both the building of the cathedral at Monreale and its mosaic decoration. His act was commemorated in this and another dedication picture, where he presents a model of the cathedral to the Virgin. The iconography of this scene is drawn directly from Byzantine imperial portraits, such as that of an enthroned Christ crowning Emperor John II Comnenus and his son Alexius in a Gospel book in the Vatican of about 1122 (Urb. gr. 2, fol. 19 verso). William is even garbed in the traditional robes of the Byzantine emperor (see pp. 186–187).

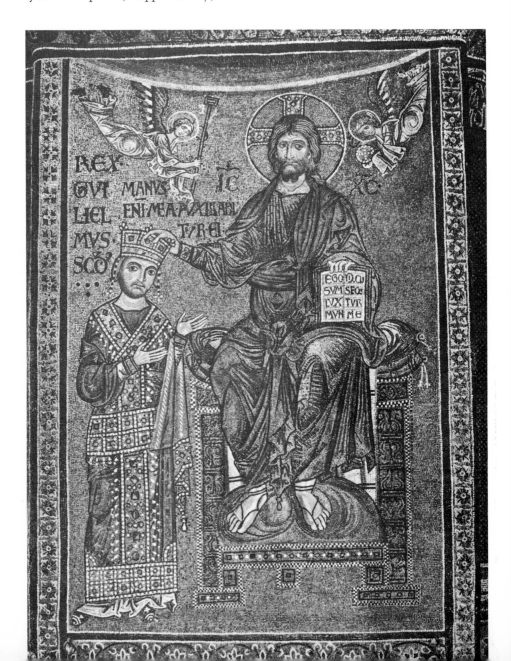

232. *Detail from the mosaics at Monreale, upper register of the north wall of the nave, Judgment of Adam and Eve, Expulsion from Paradise*

The two scenes illustrate well the particular style of Monreale. The vortices of drapery at the angel's thigh and hip in the Expulsion seem to impel the figure forward as he pushes Adam and Eve from the gates of Paradise (see p. 187). The frieze of medallions with busts of angels decorates the east, west, and north walls of the nave below the roof line.

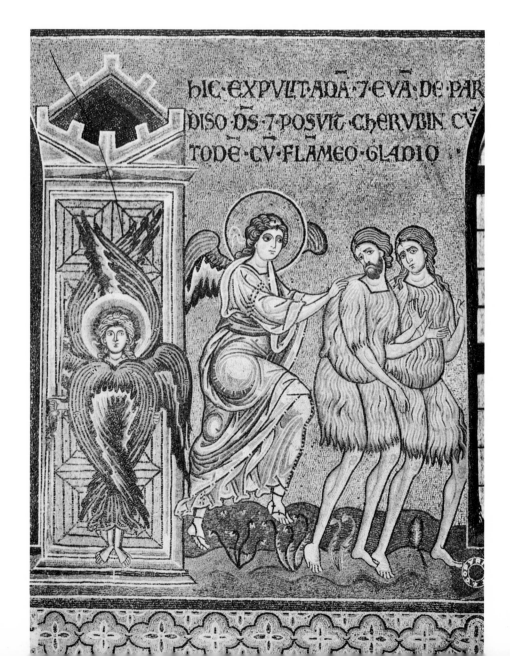

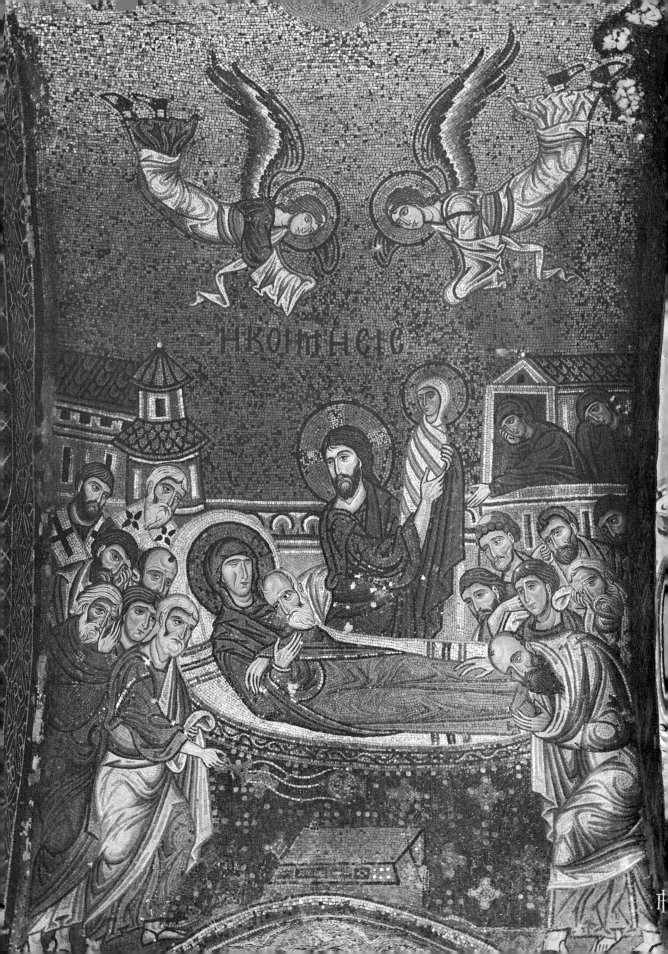

233. *Palermo, church of the Martorana, mosaic in the vault to the west of the central cupola, Death of the Virgin. 1143–1148*

The church of the Martorana in Palermo was endowed in 1143 by its founder, George of Antioch, an admiral and an important official in the court of Roger II. The church was granted to an order of Greek nuns for the practice of the Greek rite, and the admiral had it decorated by Byzantine artists. The iconography and style of this scene are typical of Byzantine work in this period (see pp. 186–187).

234. *London, British Museum, Cotton Ms. Nero C. iv, fol. 29, page from the Winchester Psalter, Death of the Virgin. England, about 1150*

This is one of the two pages in the Winchester Psalter where the illustrations, in sharp contrast to the rest, were directly adapted from a Byzantine or Italo-Byzantine model. Compare this miniature of the Koimesis, or Death of the Virgin, for example, to the same scene in the mosaics in the church of the Martorana (ill. 233).

235. *Detail of the mosaics at Monreale, south aisle, Christ healing the leper*

236. *Freiburg im Breisgau, Augustiner Museum, sheet from an artist's notebook, Christ talking to Zacchaeus, two equestrian saints. Germany, late 12th century*

The figure of Christ in the upper register of the drawing closely resembles that in the mosaic. The similarities indicate that the Western artist may have been inspired by a work that was copied directly from the mosaics (I, no. 268).

237. *Detail of the mosaics at Monreale, south transept, Entry into Jerusalem*

238. *Klosterneuburg, Abbey. Detail of the altarpiece (see ills. 100–104), Entry into Jerusalem. 1181*

These two renditions of the Entry into Jerusalem reveal the most advanced style in Byzantine and Western art about 1180. One did not, however, inspire the other. Nicholas of Verdun, although some of his iconography ultimately derives from Byzantine models, employed the new drapery style that was to revolutionize European art in the next decades (see p. 188).

239. *Detail of the mosaics at Monreale, south transept, Last Supper*

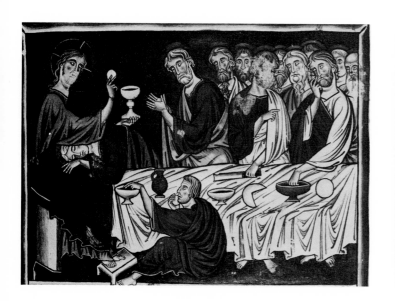 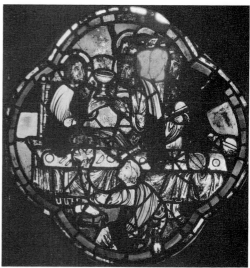

240. *Chantilly, Musée Condé. Ms. 1695, fol. 23 recto, detail from the Ingeborg Psalter (see also ills. 190–201), Last Supper. Ile-de-France, about 1195*

241. *Laon, Cathedral. Chevet, stained-glass window, quatrefoil with the Last Supper. About 1210*

These three interpretations of the Last Supper illustrate the Byzantine impact on Western iconography. In the West, Christ appeared at the center of a rectangular or semicircular table, surrounded by his apostles in a symmetrical arrangement. In Byzantine art, he was placed at the left end of the table, which was usually sigma-shaped, as at Monreale. The younger master of the Ingeborg Psalter adapted the Byzantine scheme to a rectangular table, while draping his figures in the new Western style (see p. 137). Several years later the attraction of the Byzantine scheme still remained strong, for the glass decorator at Laon placed Christ at the left end of the table, although the very shape of the quatrefoil frame called for the symmetrical composition usual in the West.

242. *Venice, church of San Marco. Mosaic in the central cupola of the nave, Ascension of Christ. About 1200*

Christ is here seated on the arc of heaven and supported in an aureole by four angels. Below, the Virgin and the apostles marvel at the scene, while in the lowest register, the Virtues stand between the windows of the drum. The draperies of the figures, especially of the Virtues, are animated by a nervous agitation of folds, which stems from late Comnenian Byzantine art. They are even more exaggerated and abstracted than in the frescoes at Kurbinovo, Yugoslavia.

243. *Nerezi (Yugoslavia), church of St. Panteleimon. Fresco of the Lamentation. 1164*

244. *Aquileia, Cathedral. Crypt, fresco of the Deposition of Christ. Northern Italy, late 12th or early 13th century*

Although earlier than most of the works in the exhibition, the fresco at Nerezi epitomizes the first wave of emotional and dramatic expressionism that was to cause a revolution in Byzantine art in the second half of the 12th century. Among its heirs were, in the East, the frescoes at Kurbinovo, and in the West, the frescoes at the cathedral at Aquileia. Here in the Deposition the ravaged faces of the mourning women and the unnatural angle of Christ's body are representative of Byzantine modes of expression that appealed strongly to the Italian artistic temperament throughout the 13th century.

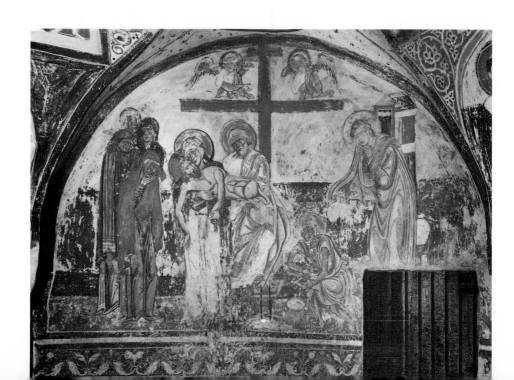

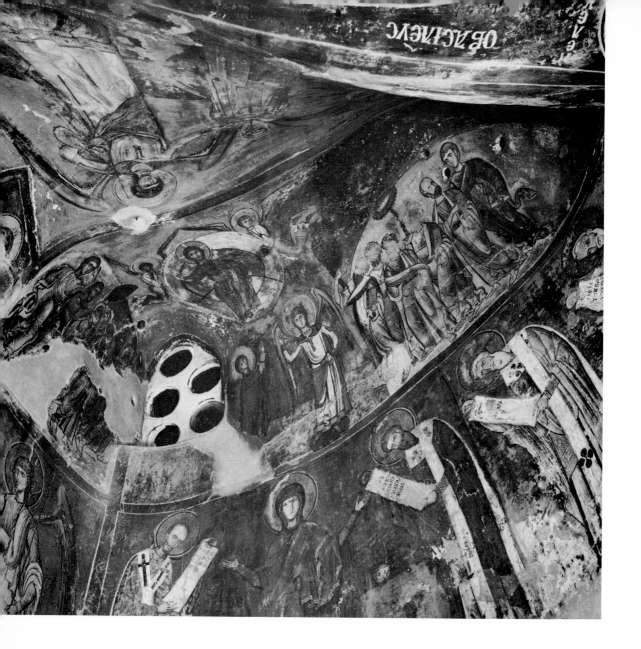

245. *St. Neophytos (Cyprus), rock-cut monastic church. Bema, fresco of the Ascension of Christ, by Theodore Apseudes. 1183*

246. *Detail of the fresco at St. Neophytos*

The frescoes in the church of St. Neophytos provide a good example of the extensive decoration of provincial rock-cut churches in the Byzantine Empire. The rather mannered pose of the young apostle on the left is a hallmark of the late Comnenian style (compare ills. 246 and 251). This pose, together with the serpentine waves of drapery, shows that Theodore came from an artistic center where the most advanced style of Constantinople was employed.

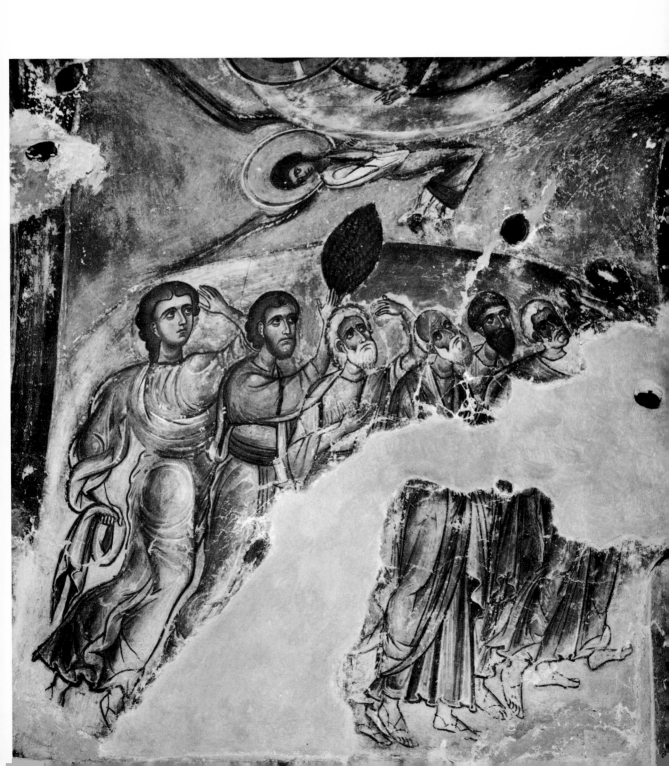

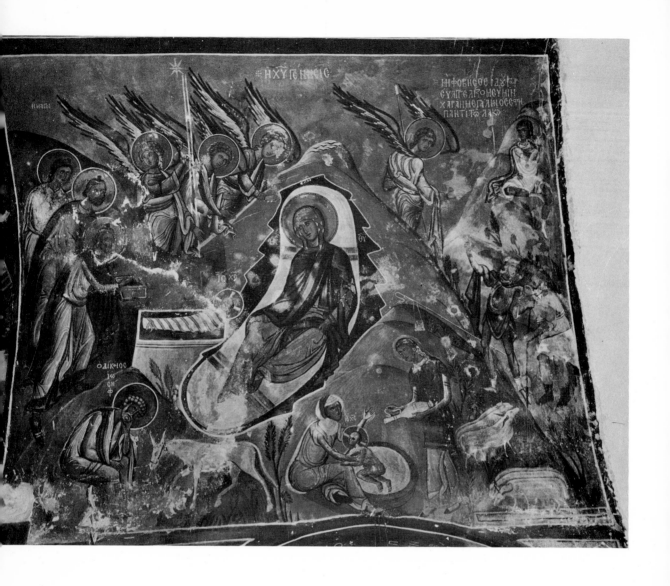

247. *Lagoudera (Cyprus), church of the Panagia tou Arakou. Bema, fresco of the Nativity.* *1192*

The scene of the Nativity at Lagoudera, as it so often does in Byzantine art, includes the Annunciation to the Shepherds and the Arrival of the Three Magi at the stable in Bethlehem. The artist must have come to Cyprus from a metropolitan center only a short time before he painted the fresco, since his art, like that of Theodore Apseudes, reflects the most advanced style of the capital. Compare the figure of the angel announcing the birth to the shepherds with the angel of the Annunciation icon from Constantinople (ill. 249), the angel of the Annunciation at Kurbinovo, and the apostle on the left of the Ascension at St. Neophytos in Cyprus (ill. 246).

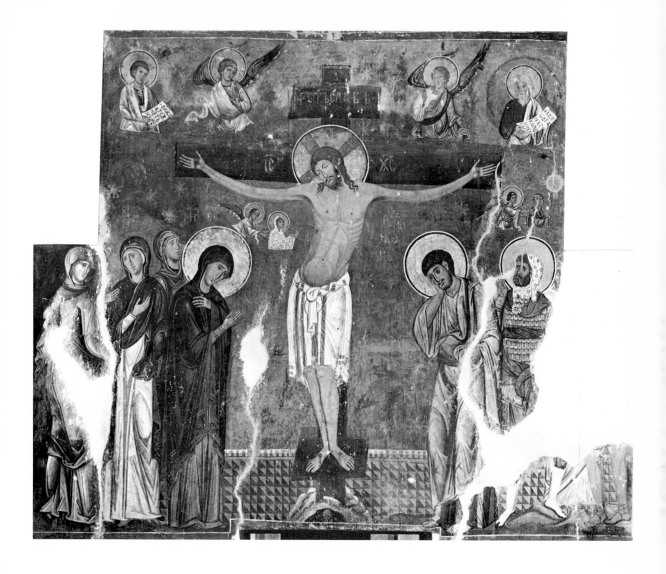

248. *Studenica (Yugoslavia), church of the Mother of God. Fresco of the Crucifixion. Byzantium, 1208–1209*

The calm portrayal of the Crucifixion contrasts sharply with the emotionalism and mannerism of the frescoes at Kurbinovo, painted less than two decades earlier. The new classicizing style appears also in the miniatures of a lectionary from Athens (National Library, Ms. 2645) and in the cross from the Dumbarton Oaks Collection (ill. 228). It is comparable to a similar wave of classicism in Western art (see pp. 187–188).

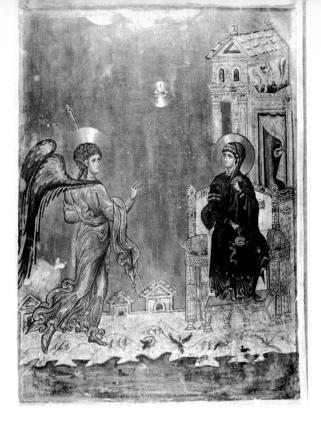

249. *Mt. Sinai, monastery of St. Catherine. Icon of the Annunciation, today part of the iconostasis of the church. Constantinople, about 1180*

This icon offers a unique example of the late Comnenian style of Constantinople, which influenced so strongly the style of the provincial frescoes in Yugoslavia and Cyprus (ills. 243, 245–248). The mannerism of the angel's pose is modified here by a purposeful direct-ness of expression. The scene is permeated by an extraordinary delicacy and sophistication, especially in the representation of the stream with birds in the foreground.

250, 251. *Mt. Sinai, monastery of St. Catherine, details from a painted, wooden iconostasis, Deesis **and** Transfiguration. Byzantium, last quarter of the 12th century*

The Transfiguration (ill. 251) forms part of a feast cycle, a series of illustrations of the most important events in the life of Christ, which are arranged symmetrically on either side of the Deesis on the iconostasis beam. The fine, incisive modeling of the faces and draperies points to a date in the last quarter of the 12th century (cf. ill. 258).

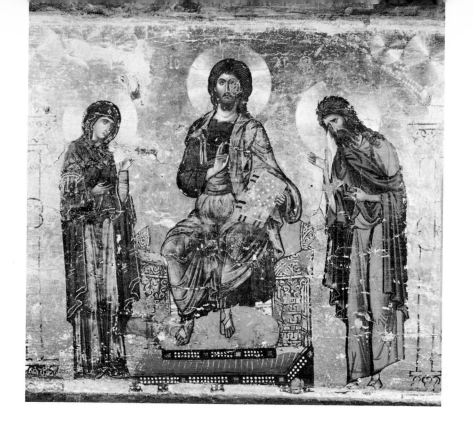

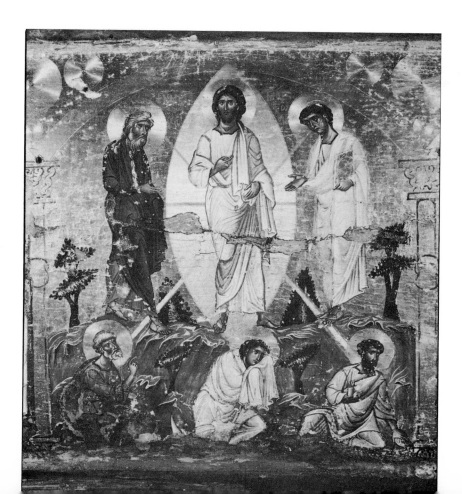

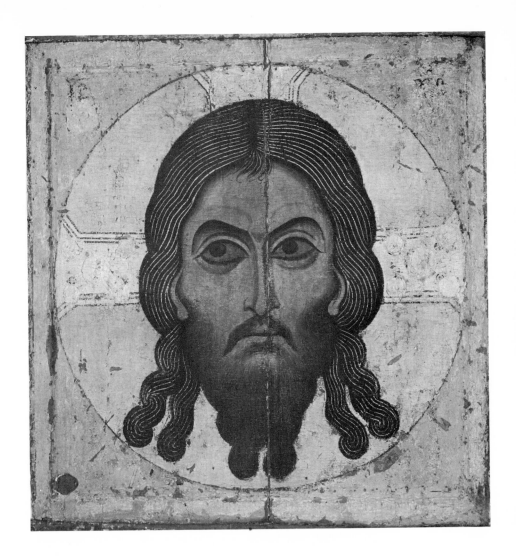

252. *Moscow, Tretjakow Gallery. Painted wooden icon with the face of Christ. Russia (Novgorod?), late 12th century*

This image of Christ derives from the mandylion, or veil, belonging to King Abgarus of Edessa, on which the fact of Christ was miraculously imprinted. The mandylion was brought to Constantinople in 944. The style of the icon, particularly the description of the hair by parallel gold lines, the evenly bilobed beard, and the stern expression, corresponds to that of Christ on the icons from an iconostasis at Mt. Sinai (ills. 250, 251) and in the mosaic at Monreale in which he crowns William II (ill. 231). The softer treatment of the flesh and the simple abstraction of the large eyes indicate the provincial origin of the icon, which was perhaps made in a workshop in Novgorod.

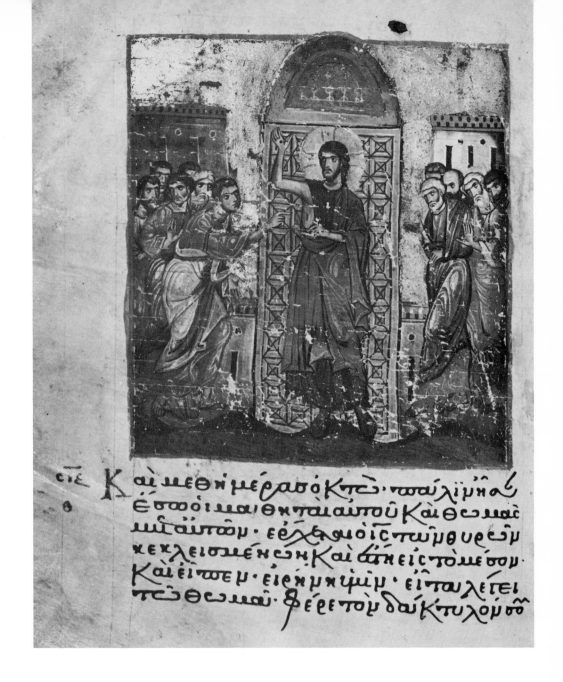

253. *London, British Museum. Harley Ms. 1810, fol. 261 verso, page from a New Testament, Doubting of Thomas. Constantinople, early 13th century*

This manuscript, like the New Testament from Berlin (I, no. 291), contains a large cycle of illustrations. Although it was probably made a few years earlier, many of its illustrations are similar to those in the Berlin manuscript. Compare, for example, the small, active figures and the compact composition of this Doubting of Thomas with those of the Washing of the Feet in the Berlin New Testament. The use of the dark line of shadow over the eyebrows of the figures is also similar.

254. *Vatican, Biblioteca Apostolica Vaticana. Ms. Barb. 320, fol. 2 recto, page from the Barberini Psalter, David playing his harp. Byzantium, last quarter of the 12th century*

Different elements in this illustration were drawn ultimately from Hellenistic and Roman paintings, principally from pastoral scenes featuring such figures as Orpheus, Paris, and Apollo. David sits on a rock, inspired in his music-making by a personification of Melodia, who sits behind him. The mountain Bethlehem appears in the right foreground in the form of an antique river god, and the nymph, peeking around the column beside a well in the right background, is also derived from a figure in ancient idyllic landscapes. David playing his harp is a well-known illustration from the so-called Aristocratic Psalter tradition, of which the most famous exponent is a 10th-century psalter in Paris (Bibliothèque Nationale, Ms. gr. 139). The scene in the Barberini Psalter, however, although produced over two centuries later, is in some iconographical respects, such as the representation of the well, more faithful to the ancient prototypes.

255. *Vatican, Biblioteca Apostolica Vaticana. Cod. gr. 1754, fol. 1 verso, table of contents from* The Heavenly Ladder *of John Climacus. Byzantium, late 12th or early 13th century*

The Heavenly Ladder, by the 6th-century monk John Climacus, was an extremely popular ascetic writing in Byzantium. Its table of contents here takes the form of a ladder with thirty rungs, corresponding to the thirty chapters of the text. Small scenes occupy the space between the rungs, each scene illustrating a chapter. They represent the different requirements of monastic life, such as obedience, poverty, and humility, which the monk must master on his "climb" toward spiritual perfection.

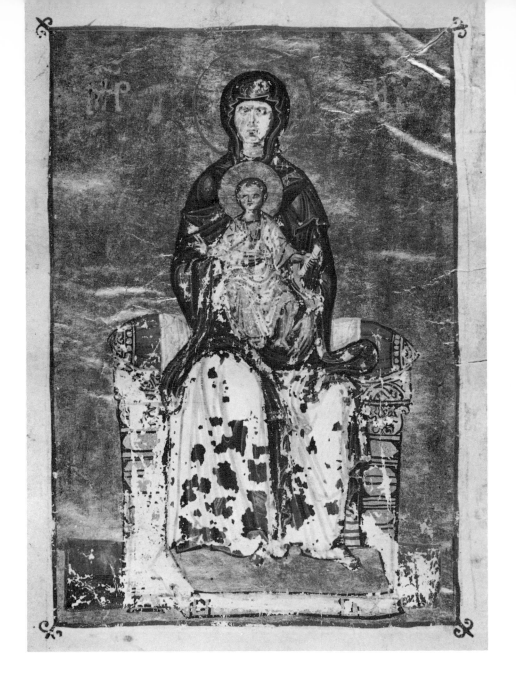

256. *Princeton, University Library. Ms. Garrett 5, fol. 12 verso, Virgin and Child enthroned. Byzantium, about 1180–1190*

Despite its damaged condition, this majestic image clearly demonstrates its derivation from monumental art (cf. ill. 230). The rather mannered laps of folds over the Virgin's thighs, the rippling hemline of her cloak, or maphorion, as it falls between her legs, and the linear accentuation of the highlights of the anatomy of both figures are features also found in other works created around 1180–1190 (see ills. 230, 251).

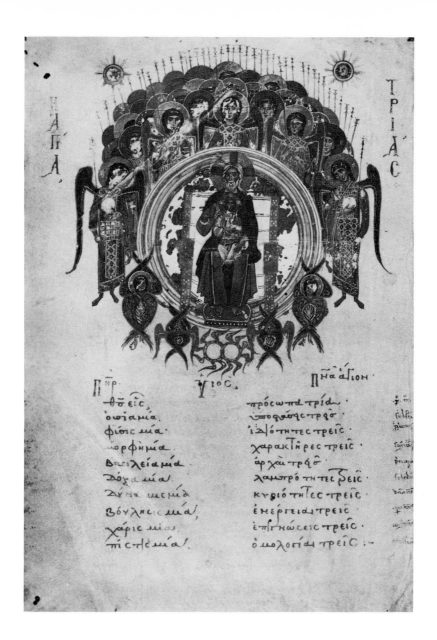

257. *Vienna, Oesterreichische Nationalbibliothek. Ms. Suppl. gr. 52, fol. 1 verso, page from a New Testament, Holy Trinity. Grottaferrata(?), about 1170–1180*

The manuscript was probably made at the Greek Basilian monastery of Grottaferrata in Italy, since the unusual iconography of the Trinity is found again in a fresco in its church. The strict Byzantine style of the illumination illustrates the close ties of the artist to Byzantium. The text of the manuscript was used in 1519 by Erasmus for his second edition of the New Testament.

258. *Vatican, Biblioteca Apostolica Vaticana. Cod. gr. 1208, fol. 1 verso, page from an Acts and Epistles, SS. Luke and James. Constantinople, about 1200*

The standing, as opposed to seated, Evangelist portrait, is a type stemming ultimately from the portraits of standing authors in the decoration of antique scrolls. Here two authors' portraits have been combined within the same frame. The fullness of the body and draperies, the high crown of the head, and the deep shadows of the eyebrows and cheeks are comparable to Byzantine work in the early 13th century (see also ills. 251, 261; I, no. 289).

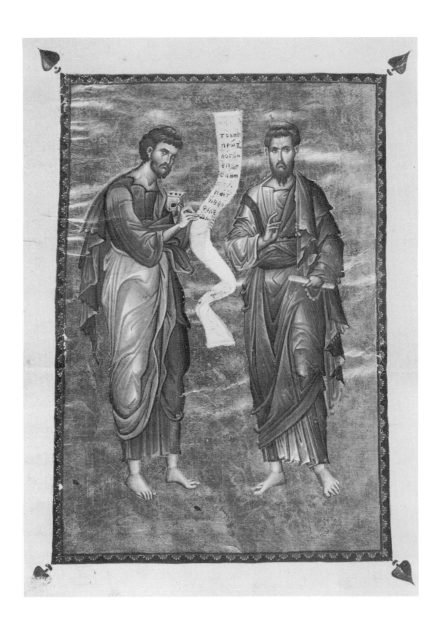

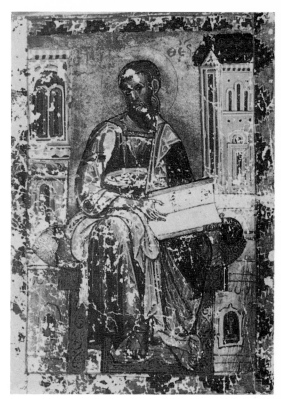

259. *London, British Museum. Ms. Add. 5112, fol. 133, page from a Gospel book, St. John. Byzantium, before 1189*

The two-volume manuscript was written by the monk Gregory, who died in 1189. The breadth of the composition and the patterning of highlights on the face and hands of St. John may be compared to the mosaics at Monreale (ill. 231), indicating a date for the manuscript within the last years of the scribe's life. The nude telamon that holds up the lectern is an adaptation from classical art and can be found in other contemporary Evangelist portraits.

260. *London, Robinson Trust. Ms. Phillipps 3887, fol. 9 verso, page from a Gospel book, St. Matthew. Nicaea or Salonika, first half of the 13th century*

St. Matthew's frontal position and his apparent proximity to the picture surface make this a most impressive illustration. This is the latest in date of the Evangelist portraits presented here, and is important as an example of the product of the Greek workshops that served the Byzantine courts in exile in Nicaea or Salonika during the Latin occupation of Constantinople.

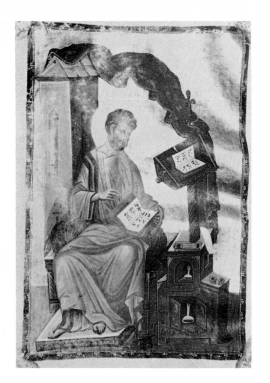

261. *Mt. Athos, Philotheu. Ms. 5, page from a Gospel book, St. Mark. Constantinople, early 13th century*

Chronologically St. Mark's portrait stands between the Evangelist portraits shown in ills. 259 and 260. The drapery gathered loosely but thickly about the body and some details, such as the deep shadow outlining the cheek, indicate that this portrait was painted soon after the Latin conquest of Constantinople in 1204 (see p. 185), around the same time as the Four Gospels from the Morgan Library (I, no. 289).

262. *Wolfenbüttel, Herzog-August Bibliothek. Cod. 61.2 Aug. oct., fol. 91 recto, sketches of the Evangelists, the Virgin, and Pilate(?). Germany, about 1230–1240*

The Evangelist portraits on this page of a twelve-page sketchbook were directly copied by a German artist in Saxony from a manuscript produced in the same Constantinopolitan workshop as the Four Gospels from Athens (National Library, Ms. 118; see p. 189). It was probably by means of such sketches that Byzantine style penetrated so deeply into Saxon manuscript illumination around 1230–1240.

Marie-Thérèse d'Alverny

THE ARABIC IMPACT ON
THE WESTERN WORLD

"WHEN I WAS STUDYING medicine and read in the books dedicated to this art in Latin, the masters and students, who were aware that I knew Arabic and that I had read texts of Galen and other authors in this specialty, kept on urging me to make a choice among the vast amount of manuscripts containing Greek works translated into Arabic, and to render some tracts into Latin for the benefit of scholars. I could not rebuke such a honorable request, so I returned immediately to Toledo and undertook the research diligently."

Canon Mark of Toledo, who wrote this short account of the motives that induced him to translate some Galenic tracts, unfortunately does not specify in what part of Europe he was studying medicine in the late twelfth century, but considering that it was not so far from Spain, it seems likely that the unnamed studium was Montpellier, whose reputation rose as high at that time as the fame of Salerno in southern Italy. The wandering scholar in quest of science had been a typical feature of the twelfth-century world of learning. The curiosity and energy of these worthy pioneers were instrumental in the discovery of scientific and philosophic texts and in their translation into Latin. With the development and organization of great centers of study at Bologna, Paris, and Montpellier, toward the end of the century, poles of attraction and meeting places were established where students could hear famous masters and at the same time get acquainted with new material brought from the countries where translations were executed, either from Greek or Arabic. It seems that the medical schools were particularly suitable for this kind of exchange.

The system of education based on the seven liberal arts (trivium: grammar, arithmetic, geometry; quadrivium: music, astronomy, dialectic, and rhetoric) had remained the fundamental program from late antiquity to the twelfth century. Although in the late twelfth century it was still considered an ideal scheme—expounded in prose and verse, represented in sculpture and painting—it was becoming in fact a poetical and artistic fiction. The sciences of the quadrivium had grown,

and with the exception of music, had undergone a substantial change. The science of nature, *Physica,* linked with mathematics and medicine, was the main novelty in a revolution that was about to transform medieval culture and to endow the faculties of arts with a program much enlarged and widely different from the program of the old schools, for which the fifth-century encyclopedia of Martianus Capella, *De nuptiis Philologiae et Mercurii* ("The Wedding of Philology and Mercury"), had been the sum of secular knowledge.

The most active agent of this transformation, together with the "new Aristotle," was the overflowing collection of Arabo-Latin translations related to the quad-rivium as well as to metaphysics and medicine, which had been or was about to be extracted at all costs and pains from the secret treasures of the Moslems. It must be stressed that the men who tried to profit by the spoils of the Saracens did so mostly because they believed that the infidels retained the wisdom of the famous Greeks. Mark of Toledo provides a good example of the attitude of the Western scholar around 1200. His fellow physicians asked for "Galen" as other amateurs sought Aristotle's *Libri Naturales,* Euclid's *Elements,* and Ptolemy's *Almagest.* The fame of Arabic learning was primarily due to the fact that Arabic libraries possessed works of Greek philosophers and scientists of whom the Western world knew only the name and a few tracts. This zealous craving had been fulfilled to a degree with Greco-Latin translations; recent investigation has proven that the *Libri Naturales* and the *Metaphysics* of Aristotle were partially available by the mid-twelfth century. In the fields of mathematics, medicine, and astronomy, how-ever, the Arabs had preserved more material than Byzantium, and their own contribution, even if considered as commentaries on, or enlargements of, Greek science, was noticeable.

The acquisition of the wished-for knowledge was submitted to two conditions: first, to get hold of the books; second, to understand the contents. Arabic is a very difficult language and could be learned only in the places where it was in current use and where it was possible to find teachers and interpreters. In many cases the interpreters were required to collaborate effectively in the work and sometimes took the leading part.

There were several points of contact in the twelfth century between Arabic and Latin culture: Spain, Sicily, and the Kingdom of Jerusalem. It is in Spain that most of the translations were executed, owing to the peculiar circumstances under which the population of the peninsula had lived for so long. In this large area, Moslems and Mozarabs were mixed in more or less pacific conditions. When the *recon-quista* began, the Christians, who spoke both Arabic and a romance vernacular,

were able to interpret the manuscripts left in numbers, it seems, in the subdued cities. So were the Jews, who knew three languages, Arabic, Hebrew, and the vernacular, and among whom it was easier to meet learned men. The vernacular was in many cases the medium of transmission, the texts being ultimately written down in Latin. Some scholars, however, were able to translate directly from Arabic into the international language of the learned world.

In the second half of the twelfth century, most of the translating activity was concentrated in Toledo, the capital of the Christian kingdom, and the seat of the primate of Spain. The fame of Toledo as a center of learning in our period was particularly due to the labor of two men who devoted their lives to the interpretation of scientific and philosophical texts. The most prolific was Master Gerard of Cremona, who came from Italy to Spain. He translated works of Aristotle, or tracts ascribed to him in the Arabic tradition, works of other philosophers, Greeks or Moslems, and treatises on mathematics, geometry, mechanics, astronomy, astrology, medicine, alchemy, and even divination. The second was a Spanish archdeacon, a member of the Chapter of Toledo, Dominicus Gundisalvi, or Gundissalinus. He collaborated with several interpreters to present to the Latin West the flower of Arabic philosophy, mostly the works of Avicenna (980–1037), the famous physician and philosopher. Moreover, the canon composed several tracts of his own, which were in fact adaptations of the works lately translated, realizing the first synthesis of Arabic philosophy and Christian tradition embodied in his favorite authorities, St. Augustine and Boethius.

Gerard died in 1187 and Gundissalinus after 1190. The students who sat at Gerard's feet scattered all over Europe. In 1200 the translations and adaptations executed during this fruitful period were available in Italy, France, England, and even more remote places, as evidenced by the recent discovery of a manuscript copied in Austria in the early thirteenth century.

Toledo was still an active center after the deaths of Gerard and Gundissalinus. Canon Mark, the physician, devoted his later years to the interpretation of the Moslem creed, for apologetic purposes. He produced a new version of the Koran in 1211 and translated in 1213, on the request of Don Rodrigo Jimenez, archbishop of Toledo, the professions of faith of Ibn Tumart, mahdi of the Almohad dynasty, who ruled Al-Andalus. This shows that, notwithstanding the war, the Toledans were in touch with the Moslem kingdom, and they did not ignore the great Cordovan philosopher Averroës, who died in 1198. A few years later a foreign scholar, Michael Scot, who became famous afterward as Frederic II's astrologer, settled in Toledo and began to translate the Cordovan's work. The

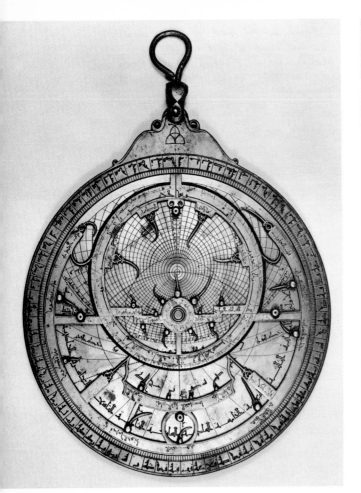

Maghribî astrolabe. Signed on the back of the kursî: "In the name of God. Made by Muhammad b. Fattûh al-Khamâ' irî in the city of Seville in the year 621" (A.D. 1224/25). University of Oxford, Museum of the History of Science

influence of Averroës did not immediately affect the faculties of arts, and therefore we cannot take this early acquaintance with Aristotle's faithful commentator into account in our picture of the intellectual interests around the year 1200.

What is, however, really striking in our period is the rapid diffusion and assimilation of the material accumulated earlier. If a student had been asked then what was the most important achievement of Arabic science, he would have answered, "astrology," the term involving all the aspects and implications of the science of stars. The precise observation of the movements of planets in the zodiacal signs was necessary to determine the influence of the heavens on the sublunary world, including human beings and their fate. The ultimate aim of the calculations,

realized with the help of that wonderful instrument, the astrolabe, was to master the configuration of the skies and to interpret the signs. The translation of tracts on astrolabes began in the late tenth century, and by the twelfth century the number of available astronomical tables, catalogues of stars, and treatises on astrology had become truly impressive. The Western astronomers were able to make use of this material by adapting the Toledan tables to other meridians, constructing astrolabes, predicting eclipses, and elaborating methods for casting horoscopes and interrogating the stars to solve various problems. The impact of this aspect of Arabic science can be traced not only in technical books, but also in historical, and even theological, literature.

In the chronicles written in the late twelfth and early thirteenth century, the eclipses were frequently recorded, and when there was some fateful coincidence, it was carefully noted. On the other hand, the astronomers, when they predicted an eclipse, did not always refrain from adding some omen, though they must have considered that an eclipse was a natural phenomenon.

Though astronomy and astrology were the most conspicuous contribution of

Solomon as astronomer, detail from the Bible of St. Bertin. The initial V belongs to the text describing Solomon's vision of the world (Eccles. 1:5–7). Paris, Bibliothèque Nationale, Ms. lat. 16745, fol. 108 recto

the Arabs to European culture in 1200, other sciences were indebted to them. The greatest mathematician in that period, Leonardo Fibonacci of Pisa, wrote the first draft of a *Liber abaci* about 1202. He used the so-called Arabic numerals, of Indian origin, which were known previously but had had a slow diffusion. He expounded progressions and proportions, square and cubic roots, and algebra and geometry. In the hands of a great man, the new material was not only assimilated but also developed, and Western mathematics experienced real progress.

Medicine, with astronomy, had been one of the sciences much in demand. Translations from Arabic had been executed in Monte Cassino and southern Italy by Constantinus Africanus and his followers in the late eleventh and early twelfth centuries. This first corpus was enlarged by a new set of translations made in Toledo by Master Gerard. Among the texts that he produced were tracts written by Razi and the medical encyclopedia of Avicenna.

By 1200, Arabic medicine, including Galen and pseudo-Galen, had invaded most of the European studia. In that field, too, a great change took place. The old Greco-Roman medicine had been chiefly empirical. Galen and his Arabic followers, however, were philosophers as well as physicians. They mixed ethical and psychological observations with practical advice. So theoretical medicine was developed, and practical medicine progressed with an increased teaching of anatomy, pathology, and pharmacology. Further evolution of medical science was already made in the twelfth century, by the association of the art of healing with astrology. A good physician, as Master Urso of Lodi wrote in 1198, must be proficient in the seven arts, but especially in astrology.

An anonymous author tried a bold reconciliation of Arabic and Christian views about 1200, and his work was illustrated by a striking picture of the celestial world. The unique manuscript (Paris, Bibliothèque Nationale, Ms. lat. 3236A) was probably executed in Bologna; the author of the tract may have come from Toledo, with a collection of philosophical tracts and some knowledge of Moslem mystics. In the Avicennian system, the earth is surrounded by nine spheres, or orbs, each governed by an intelligence and moved by a soul. Above is the tenth

Illuminated flyleaf containing a diagram of the heavens with Christ in Majesty as Creator, First Cause, and Divine Will. This illumination was probably intended as an illustration for an anonymous text of about 1200 found on the flyleaf of the manuscript, describing the nature of man and the fate of his soul after death. However, the arrangement of the celestial zones in the illumination does not correspond in detail to the text, and there are other unexplained features, such as the ten climbing figures that show, among themselves, a noticeable progression in age. Paris, Bibliothèque Nationale, Ms. lat. 3236A, fol. 90

divine intelligence, from which flow all the others. The unknown philosopher had identified these intelligences with the nine choirs of angels, and described the ascension of the soul through mystical steps of purification toward the supreme God. In the illustration, the Pantocrator is represented dominating the world, as creator of the universe and First Cause. Ten small figures climb up with great energy from earth to God. The details of the picture are slightly confused, for the illuminator separated the elementary and planetary spheres, which are in the realm of *Natura,* from the superior world of souls and intelligences linked with the angels and elders of the Apocalypse. This striking picture, however, is a remarkable instance of the syncretism of our period.

As long as the scientific and philosophical translations were in the hands of naturalists and physicians, they circulated freely and were received with great interest. They reached the studia of Bologna and Paris and attained a less specialized audience shortly after 1200. Two men, Master Roland of Cremona in Bologna and William of Auvergne in Paris, both of whom studied in the first quarter of the century and became theologians, are important witnesses to the impact of the new Arabic material on the rising universities. Both of them quoted extensively from Arabic philosophers.

We see from the reaction of ecclesiastical authorities in 1210 that the peaceful invasion of the new tracts was successful enough to provoke an ecclesiastical interdiction to teach "the books of Aristotle on natural philosophy and their commentaries, neither openly nor privately." Aristotle and his followers were officially banned from the faculty of arts, to return in force only some thirty years later, after hard fights.

No interdiction could prevent the young scholars from quenching their thirst for learning in the stream flowing from the "armaria Arabum." The precious little books of medicine, mathematics, astrology, and natural philosophy were copied and passed from hand to hand, sometimes in secret when they contained alchemy or magic. Only a few survive, but when we read them, we can realize the steady progress of the Arabic impact around 1200.

Sources of Illustrations

Alinari, ills. 38, 39, 239

Anderson, Rome, ills. 230, 231, 232, 235, 237

ATA, Stockholm, ill. 66

Biblioteca Apostolica Vaticana, Rome, ills. 254, 255, 258

Bibliothèque Municipale, Reims, ill. 185

Bibliothèque Nationale, Paris, ill. 180, pp. 235, 237

Osvaldo Böhm, Venice, ills. 214, 216, 217, 218, 242

Robert Branner, Baltimore, pp. 8, 10

British Museum, ills. 163, 164, 175, 176, 177, 178, 179, 186, 187, 253, 259

Brogi, ill. 233

Courtauld Institute of Art, London, ills. 234, 260

Walter Dräyer, Zurich, ill. 12

Dumbarton Oaks Collection, Washington, D.C., ill. 228, p. xxi

Courtesy of the Dumbarton Oaks Field Committee, ills. 245, 246

Edizione Frati Minori Conventuali, Abazia di Fossanova, Italy, ill. 22

Hans Fischer, p. xii

Gallery of Frescoes, Belgrade, ills. 243, 248

François Garnier, Pontoise, France, ill. 167

Giraudon, Paris, ills. 83, 99, 141, 190, 191, 192, 193, 220, 240, p. xiii

The Green Studio, Ltd., Dublin, ill. 153

Jane Hayward, ill. 90

Herzog-August Bibliothek, Wolfenbüttel, ill. 262

Hirmer Fotoarchiv München, ills. 213, 215, 221, 226, 227, 244

Historical Museum, Copenhagen, ills. 150, 151

Historisk Museum, Stockholm, ill. 122

Martin Hürlimann, Zurich, ills. 9, 154, 155, 156

Kestner Museum, Hannover, ill. 206

J. Lafontaine, Brussels, ill. 247

Landesamt für Denkmalpflege, Vienna, ills. 100, 101, 102, 103, 104, 238

Charles J. Liebman, New York, p. 3

Foto Marburg, ills. 1, 3, 4, 5, 6, 7, 8, 10, 11, 13, 14, 20, 21, 23, 24, 25, 26, 30, 31, 32, 33, 34, 35, 36, 37, 40, 41, 42, 43, 45, 50, 52, 53, 54, 55, 56, 57, 60, 61, 62, 65, 67, 68, 69, 70, 71, 72, 73, 74, 75, 78, 93, 94, 95, 96, 97, 107, 109, 110, 123, 124, 125, 126, 127, 128, 129, 130, 131, 138, 139, 142, 143, 144, 145, 146, 147, 148, 152, 157, 158, 165, 168, 169, 170, 171, 172, 173, 174, 181, 202, 203, 204, 205, 207, 208, 209, 210

Foto Mas, Barcelona, ill. 46

Reproduced through the courtesy of the Michigan-Princeton-Alexandria Expedition to Mount Sinai, ills. 249, 250, 251

Monuments Historiques, Service Photographique, Paris, ills. 2, 49, 79, 80, 81, 82, 85, 86, 241

Ann Münchow, Aachen, ills. 132, 133, 134, 136, 137, 211, 212, 222, p. xviii

Museum of Fine Arts, Boston, ill. 63

Österreichische Nationalbibliothek, Vienna, ill. 257

The Pierpont Morgan Library, ills. 166, 223

Princeton University Library, Princeton, N.J., ill. 256

Rheinisches Bildarchiv, Cologne, ills. 18, 19, 27, 28, 29, 47, 51, 64, 76, 77, 88, 89, 105, 106, 108, 111, 112, 113, 114, 115, 116, 117, 118, 119, 120, 121, 135, 159, 160, 161, 162, 224, 225

Scala, Florence, ills. 15, 16, 91, 92, 98, 229, pp. xi, xv, xvii, xxiii

Stiftung Preussischer Kulturbesitz, Berlin, ills. 58, 59

Tretjakow Gallery, Moscow, ill. 252

University of Oxford, Museum of the History of Science, p. 234

Victoria and Albert Museum, Crown Copyright, ill. 219

Hildegard Weber, Freiburg im Breisgau, ill. 236

Kurt Weitzmann, Princeton, N.J., ill. 261

Francis Wormald, London, ills. 188, 189

Württembergisches Landesmuseum, ill. 87